Drawing Birds
with
Colored Pencils

© 2007
K Poole

Drawing Birds with Colored Pencils

Kaaren Poole

STERLING

New York / London
www.sterlingpublishing.com

Prolific Impressions Production Staff:
Editor in Chief: Mickey Baskett
Copy Editor: Miche Baskett
Graphics: Dianne Miller, Karen Turpin
Styling: Lenos Key
Photography: Jerry Mucklow
Administration: Jim Baskett

Every effort has been made to insure that the information presented is accurate. Since we have no control over physical conditions, individual skills, or chosen tools and products, the publisher disclaims any liability for injuries, losses, untoward results, or any other damages which may result from the use of the information in this book. Thoroughly read the instructions for all products used to complete the projects in this book, paying particular attention to all cautions and warnings shown for that product to ensure their proper and safe use.

STERLING and the distinctive Sterling logo are registered trademarks of Sterling Publishing Co., Inc.

Library of Congress Cataloging-in-Publication Data

Poole, Kaaren.
 Drawing birds with colored pencils / Kaaren Poole.
 p. cm.
 Includes index.
 ISBN-13: 978-1-4027-5263-6
 1. Birds in art. 2. Colored pencil drawing--Technique. I. Title.

NC892.P56 2008
743.6'8--dc22
 2007042143

10 9 8 7 6 5 4 3 2

Published by Sterling Publishing Co., Inc.
387 Park Avenue South, New York, NY 10016
©2008 by Prolific Impressions, Inc.
Distributed in Canada by Sterling Publishing
c/o Canadian Manda Group, 165 Dufferin Street,
Toronto, Ontario, Canada M6K 3H6
Distributed in the United Kingdom by GMC Distribution Services,
Castle Place, 166 High Street, Lewes, East Sussex, England BN7 1XU
Distributed in Australia by Capricorn Link (Australia) Pty. Ltd.
P.O. Box 704, Windsor, NSW 2756, Australia

Printed in China
All rights reserved

Sterling ISBN 978-1-4027-5263-6

For information about custom editions, special sales, premium and corporate purchases, please contact Sterling Special Sales Department at 800-805-5489 or specialsales@sterlingpublishing.com.

For Belle and my entire feline tribe who are, without exception, great admirers of all things avian.

(My cats are all strictly indoors, for their own safety as well as the safety of the local wildlife.)

Acknowledgments

- Thanks to my daughter, sisters, and friends who encouraged me on this project. They lifted me up when I was down, and cheered me on when I was "on a roll!"

- I must acknowledge my cats, especially Belle, Mopsy, and Simon, who traded off in carrying the heavy burden of weighing down my drawings, ensuring that a sudden shift in the laws of gravity could not interfere with my progress. Thanks, guys! I could not have done it without you!

- Janine Russell is a talented photographer who has graciously allowed me to use several of her lovely photographs as bases for my drawings. Her love of nature and God's creation is apparent in her work. She finds beauty in the most seemingly insignificant, as well as the most glorious, aspects of nature. She generously shares her talent on WebShots (www.webshots.com).

- Dick Blick has a great selection of all types of art supplies. I especially like this site for their variety of colored pencils, both in sets and open stock. They also have a good selection of drawing papers available in pads or by the sheet (www.dickblick.com).

- Daniel Smith Co. has their own brand of watercolors (for mixed media) that I find particularly fine. Their selection of paper is wonderful, including many hand-made and usual papers that are fun to experiment with (www.danielsmith.com).

- And special thanks to Mickey Baskett and her company, Prolific Impressions, who did such a wonderful job of turning my drawings and writings into a beautiful book.

Contents

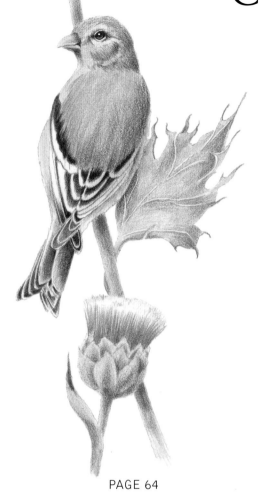

PAGE 64

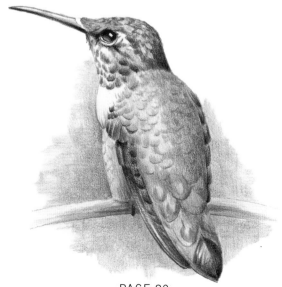

PAGE 80

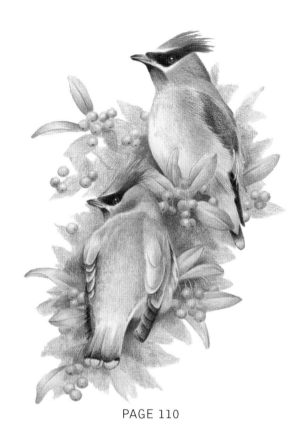

PAGE 110

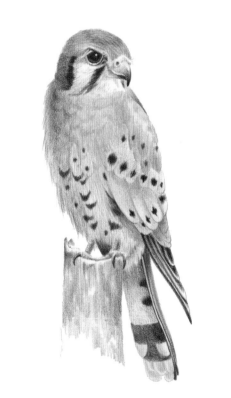

PAGE 134

The Allure of Birds

I hear a thump on the deck and look out to see a half dozen turkeys crowding to raid the bird feeder I have attached to the deck railing. These large birds can clean out my feeder in a matter of minutes and have effectively chased the song birds away since there is never any seed left for them. I have tried various locations for my feeder, looking for one that is convenient for me to fill, but out of reach of the turkeys. So far, it is turkeys 5, Kaaren 0!

But I must admit that these turkeys have their own charms. The males have been displaying lately, and what a sight they are! Their plumage, somewhat dull the rest of the year, has taken on iridescent glows of copper and teal, and their wattles are bright red. The females are being coy, but the inevitable appearance of the chicks betrays their interest. When the chicks are hatched, family groups roam my yard in search of turkey treats, the moms and dads whistling softly to herd the young. When they pick up speed, their profiles and gait remind me of some of the dinosaurs in Jurassic Park.

On the side deck, I see a brown towhee, a visually unremarkable bird of dull brown. But she, too, has her charms. Her body is round and her plumage beautifully smooth. Her eyes and movements are bright and alert. Often I see these birds perched on the hood of my car, attacking their reflections in the windshield, so they must also be smart! All in all, she is downright cute!

It seems that each bird species has its own appeal: the joy and energy of the hummingbird, the parrot's gorgeous plumage, the spritely gregariousness of the goldfinch, the bluebird's sweetness, the swallow's graceful and acrobatic flight, the hope for spring that the robin brings with her, the majesty of the eagle.

The world of birds offers a spectrum of size, shape, color, and mobility. We have the tiny hummingbirds and the enormous condor; the tall slender roadrunner and the chubby round quail; the brilliantly colored macaw and the understated sparrow; the solitary bluejay and the blackbirds flocking by the hundreds. Each species has its own special calls. Each flying species has its characteristic flight pattern. Some birds are graceful and skillful in the water, and others are entirely flightless.

And their behavior is fascinating and often tender. There are birds who use tools! There are birds who migrate thousands of miles with amazing stamina and predictability. And most show extreme devotion to their young and their mates. Birds definitely espouse family values!

Fortunately for us, many species of birds, especially songbirds, happily share their habitats with people. So, no matter where one lives – city, town, suburbs, or country – there are birds to observe and enjoy. Put out a few feeders – carefully placed! – and you will see a variety of birds for most or all of the year. Join a bird-watching group and go on expeditions with binoculars and camera. Or, get involved with a local wildlife rehabilitation group and experience the wonder of raising and releasing orphaned babies.

I believe that the artistic nature paints or draws what it admires and finds beautiful. Birds are one of the joys in my life, and, naturally, one of my favorite subjects. I hope this book will inspire you, also, to draw birds.

How to Use This Book

This book contains several step by step demonstrations of my layered colored pencil technique. I hope that reading through the various projects will give you an understanding of my method and how you might use it to complement your own style.

You may want to duplicate some of the projects. To do so you may begin with your own line drawing, or you may trace a line drawing from the photograph of the finished piece (Please be aware that my drawings are protected by copyright, so trace them only for your own learning purposes.)

I have included palettes of the colors I used with each drawing. My intent is to demonstrate the range of colors I used to construct the final effect. Colored pencil manufacturers change their product lines through time so the exact named colors may or may not be available in the future. But if you wish to do the drawings yourself and duplicate my color schemes these color swatches will provide you a visual reference for matching your colors to mine.

FOR INSPIRATION

Leigh Yawkey Woodson Art Museum sponsors an annual show, Birds in Art. This is a world-famous show and the artists who are fortunate enough to have their work selected have earned a great addition to their resumes. Catalogs of past shows are available on their website, www.lywam.org.

Check a book of Audobon's works out of the library. I think you will enjoy his beautiful compositions of birds in settings.

Colored Pencils

I enjoy both drawing and painting, but drawing is my favorite. The range of value available from such a simple act as varying my pressure on my pencil yields incredible detail and expression. So, for me, colored pencil is the best of both worlds – the beauty of color added to my favorite pencil technique. It also has several practical advantages – it is economical, portable, and there is no clean up!

Like watercolor, acrylic paint, oil paint, or pastel, colored pencil is simply a method of applying pigments to a surface. Artists' quality colored pencils use the same pigments as fine paints. But instead of mixing the pigments with "binders" such as gum (watercolor), acrylic resin (acrylic paints), various oils (oil paints), or chalks, clays, and oils (pastels), manufacturers mix the pigments with wax or clays to form leads, then encase the leads in wood in pencil form. The formula for the binder determines the workability of the pencils, and varies between brands.

Colored pencil is primarily a transparent medium. Among other things, transparency means that the color of the paper plays a major role in the drawing. "White" is

Medium Lead Type

achieved by working on white paper and allowing the color of the paper to show. Manufacturers make white pencils, but white pencil laid over another color will not result in white, but in a lighter version of the underlying color. Transparency also means that the method of "mixing" colors with colored pencil is layering one color over another. Layering is a wonderful subtle way of mixing colors because the mixing occurs on the paper. (See the General Information section "Color Theory Basics.")

There are several brands of art quality colored pencils available through large art supply stores or web sites. Many are available as "open stock" – meaning that you can purchase individual pencils, in addition to sets. Sets are typically good values and are a good way to begin building your colored pencil collection. Some manufacturers add several new colors periodically, and offer their new introductions in sets. Open stock is great for replacing individual colors that you use over and over again. Open stock is also a good way of trying out a new brand. Buy a few of your favorite colors and see how you like them!

Soft Lead Type

Although I enjoy building color by layering and so theoretically only need a limited number of colors, I have a "collector" facet to my personality, and so have a large number of colors. I find that looking at the array of colors inspires me.

TYPES OF COLORED PENCILS

I use several brands of color pencils within each drawing because of their special qualities. Some pencils are soft and blend better, while others are hard, allowing finer lines. You will need to have all the types of pencils on hand.

Soft Lead Type Colored Pencils:

The soft, thick core of these pencils make them well suited for layering, blending, and shading. The pencils have a rich, smooth laydown, making them ideal for use on a variety of papers, vellum, and even wood. The leads are soft and waxy. With pressure, they yield fully saturated fields of brilliant color. They will hold a good point, but not a fine one. They are available in sets of 12, 24, 36, 48, 72, 120, or 132 colors, or in open stock. They are also available in "portrait" and "landscape" 24-pencil sets.

Medium Lead Type Colored Pencils:

The core allows for extra control when drawing and sketching. The leads hold a sharper point than soft core pencils, but the colors are brilliant and blend easily. They are available in sets of 12, 24, 36, or 72 colors as well as open stock. In some brands of this type, the leads are clay based. They hold a sharper point than soft core pencils, but yield more brilliant saturated color than thin core pencils. Their range of color rivals soft core pencils and they are available both in sets and open stock.

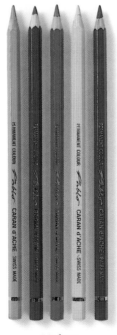

Medium Clay-based Lead

Hard Lead Type Colored Pencils:

These type of pencils have a harder, thinner core than other pencils. They can be sharpened to an extremely fine point. They are perfect for outlining, or doing other types of detail work. I find them invaluable. These pencils come in sets of 12, 24, or 36 and also in open stock. The range of colors is limited, but they layer beautifully and through this technique you can get a wide range of color. These pencils lay down very smoothly and I tend to use them exclusively in my first layer of a drawing, and nearly exclusively in the second. Because the leads are hard, even a heavy pressure will not yield a field of deep color. So I usually layer other brands of pencil over them in my third layer.

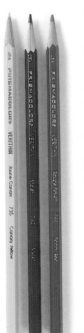

Hard Lead Type

Watercolor Pencils: I do not use watercolor pencils because I find them difficult to control as the colors can be greatly intensified when water is added. But I encourage you to try them and see if you like them. Many artists achieve beautiful results with them.

Colorless Blender

A "colorless blender" looks like a pencil. The "lead" is formulated to soften and blend pencil strokes. I find that it also intensifies the color a little bit. I do not use this tool often, but it is worth experimenting with. To use, simply apply it over your colored area.

Sketching Supplies

The first step in colored pencil drawing is to make a separate graphite sketch. This sketch is the basis for the finished drawing. Here are supplies related to the graphite sketch.

Graphite Pencils

You can use a mechanical pencil or a graphite drawing pencil to make your sketch. Mechanical pencils keep their sharpness better and are what I prefer. Mechanical pencils are available in drug stores and office supply stores in 5mm, 7mm, and 9mm leads. The thinnest leads such as 5mm are best for drawing details. In addition to being available in a range of thicknesses, the leads are also available in different hardnesses. The hardness scale runs from 6H (the hardest) through 2H, HB (the middle hardness), then from 2B through 6B (the softest). HB and 2B leads are commonly available. HB leads are great for sketching. 2B are softer and smudge more easily.

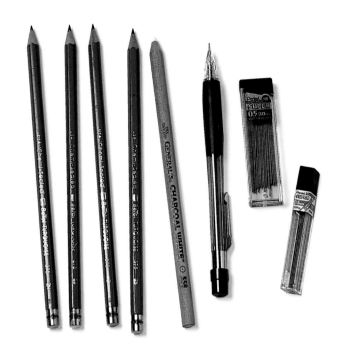

Erasers

White "brick" erasers are great for erasing large areas; "click" erasers are invaluable. Click erasers are available at office supply stores and larger drug stores. A click eraser looks like a mechanical pencil and, with a clicking action, advances a stick of white eraser. This eraser is great for cleaning up small areas.

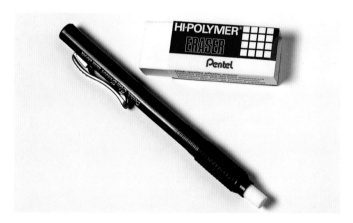

Sketching Paper

Use drawing paper for the initial sketches. It is relatively inexpensive but holds up well under lots of erasing and re-working. It has a smooth surface. Copy paper can also be used for a quick sketch.

Compass

When using a photo or other drawing as the inspiration for your sketch, a compass works for measuring and checking proportions.

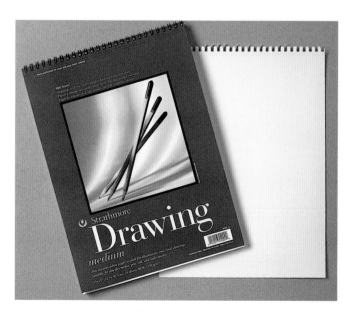

Papers

Paper plays a major role in the look and success of drawings. Its texture, color, and "body" are all important considerations. Use papers that are acid-free to prevent your colors changing or fading over time. Smooth papers are preferred because these types of drawings have a lot of detail which tend to get lost on rougher surfaces. Keep in mind that there are several more alternatives than the ones I have discussed here. Consider, for example, the wide range of scrapbook papers that are available. The "papers" might be too thin, but the "cardstock" weight should be tough enough for colored pencil, and scrapbook papers are usually acid free. Here are some choices to use for your finished drawing.

Vellum Finish Drawing Paper

The type of paper that is best to use for the finished drawing is vellum finish, 100% cotton and acid free paper. Its weight of 250 GSM is heavy enough to stand up to multiple drawing layers. This paper comes in pads as well as large, single sheets. The handiest size to have on hand is 9" x 12" pads. If you have some larger or odd-size drawings, they can be cut from 20" x 30" sheets. The pads are available in white, but the large sheets are available in cream, natural, and fawn as well as white. These colors are pleasant alternatives to white, but do not overwhelm the drawing.

Watercolor Paper

Use hot finish watercolor paper as an alternative to drawing paper However, it has a softer surface that makes it a little more difficult to get crisp lines. Its advantages are that it is readily available, and that it will stand up to water if you want to use mixed media techniques with colored pencil and watercolor.

Illustration Board

Hot press illustration board is sturdy, but it is not available in small sizes. The boards are available individually in 15" x 20", 20" x 30" and 30" x 40" sizes. The surface is very smooth to allow both crisp, fine detail and water media washes.

Colored Paper

There are some considerations when using colored paper. Your drawings will not be as bright as it is when done on white paper. Colored pencil is largely a transparent medium. Many of the pigments themselves are transparent. Additionally, the "tooth" of the paper usually allows a little of the color of the paper to show through. With a colored paper, this means that all of the colored pencil colors are effectively tinted with the color of the paper, often an undesirable effect.

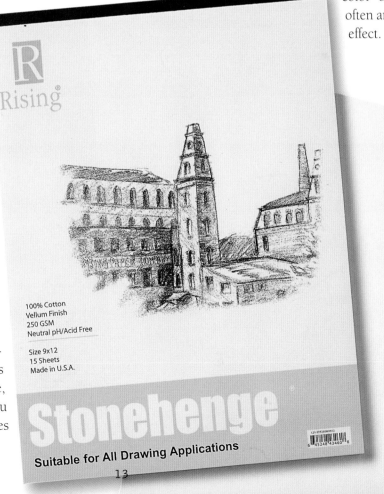

100% Cotton
Vellum Finish
250 GSM
Neutral pH/Acid Free

Size 9x12
15 Sheets
Made in U.S.A.

Stonehenge

Suitable for All Drawing Applications

Other Helpful Supplies

Tracing paper, Transfer paper, Stylus

Use tracing paper, transfer paper, and a stylus to transfer the pencil sketch to the final drawing surface.

- **Tracing paper** is used to trace the drawing. It is readily available in office supply and art supply stores.
- **Transfer paper** is used between the tracing and the paper surface to transfer the sketch to the final drawing surface. It is sometimes called "graphite paper" and is available from art supply stores. Do not confuse transfer paper with carbon paper. Carbon paper deposits an ink on the paper that you can not erase.
- A **stylus** is a pencil-like tool with a metal tip at one or both ends that is used to trace over the sketch. A two-tipped stylus has a thicker and thinner end — use the thinner tip for a finer liner. If you can not find a stylus, you can use a mechanical pencil or a fine tipped ball point pen as a substitute.

Ink Pens

Use black permanent archival ink pens for drawing very dark areas, such as eyes and claws. The ink is waterproof and acid-free. The pens come in different tip widths. I find 01, 03, and 05 useful.

White Acrylic Paint

With colored pencil, the only way to achieve a true white is to work on white paper and allow the paper to show. So, for example, for a white highlight in the eye, draw around the highlight, allowing the uncolored white paper to be the highlight. If you lose your highlight, you can use a small dot of white acrylic paint for the highlight. White acrylic works well for dots, but not so well for lines because it just is not opaque enough. For white lines, carefully draw around them, or incise them into the paper with a stylus (colored pencil will skip over the indentations).

Pencil Sharpener

Use an electric pencil sharpener rather than a hand one to sharpen your colored pencils. The main advantage of the electric sharpener is that it collects the shavings. Loose shavings in your work space are just waiting to make unwanted smudges on your drawing!

Workable Fixative

Colored pencil will smudge. Also, with wax-based colored pencils, a white, opaque, waxy "bloom" may appear on your drawing over time. Spraying your drawing with a fixative will prevent both of these problems. "Workable" fixative is fixative that you can continue to work over after you spray it on.

Paper Towels

Always keep a paper towel folded in fourths to keep under the heel of your hand when drawing to lessen smudging.

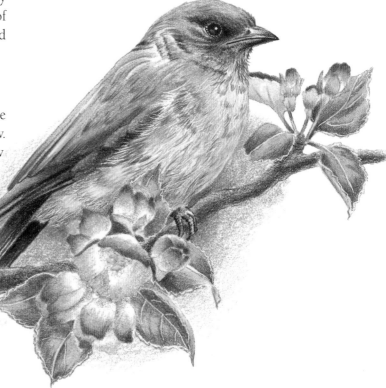

General Information

In this chapter you will learn the mechanics of working with colored pencils, as well as get an overview of the technique I use for building my drawing. I've also included some handy information about color basics and the anatomy of birds. Armed with this information, you should be able to proceed to the bird drawing chapters with confidence.

Pencil Drawing Basics

*Drawing with pencil creates an image composed completely of
lines – the pulling of the pencil lead across the paper.*

Strokes

• Lines define shapes.

• Lines – placed close together
– also fill shapes.

• Lines create texture.

• Pencil leads may be sharp, dull, or in-between.
 1. Sharp pencils yield thin crisp lines.
 2. Dull pencils give wider lines with soft edges.
 3. In-between pencils yield in-between strokes.

• The pressure you use on your pencil controls the relative
 darkness or lightness of the stroke.
 1. Heavy pressure yields dark lines.
 2. Light pressure yields light lines.
 3. Varied pressure can create a smooth transition from
 light to dark, or vice versa.

1.　　　 3.　　 2.

1.　　　 2.　　　 3.

16

The Effects of Paper on the Pencil Strokes

The same pencil used in the same way yields different results on different types of paper.

Rough Texture:
Rough textured paper results in a rough stroke as the pencil catches on the high points of the paper but tends to skip over the low points. Given the same pressure on the pencil, the rougher the paper the more paper shows through the stroke.

Smooth Texture:
Smooth paper yields a smoother stroke with less of the paper showing through. (For my drawing style I prefer smooth paper.)

White Paper:
Drawing is a "light to dark" process and, generally speaking, the color of the paper will be the lightest color in your drawing. (Sometimes white pencil will be opaque enough to lighten a darker paper, but pure, bright white is difficult if not impossible to achieve over a darker ground.) This is an example of colors on white paper.

Colored Paper:
Colored paper will tend to show through the pencil strokes (even more so if the paper is rough) and tints the drawing. Here is an example of the same colors on pink paper.

Creating the Sketch

The first step in colored pencil drawings is a graphite sketch of the subject and any major elements in the background. This sketch will be the foundation of the finished piece, so the better the draftsmanship is at this stage, the better chance of completing a successful drawing. As an alternative to creating your own sketch, you can trace one of the drawings in this book.

Working from Photographs

I often work from photographs. Usually I do not directly copy a photo, but combine elements from several different sources. However, for this demonstration I am going to directly copy this lovely photograph that Janine Russell took of a female Black-Headed Grosbeak. Please note that if you work from photos, they should either be your own photos or you should have permission from the photographer.

When creating a likeness from a photograph, carefully observe and re-create shapes, alignments, and proportions. This is seeing "with an artist's eye" and it is a skill developed through practice. Creating a likeness can sometimes be difficult and frustrating, and every once in a while I am tempted to trace a photo, but I never do. If I did, I would be denying myself an opportunity to develop one of my most valuable skills. I develop my sketch in two or more passes, depending on how complicated the subject is. The first pass is a very rough sketch. I block in the main shapes and features then refine them later.

Following are some of the observations I made about the Black-headed Grosbeak. I will use these observations when I create my sketch.

Shapes:
- The tip of the head is a very gentle curve that turns sharply at the back of the head.
- The top of the beak is blunted rather than pointed. The toes swell at the knuckles.
- The chest is rounded and fluffy.
- An imaginary line through the white tips in the lower white bar on the wing is more rounded than the imaginary line through the upper bar.
- The long tail feathers end in rounded points and the points are towards the outside edge of the feathers, not the center.

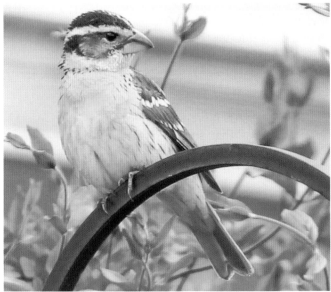

Photo by Janine Russell.

Alignments:
- The line at the front of the chin is nearly parallel to the line at the back of the head, but the chin line is slightly more angled.
- The line at the edge of the wing is parallel to the right edge of the tail.
- The line at the bottom edge of the light stripe above the eye curves smoothly into the line between the upper and lower beak.

Proportions:
Use a compass to measure and check proportions. Open it to the width of the birds head, from the back of the head to the tip of the beak, to notice the following:
- It is the same length from the tip of the wing to the tip of the tail.
- It is the same length from the forward edge of the wing to the left edge of the body.
- It is about 1¼ times this length from the line dividing the head from the chest to the top of the left foot.

Open the compass to the length of the beak and notice the following:
- It is twice this length from the left edge of the beak to the back of the head.
- It is just slightly less than this length between the large toes on the two feet.

Composition Tips

Composition is a very large subject, but a few guidelines are useful when drawing birds. These guidelines assume that you are aiming for a realistic result. Remember that there are always exceptions.

- When you have more than one bird in your drawing, choose poses that suggest some interaction between them and if they are two different types of birds, be sure that both are found in the same locality and terrain.

- Placing birds with plants is a natural. However, be sure that the bird and plants are found in the same locality and terrain type and be sure that the bird and plants are consistent in scale.

- Control the balance between the bird and the background – you may or may not want the bird to disappear into its surroundings.

- If your bird is in an abstract background, choose colors that enhance but do not overwhelm the subject (for example, a brightly colored background for a sparrow). To set off the subject, use darker values in the background on the highlight side of the bird and lighter background values on the shadow side.

Drawing Styles

Typical drawing styles for birds include complete drawings, vignettes, and realistic illustration.

Complete Drawings:
In a complete drawing, the subject(s) and background cover the entire page. The drawings of the duck and parakeets in the section on mixed media are examples of complete drawings. I seldom do complete drawings in colored pencil because it is laborious to cover an entire page with colored pencil – one line at a time!

Vignette Style:
My favorite style for drawing birds is the vignette. In the vignette, the bird(s) are surrounded by a bit of background that fades off to the color of the paper. The background

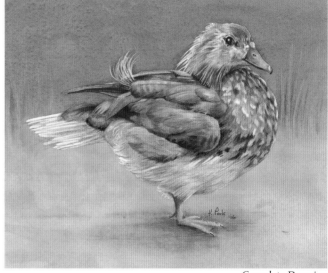

Complete Drawing

can be abstract, as in the Goldfinch on Wild Oats, or realistic, as in a long list of examples including the Costa's Hummingbird in Mimosa Tree, Cedar Waxwings, or Cactus Wren. I find that drawings in this style are little jewels that, when framed, group beautifully.

Realistic Illustration:
Realistic illustration shows the bird with no background. The markings and details of the bird are portrayed in as much detail and as realistically as possible. Examples are the illustrations in bird field guides.

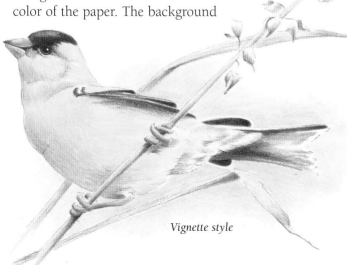

Vignette style

Creating the Sketch, continued

Step 1 – Sketch the Shapes

Begin by sketching an oval for the rough shape of the head. Then draw the head's outline within it. Pay careful attention to the shape of the head. How sloped is the forehead? Is the top of the head flat or rounded?

Eye:

Study the photo to determine the location of the eye. In this case it is right of center and a little closer to the top of the head than to the bottom of the neck. Notice that the eye is very round except for the top edge. The brow overhangs the eye and flattens on the top edge.

Beak:

To draw the beak, begin with the line between the upper and lower beaks. The head end of this line is the corner of the mouth and the other end is the tip of the beak. Notice where the corner is located relative to the eye. It is directly below the forward edge of the eye. The shape of this line is very important in portraying the bird, so pay attention to the small curve and angles. Now, draw the upper and lower lines of the beak. See that the lower beak is wider than the upper one. Also notice that the length of the beak is about half the width of the head behind it.

Body:

The body is a simple shape, but proportions are key. Draw an imaginary vertical line down from the center of the head and notice that the distance between the head and body and the top edge of the iron bar is about twice the height of the head. Place the curve of the bar. Draw the left edge of the body and the cleft in the center of the belly.

Wing:

Roughly sketching the outline of the wing, the base of the tail and the tail feathers completes the first pass.

Step 2 – Refine the Sketch

Begin by checking the elements of the head. Darken the final lines for the outlines of the head, eye, and beak.

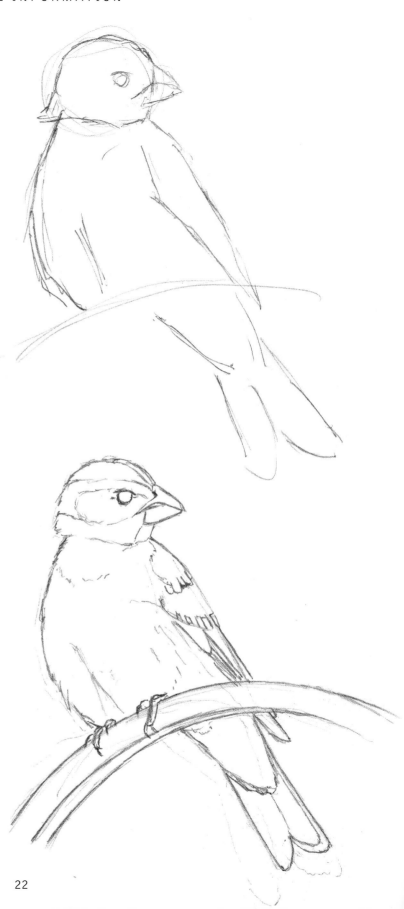

Beak:

Add the left edge of the beak. The left edge of the lower beak is essentially vertical, but the left edge of the upper beak curves around the head. It looks like the nostril is in the point of that curve.

Eye:

Indicate the forward and back corners of the eye. An imaginary line between these corners indicates the slant of the eye. In this photo, the slant is very slight, a little higher in the front than in the back.

Head:

Next, draw the markings on the head. There is a teardrop shape on the cheek and around the eye with a black patch behind it. There is a light stripe above the eye stretching from the beak to the back of the head. The forward part of this stripe is light yellow, blending to white for the rear portion. There is a light stripe over the center of the crown and a wide black stripe on either side of it. From this angle, the center light stripe appears very narrow, curves over the crown, and disappears from sight at the top of the head. I can see a very little bit of the far black stripe just above the beak. (From the photo, I could not tell whether the light stripe or the farther black stripe is at the center of the head, so I checked that detail in a field guide.) Some details, such as the lower eyelid, are a little too small to include in a graphite drawing, but constantly refer to the photo as you work with the colored pencil.

Body:

Paying attention to vertical and horizontal alignments is very helpful at this stage. (I notice that I have the left side of the body bulging out beyond the back edge of the head a little too much, so I correct it.)

- I refine the curve of the metal bar because it is in front of the bird and I need to know where it is before I can place the feet.
- Once the bar is drawn in, notice that the long toe on the right foot as you look at it is vertically below the left edge of the beak. Also see that the left foot is vertically below the back edge of the patch on the cheek. See all three of the forward toes on the left foot, but only two on the right foot.
- After I have drawn the feet, I see that I have the tail too far to the left and slightly too wide. Using a compass to measure relative distances, I see that the vertical length of the tail is the same as the distance from the dividing

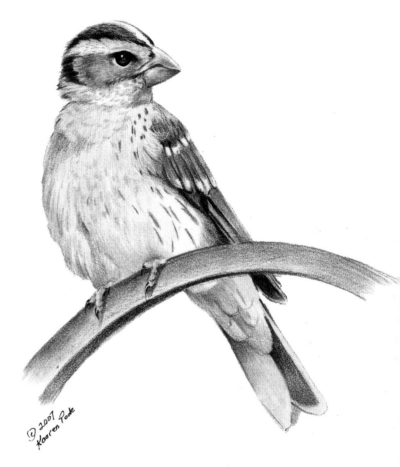

line between the head and body and the right foot. So, I have the tail too long. And, by visually comparing my sketch to the photo, I can see that I have the tail feathers flaring too dramatically. I make these corrections, and draw the outlines of a few of the largest tail feathers.

- There are several elements in the wing. The most obvious are the two white bars formed by the white tips on two upper rows of feathers. Although there are dividing lines between these feathers, the tips are the more prominent feature. Draw them in. There is a large triangular feather at the forward edge of the wing just below the lower white bar. Behind this feather is a row of long wing feathers. The divisions between them are clearly indicated by dark shadows. Draw lines separating the feathers.
- The chest has a few large distinct puffs. Lightly indicate their outlines.

Begin Your Colored Pencil Drawing:

1. Transfer your sketch to high quality drawing paper.
2. Begin your colored pencil drawing. ❏

Color Theory Basics

*When drawing from Nature, we have the advantage of using the gorgeous
color schemes that she has already worked out. Nonetheless, taking the
time to understand a few basics of color theory is time well spent.
I use color theory in several ways. My finished drawings are seldom direct copies
of photographs but, rather, combine elements from different sources, so I must develop
an overall color plan that is appropriate for my subject. Also, I often create finished
color by layering several different colors, choosing colors based on color theory guidelines.
Color theory also gives me ideas for toning down parts of my drawings that are too bright,
brightening colors that are too dull, and choosing colors for highlights and shadows.*

The Color Wheel

The Color Wheel maps out relationships between colors. There
are three "primary" colors – red, yellow, and blue. They are like
"elements" because they can not be made by mixing other
colors. The primaries, mixed in different proportions, combine
to make the other colors. In a color wheel, the primaries are
placed evenly around a ring. In my wheel, I have placed them
at 2 o'clock, 6 o'clock, and 10 o'clock, but this is arbitrary. The
color between each pair of primaries results from mixing those
two colors. So orange, lying between red and yellow, is the
combination of equal amounts of red and yellow. Likewise,
green is the combination of equal amounts of yellow and blue,
and violet is the combination of equal amounts of blue and red.
Orange, green, and violet are the three "secondary colors."
Continuing to combine equal amounts of adjacent colors fills
the wheel with an even gradation of color.

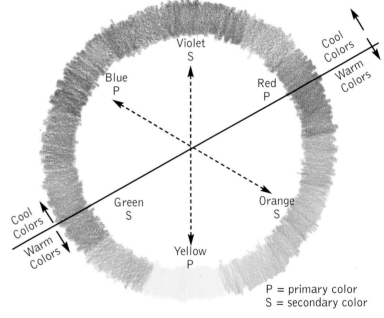

P = primary color
S = secondary color

Complementary Colors

Colors that are opposite each other on the wheel are "comple-
ments." Complements make uncomfortable neighbors. When
mixed, they dull each other. When placed side-by-side they
create a mood of excitement or tension. They intensify each
other, and draw the eye. Layered over each other, they produce
a brownish gray.

Complementary colors are opposite each other on the color wheel.

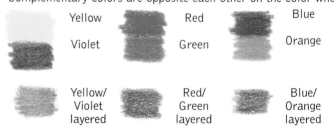

Analogous Colors

Colors that are next to each other on the wheel are "analogous."
Analogous colors are very easy with each other. Placed next to
each other, they suggest calm and well-being. Layered over
each other they produce a pleasing mix.

Analogous colors are adjacent to each other on the color wheel.

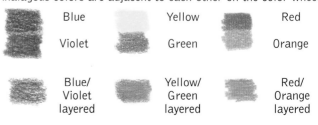

Cool and Warm Colors

Drawing a diameter through the color wheel through red and green divides the wheel into "warm" and "cool" colors. Warm colors "feel" warm, and cool colors "feel" cool. Using predominantly either warm or cool colors can set a mood. Cool colors are relaxing, soothing and peaceful. Warm colors are exciting, vibrant, and nurturing.

In a composition, warm colors tend to "come forward," or seem closer to the viewer, while cool colors seem to recede. Using cool colors in the background and warm colors in the foreground increase the composition's depth. In contrast, using warm colors in the background and cool colors in the foreground tends to flatten the composition and may seem confusing.

In nature, highlights are typically cool, reflecting the cool color of the light source – the sky. Shadow colors tend to be warm.

Warm and cool colors placed next to each other intensify each other and draw the eye.

Highlights are cool and shadows are warm.

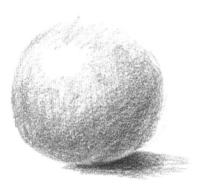

Highlight	Object	Shadow

A subject that is a cool color with a warm background looks flat.

A warm subject with a cool background has depth.

The subject is very cool. The background is light in value and cool.

Color Theory Basics, continued

Color Composition

The color wheel illustrates the composition of colors. A color's position on the wheel shows which hues combine to create it (except for the primaries which can not be created by mixing other colors). For example, emerald green color can be created by layering a yellow-green pencil over a blue-green one. This can be done if you do not have an emerald green pencil. But even if you have one, the layered color will likely be more vibrant than the emerald green pencil. That is because the yellow-green and blue-green pencils each deposit tiny specks of color on the paper. The observing eye then performs two tasks – it sees both of the colors separately, and at the same time interprets them as the mixed color.

Theoretically, we could, through layering, create a myriad of colors from only four pencils – true red, true yellow, and true blue to create all the hues; black to darken colors – and the white of the paper to lighten colors by using a light pressure. But, in the real world of paper and pencils, this is impractical.

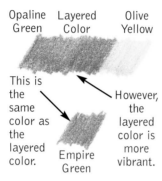

Opaline Green | Layered Color | Olive Yellow

This is the same color as the layered color.

However, the layered color is more vibrant.

Empire Green

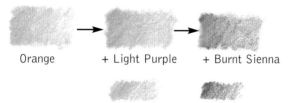

Orange | + Light Purple | + Burnt Sienna

Create a complex color by layering its components.

I like having as wide a range of pencil colors as possible. I find that looking at the colors of the leads inspires me and makes me more aware of my options. Still, I often layer colors. Sometimes I am trying to create a color that I do not have a matching pencil for. In this case, I stare at the desired result (in a photograph, for example) and "see" the separate colors that compose it. I identify a main color (perhaps orange) and then look for other hues that modify it (perhaps pink) or darken and dull it (perhaps brown).

Making a Color Warm or Cool:

Other times I want to warm or cool a color. To warm a color, I layer it with an analogous color towards the warm part of the wheel. To cool a color, I layer it with an analogous color toward the cool part of the wheel.

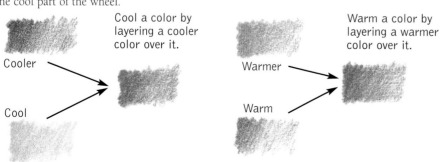

Cool a color by layering a cooler color over it.

Cooler

Cool

Warm a color by layering a warmer color over it.

Warmer

Warm

Dulling and Brightening Colors:

I also use layering to dull or brighten colors. Layering a color's complement over it will dull it. Layering a brown over a color will dull it and also warm it. Layering a gray over a color will dull it and also cool it.

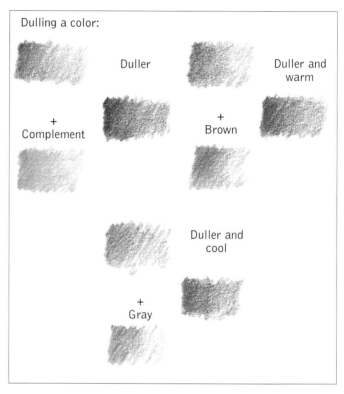

Dulling a color:

Duller

Duller and warm

+ Complement

+ Brown

Duller and cool

+ Gray

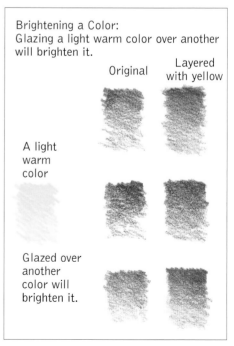

Brightening a Color:
Glazing a light warm color over another will brighten it.

Original | Layered with yellow

A light warm color

Glazed over another color will brighten it.

Value

A color's darkness or lightness is its value. Value is important because value contrast is a critical element in a successful drawing. If you use a copier to make a black and white copy of your drawing, you will see the values in it. A black and white copy of your drawing should be as successful as your color drawing in terms of balance and leading the eye to the focal point.

A drawing may be mostly light or mostly dark, but generally, somewhere in the drawing, there should be a nearly full range of values. Placing very dark colors next to very light colors creates a high contrast that draws the eye. It is a common practice to place a drawing's darkest dark next to its lightest light to draw the eye to the most important element in the drawing.

Tip: When drawing birds, the eye is frequently the focal point. In the eye, the bright white of a highlight contrasts with the black of the pupil. But often there are feather patterns which juxtapose black and white, and these areas complete with the eye. To reduce this effect, reduce the contrast in the markings by slightly graying the white and using a very dark gray rather than black.

Each pencil color has an inherent value. Yellows are light in value. No matter how much pressure you apply, there is a limit to how dark it will be. Indigo Blue is dark. Still, no matter how much pressure you apply, you can not make it darker than its inherent value. See Value Fig. 1.

To darken a color, layer it with its complement, with black, brown, or gray, or with a similar hue that has a darker value. In each case, you will darken it, but you will also change the color in different ways. See Value Fig. 2. To lighten a color, simply reduce the pressure on your pencil.

`Notice that two very different colors can have the same value. A drawing composed entirely of colors that are very close in value may have good color contrast, but will have very little value contrast and will be uninteresting. See Value Fig. 3.

If you are in doubt about a color's value, squint your eyes as you look at it. This tends to reduce the color component and allow us to better see values.

Tip: If your drawing seems to lack a mysterious something, check for value contrast.

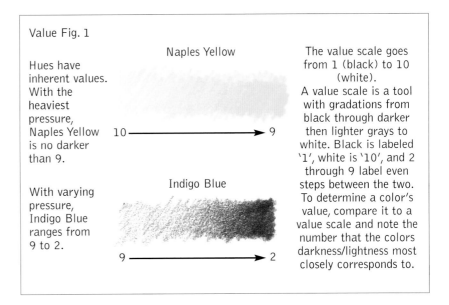

Value Fig. 1

Hues have inherent values. With the heaviest pressure, Naples Yellow is no darker than 9.

Naples Yellow

10 ⟶ 9

With varying pressure, Indigo Blue ranges from 9 to 2.

Indigo Blue

9 ⟶ 2

The value scale goes from 1 (black) to 10 (white).
A value scale is a tool with gradations from black through darker then lighter grays to white. Black is labeled '1', white is '10', and 2 through 9 label even steps between the two. To determine a color's value, compare it to a value scale and note the number that the colors darkness/lightness most closely corresponds to.

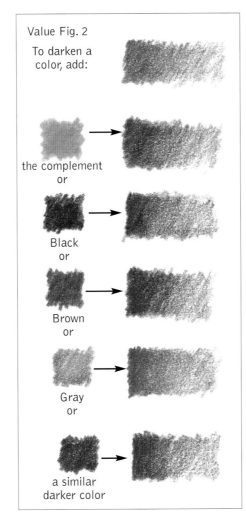

Value Fig. 2

To darken a color, add:

the complement
or

Black
or

Brown
or

Gray
or

a similar darker color

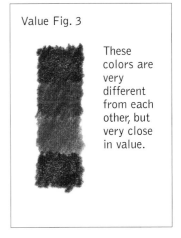

Value Fig. 3

These colors are very different from each other, but very close in value.

Bird Shapes and Anatomy

All of the world's birds are classified into 28 orders. In this book, with the few exceptions of quail, kestrel, Mandarin duck, parakeets, and hummingbirds, I have concentrated on a single order, the Perching Birds (or Passerines). This order includes 70 families and over one half of the world's bird species. The birds which we think of as songbirds are in this order. The most notable characteristic of the order is the perching foot with three toes pointing forward and one pointing backward. When the foot muscles are relaxed the foot is tightly curled, explaining how the birds can sleep on branches without falling off!

Skeletal Structure:

Birds are built for flight. So their anatomy of skeleton and muscles is clothed in an aerodynamic plumage which hides much of the underlying complexity. Nevertheless, it is useful to understand their basic skeletal structure because it dictates how the bird can move and pose.

In the drawing, I have not given the technical names for the bones but have instead related the parts of the skeleton to our own. It is amazing how similar our structures fundamentally are! Nonetheless, there are critical differences.

- The **vertebrae between the "shoulders" and "hips"** are fused into a single bone. This means that, unlike us, their backs are rigid. We can stand with one hip higher than the other or one shoulder higher than the other. This is because we can bend our spines. Birds do not have this particular range of motion.
- The upper two sections of birds' **wings** are very similar to our arms with a single bone at the shoulder and two bones between the elbow and "wrist." But the lower two sections are quite different from our hands and fingers. The upper of these has essentially two bones and the lower, one. The two middle sections of the "arm," with two bones each, allow for a twisting motion supporting complex patterns for beating wings.
- The **breastbone** is formed like a deep keel. It provides an anchor for the strong muscle stretching to the wing and supporting flight.

- The **neck** is very flexible. It has anywhere from 11 to 25 vertebrae, depending on the species, compared to 7 in mammals. The flexible neck gives the bird a wide range of sight.
- Compared to mammals, birds' **skulls** are small and simple. There is no need to support strong jaw muscles as birds do not chew. (The job of chewing has been relegated to the gizzard.) A bird's skull seldom contributes more than 1% of the bird's total body weight! The combination of a light-weight head and heavy muscles from the keel to the wings concentrates the bird's weight in the center of its body which adds to stability in flight. Birds are truly wondrous creations!

Shading and Highlighting

Despite this internal complexity, birds appear pretty simple in terms of external shapes. Their smooth forms are comprised largely of egg and sphere shapes. In drawings, I use shading and highlighting to portray these round forms dimensionally. Here is a brief review of shading and highlighting basic forms. Remember that shading and highlighting is always relative to the light source. The light source is seldom directly portrayed in a drawing, but the artist must select one and use it consistently throughout the composition.

- The highlight is the portion of the shape that faces the light source. It is the lightest area. Its brightness tends to fade out details.
- The shadow is the darkest area and faces away from the light source. As with the highlight, details are hard to see in the shadow.
- The midtone area lies between the highlight and shadow and is, in value, between the light highlight and the dark shadow.
- The reflected light is an area "behind" the shadow. It is a little lighter than the shadow, theoretically lightened by light reflected off of surfaces behind the object.

Rough Sketch of a Perching Bird's Skeleton

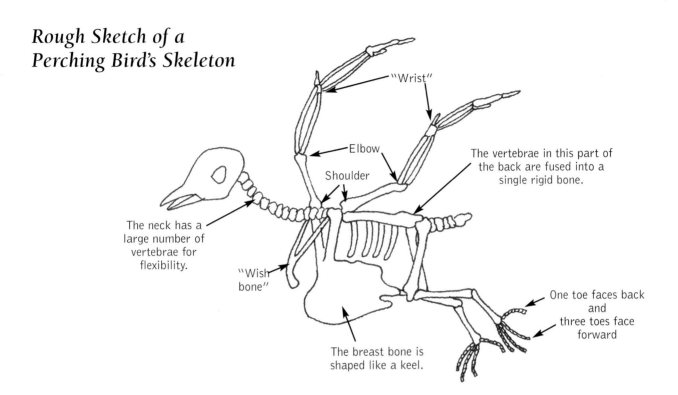

"Wrist"

Elbow

Shoulder

The vertebrae in this part of the back are fused into a single rigid bone.

The neck has a large number of vertebrae for flexibility.

"Wish bone"

One toe faces back and three toes face forward

The breast bone is shaped like a keel.

Shading and Highlighting

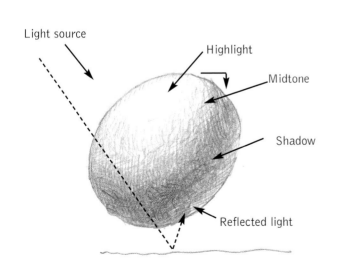

Light source

Highlight

Midtone

Shadow

Reflected light

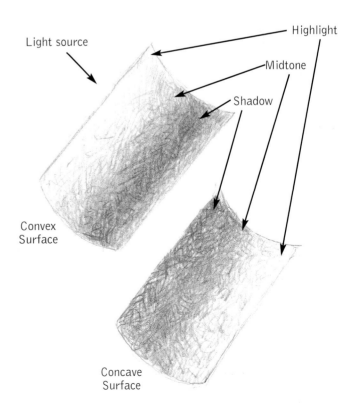

Light source

Highlight

Midtone

Shadow

Highlight

Midtone

Convex Surface

Concave Surface

Drawing Details

Eyes, beaks, feathers, and legs are special features that make a bird drawing convincing.

Eyes

Birds' eyes appear very round. The roundness of the eyeball is generally not obscured by prominent lids. The eye is, however, set into the head so there will typically be a highlight over the eye and shadows at the corners. When you are working on your sketch, note the position of the front corner of the eye relative to the corner of the mouth. Correctly positioning the eye and beak relative to each other is important in portraying the species.

All birds have irises, but in many they are so dark that they are indistinguishable from the pupil and the eye looks solid black.

Depending on how large the eye is in your drawing, you will be able to add more or less detail. I draw my birds' eyes with an ink pen to get a crisp, dark black. The eyes will be the darkest value in your drawing.

Simple Eye:
See Fig. 1.
The first eye example is a very simple one. Outline the eye and the primary highlight, then fill with ink. If the eye is too small to draw around the highlight, add a tiny dot of white acrylic paint with the small end of a stylus.

More Complex Eye:
See Fig. 2.
This eye is more complex because it has a secondary highlight. The secondary highlight is always opposite the primary highlight. The primary highlight is a reflection of light off the surface of the eyeball. Although most of the light that falls on the eye reflects back, some passes through the clear fluid in the eyeball producing a "secondary highlight." This secondary highlight is always placed opposite the primary highlight. In this example, begin the same as the first, but when I inking in the eye, leave a large blank area for the secondary highlight. Then, fill that area with a mid-tone of Black pencil and soften its edges with darker Black pencil so that the boundary between the ink and the pencil does not show. If the eye is large enough, the final step is to soften the outer edge of the eye with Black pencil.

Most Complex Eye:
See Fig. 3.
The third example is more complex because the iris shows. Draw the pupil the same way as the entire eye in the first example. The iris is darkest near the primary highlight and lightest for the secondary highlight.

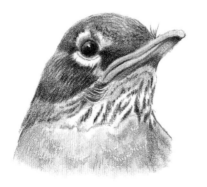

Robin

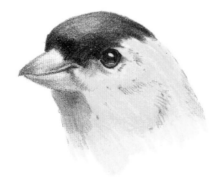

Goldfinch

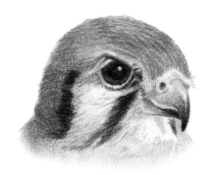

Kestrel

Fig. 1
Simple Eye

1. Outline the eye and primary highlight with ink.

2. Fill the eye with ink but avoid the primary highlight.

3. Soften the outside edges of the eye with Black pencil.

Fig. 2
Eye with no Visible Iris

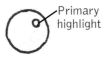
Primary highlight

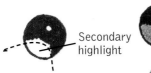
Secondary highlight

3. Fill the secondary highlight with a medium tone of Black.

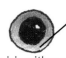

 Black

1. Outline the eye and the primary highlight with ink.

2. Fill the upper part of the eye with ink but avoid the primary highlight and leave a large secondary highlight. The curved edge suggests the spherical shape of the eyeball.

4. Soften the edges of the secondary highlight and the outside edge of the eye with Black pencil.

Fig. 3
Eye with Visible Iris

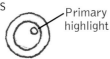
Primary highlight

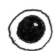

Secondary highlight

1. Outline the eye, the iris, and the primary highlight with ink.

2. Fill the pupil with ink, but leave the primary highlight white.

3. Fill the iris with a color. Use light pressure opposite the primary highlight – this is the secondary highlight.

 Sanguine

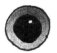

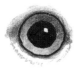

5. Soften the outside edges of the ink line around the eye. Use Black along the lower half and Umber for the rest.

4. Darken the upper part of the iris with a darker color.

 Umber

 Umber

 Black

Brown Ochre

31

Beaks

The shape of a bird's beak reflects its diet – an example of the famous "form follows function" rule. Seed eaters have thick blunt bills for cracking hard seeds. Insect eaters, on the other hand, have slender sharp bills for plucking insects out of the air or ground. Flesh eaters, like the kestrel, have sharp, hooked beaks for tearing flesh. And the long, slender hummingbird's beak is perfectly engineered for sucking nectar from tubular flowers.

Regardless of the shape, beaks are hard, smooth, and shiny. Preserving highlights as you draw and adding sharply contrasting shadows will give the illusion of shine. By smoothly applying colors and transitioning between them you will give the illusion of a hard, smooth surface.

Beaks

1. Establish shading but leave strong highlights.

2. Add glazes of color, if appropriate, and strengthen shadows.

3. Continue adding color and deepening shadows to increase value contrast.

Seed eaters have short thick strong beaks.

Insect eaters have sharp narrow beaks.

Bright highlights, deep shadow, and smooth gradations of color and value portray hard, shiny surfaces.

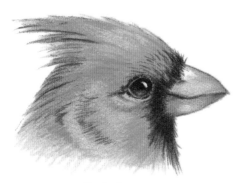

Cardinal

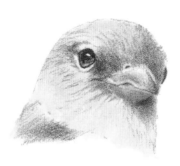

Goldfinch

Legs and Feet

Legs and feet are hard, shiny, and scaly. The toes are slender and they are typically too small for much detail. They are hard surfaces, so shadows and highlights are important. They are also scaly and, when possible, I outline and shade these scales. I usually draw the claws with two strokes and a very sharp pencil lead. I curve the strokes from the toe to the tip, starting the strokes separate from each other, but joining them at the sharp tip. This leaves a space between the two strokes which becomes the bright highlight and gives the illusion of a shiny hard surface.

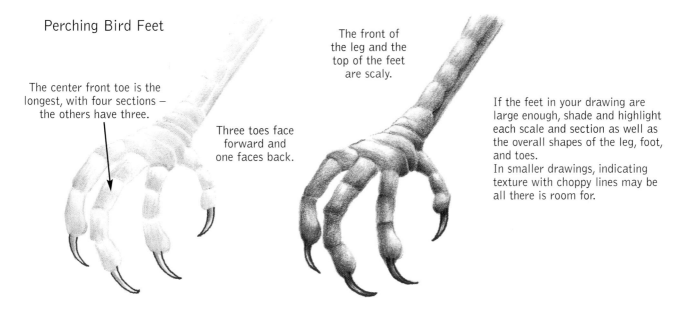

Perching Bird Feet

The center front toe is the longest, with four sections – the others have three.

Three toes face forward and one faces back.

The front of the leg and the top of the feet are scaly.

If the feet in your drawing are large enough, shade and highlight each scale and section as well as the overall shapes of the leg, foot, and toes.
In smaller drawings, indicating texture with choppy lines may be all there is room for.

Feathers

Birds have several different types of feathers in their plumage. Contour feathers are feathers with a strong spine. The individual "hairs" have tiny barbs which "zip" them together to form a single surface. These feathers cover and form the body of the feather. Specialized contour feathers form the wing and tail feathers and enable flight. Downy feathers cover the body under the contour feathers. They provide an efficient blanket of insulation without interfering with the body's aerodynamic shape. Most "markings," such as colored bars on the wings are created by feathers banded with different colors lying side by side.

Individual feathers are clearly visible on the wings and tail. Large, strong contour feathers attach to the sections of the wing – "primaries" nearest the body, "secondaries" in the middle portion, and "tertiaries" on the "hand," which enable flight. Other large, strong contour feathers attach to the tail and act as a rudder. The individual feathers covering the head, neck, back, chest, and belly are usually not distinct. Instead, we see texture and markings.

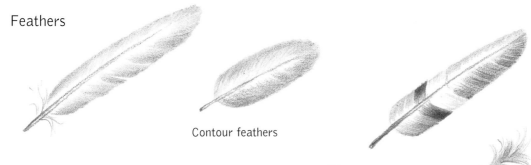

Feathers

Contour feathers

A bird's markings are often due to banded or tipped fleathers.

Downy feather

NORTHERN CARDINAL

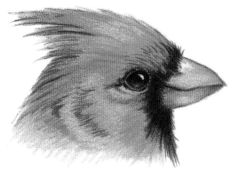

With the male's bright red plumage, the Northern Cardinal is one of the most spectacular and recognizable of our songbirds. The birds may have been named after the Cardinals of the Catholic church who wear red robes.

"Northern" cardinals have southern roots – their original range was the southeastern United States. During the 19th century the practice of caging these beautiful birds helped spread their habitat north and northwest. By the 1890s the birds had settled as far north as Ohio, and they reached New York, New England, and southern Canada in the mid 20th century. They have since expanded westward into parts of the southwest, and, thanks to deliberate introduction, to Hawaii. Humans have assisted in expanding the cardinals' territory both directly, by intentionally introducing the birds into new territories, and indirectly, by providing ample supplies of food at backyard feeders.

Cardinals do not migrate, but inhabit their home territory year round. Preferring areas with small trees and thick brush, they produce 3-5 young in nests of twigs and grass. Some pairs produce two broods a year.

Among their many endearing qualities is their habit of mating for life. Pairs seem devoted to each other, and the male is often seen feeding the female.

Cardinals are medium-sized songbirds, slightly larger than robins. They have large head crests and strong, conical beaks perfect for cracking hard seeds. In addition to a variety of seeds, their diet includes fruit and an occasional insect.

Except for its black face patch and orange beak, the male is all glorious red. The wing and tail feathers are a slightly darker red. The female's plumage is less bright, but the subtle coloring of fawn, cream, and tinges of orange and red are beautiful in their own way. Her crest is tinted orange or red, as are parts of the wing and tail feathers. In the sunlight, her plumage can radiate a beautiful golden glow. As with the male, her beak is orange and she has a face patch. Dull brown plumage camouflages the juveniles as they work their way through that gangly stage.

Male Cardinal on Snowy Branch

Instructions begin on page 36

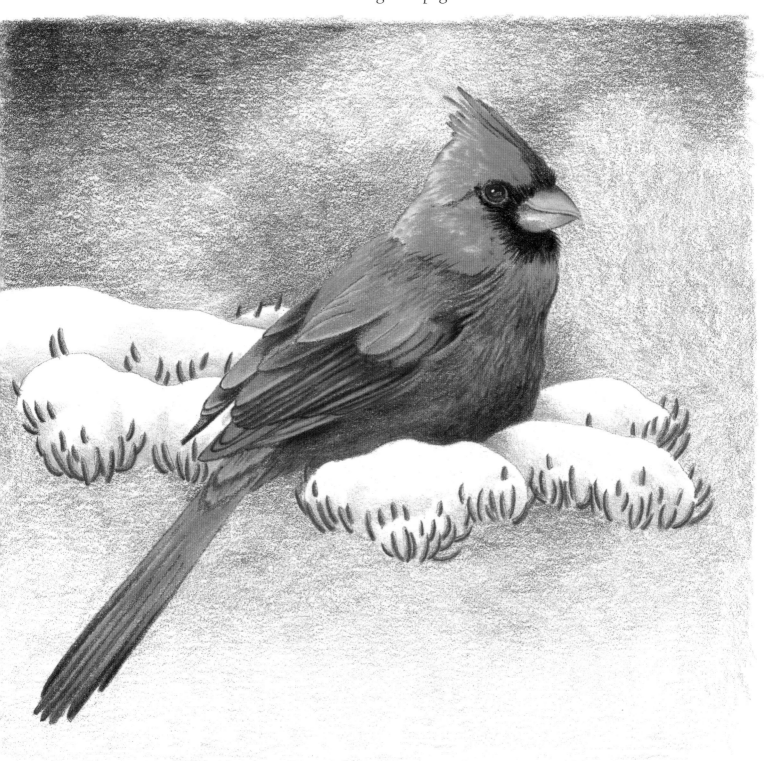

Male Cardinal on Snowy Branch
Continued from page 35

The male Cardinal is a dramatic sight against snow-covered spruce. For this drawing I used soft lead pencils because the colors are intense. I decided to work on white drawing paper. The snow is white, so I had to color the background to make it stand out, but I needed white paper for the reds to be bright enough.

SUPPLIES

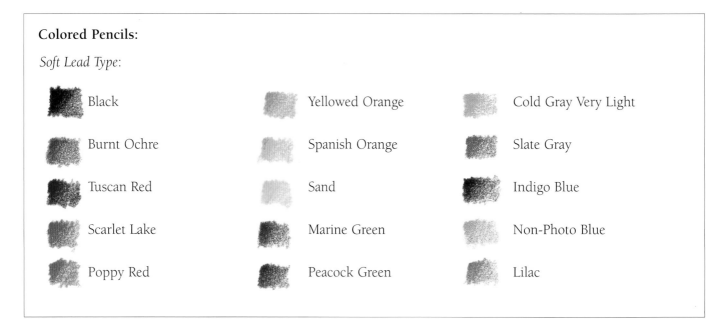

Colored Pencils:

Soft Lead Type:

Black	Yellowed Orange	Cold Gray Very Light
Burnt Ochre	Spanish Orange	Slate Gray
Tuscan Red	Sand	Indigo Blue
Scarlet Lake	Marine Green	Non-Photo Blue
Poppy Red	Peacock Green	Lilac

Other Supplies
Drawing paper, white
Size 01 black permanent pen

FIRST LAYER – Establishing Local Color

Eye:
1. Using a black permanent pen, outline the eye, the pupil, and the tiny highlight on the pupil.
2. Carefully avoiding the highlight, fill the pupil with ink, then use Burnt Ochre for the iris.
3. In the area between the pupil and the eye outline, use small areas of Tuscan Red and Burnt Ochre, leaving very tiny dots of white for brilliance.

Wings, Chest, and Tail:
1. Establish the basic color areas, using Poppy Red for most of the bird, but placing a slightly darker red, Scarlet Lake, on the wings, lower chest, and lower tail.
2. By varying the pressure on the pencil, indicate the main shadow and highlight areas. Carefully leave the highlights on the wing and tail feathers the white of the paper.

Feathers:
Outline the wing feathers and tip the tail feathers with Tuscan Red to differentiate one feather from another.

Highlights:
Establish highlights on the back of the neck and cheek by brightening these areas with Spanish Orange.

Beak:
1. Use Yellowed Orange to draw the lower bill.
2. For the upper bill, use Sand at the bottom and blend to Yellowed Orange and Poppy Red at the top.

Branch:
Draw the spruce needles with Marine Green. Since there is snow on the branch, we only see the needles at the bottoms and edges of the snow clumps.

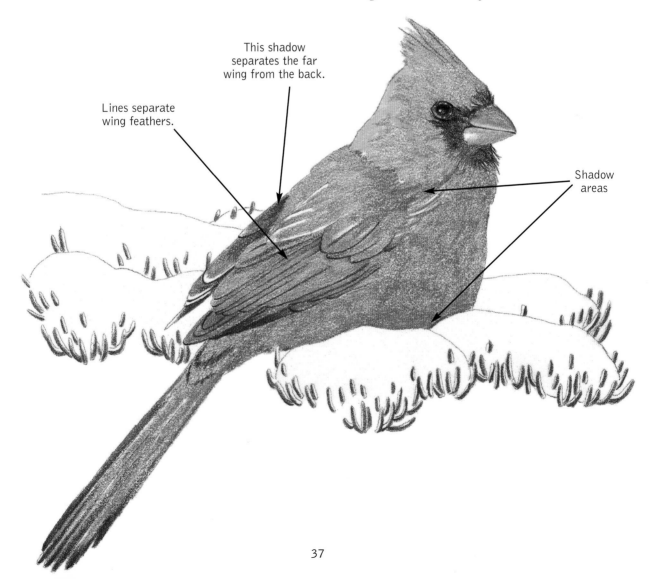

This shadow separates the far wing from the back.

Lines separate wing feathers.

Shadow areas

Male Cardinal on Snowy Branch
Continued from page 37

SECOND LAYER – Deepen Color and Build Form

Head, Chest, and Wing:

1. Intensify the colors using the same colors as in the first phase. Work on the head, chest, and upper wing using short, slightly criss-crossed strokes for a fluffy textured look.
2. Use Tuscan Red to deepen the shadows between the large wing feathers, on the flank under the wing, and at the left edge of the upper chest. These shadows help build the bird's form.

Beak:

Detail the bill by adding shadows of Tuscan Red.

Branch:

1. To liven up the spruce needles, add strokes of Peacock Green next to the Marine Green.
2. Begin to form the snow clumps by shading with Cold Gray Very Light.

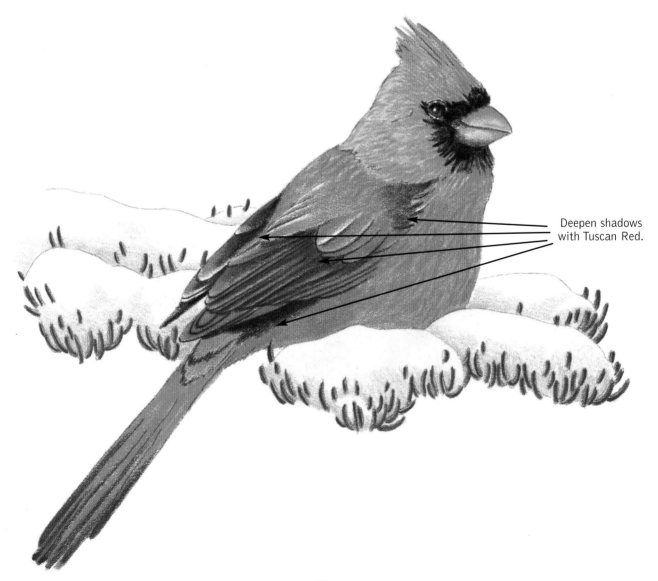

Deepen shadows with Tuscan Red.

THIRD LAYER – Final Detail, Intensity, and Form

Snow:

To bring out the snow, add a background of Indigo Blue, Slate Gray, and Cool Gray Very Light. At the bottom, use primarily Cool Gray Very Light and fade away to nothing. Concentrate the darker colors at the top and around the snow.

Shading Background:

1. Shade the snow clumps with Lilac, Cool Gray Very Light, and Non-Photo Blue.
2. If needed, darken some of the needles with Peacock Green.

Shading Bird:

1. Deepen the chest with small criss-cross strokes of Tuscan Red and a little Black in the lower portion.
2. Deepen the shadows on the wing and tail with more Tuscan Red and a little Black.

Bird Details:

1. On the head, use Black to extend the line leftwards from the corner of the eye.
2. Add a few texture strokes on the crest.

Highlights:

Brighten the highlights on the wing and tail by going over the white areas with Spanish Orange. ❏

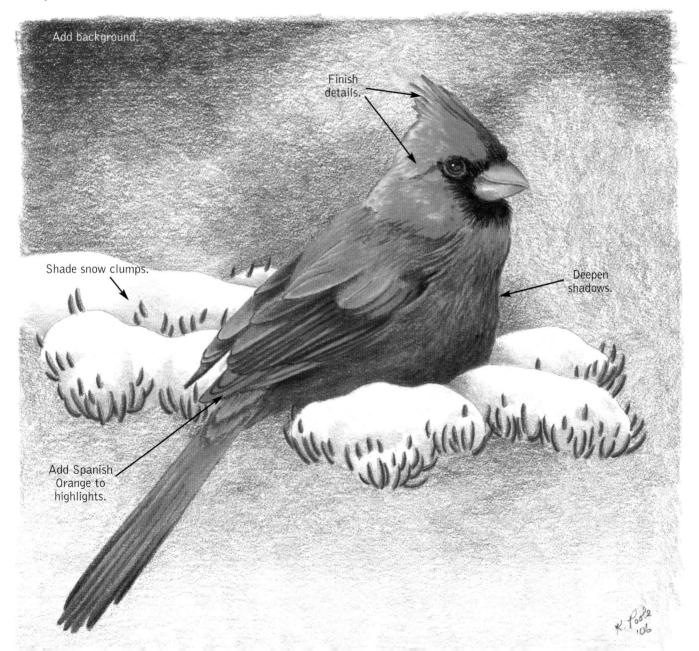

Add background.

Finish details.

Shade snow clumps.

Deepen shadows.

Add Spanish Orange to highlights.

K. Poole '06

Female Cardinal

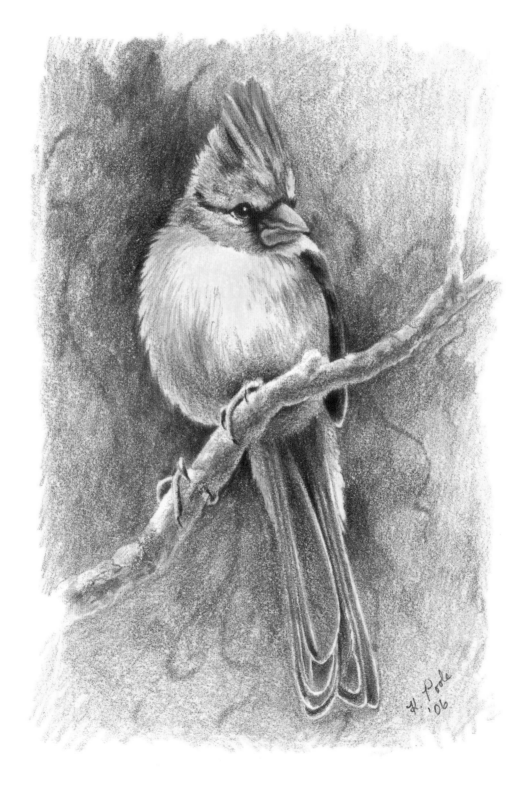

There is no doubt that the male cardinal is spectacular, however, I appreciate the beautiful subtle coloring of the female. I find her tawny golds, touches of red, and orange beak beautiful. I truly enjoy drawing her.

SUPPLIES

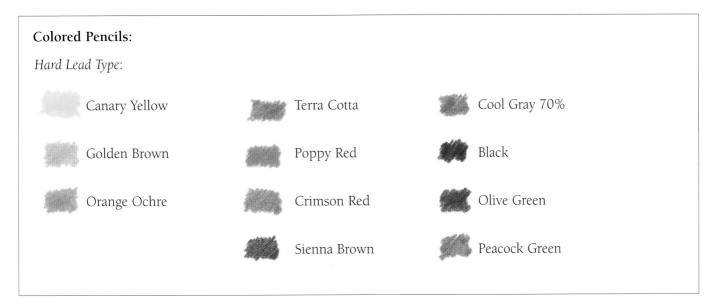

Colored Pencils:

Hard Lead Type:

Canary Yellow Terra Cotta Cool Gray 70%

Golden Brown Poppy Red Black

Orange Ochre Crimson Red Olive Green

Sienna Brown Peacock Green

Other Supplies

Drawing paper, white

Size 01 black permanent pen

Stylus

Tip: Use value in the background to emphasize the form of the subject.

FIRST LAYER – Establishing Local Color

See drawing on page 42

Eye:

1. Use the permanent pen to outline the eye, the pupil, and a tiny highlight in the pupil.
2. Fill the pupil with ink, but leave the highlight untouched.
3. With a very sharp pencil, fill the iris with Sienna Brown.

Head:

1. Draw her mask with tiny strokes of Black radiating outwards from the beak.
2. Fill in the rest of her head with a light application of Golden Brown, pulling strokes in the direction the feathers grow.
3. Add Orange Ochre to brighten and deepen the crest.

Continued on page 42

Female Cardinal
Continued from page 41

FIRST LAYER – Establishing Local Color

Beak:
Shade the beak with Orange Ochre, leaving large areas of white highlight.

Chest:
1. Cover her chest with short strokes and a dull pencil, laying the foundation for a soft texture. The highlight at the top of her chest is Canary Yellow, the shadow at the bottom is Sienna Brown, and the remainder is Golden Brown.
2. At the bottom, add a secondary highlight of Golden Brown between the Sienna Brown shadows.

Incising Marks:
With the narrow end of a stylus, incise lines along the edges of the tail feathers and along the forward edge of the wing. The incised lines will remain white.

Wing and Tail:
1. Use Sienna Brown to draw the wing and most of the tail.
2. Use Cool Gray 70% at the tip of the tail, and small bright lines of Orange Ochre.
3. The fluff at the edges of the upper tail is Golden Brown.

Feet:
With a sharp pencil, add Sienna Brown shadows on the feet.

Branch:
To texture the branch, use small, random areas of Sienna Brown and Terra Cotta, being careful to leave some patches of white.

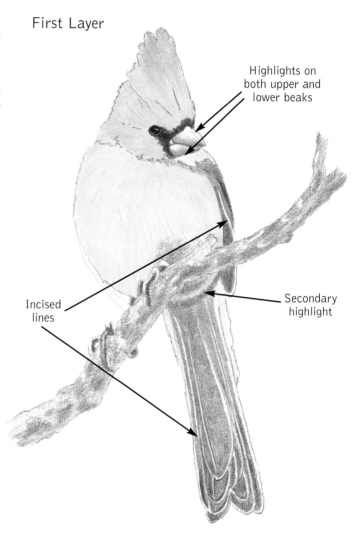

First Layer

Highlights on both upper and lower beaks

Incised lines

Secondary highlight

SECOND LAYER – Deepen Color and Build Form

Head:
1. Add texture with small short strokes of Sienna Brown using a sharp pencil. Concentrate texture strokes in the center of the forehead forming three subtle stripes.
2. Also use Sienna Brown to define "spikes" in the crest.
3. Brighten the crest with Poppy Red.
4. Add touches of Orange Ochre above the eye and on the cheek.

Beak:
1. Deepen the shadows with more Orange Ochre, then add a little Poppy Red.
2. With a very sharp Black pencil, add the line between the upper and lower parts of the beak and deepen the corner of the mouth.

SECOND LAYER – Deepen Color and Build Form

Chest:
Add texture and color to the chest with small strokes of Sienna Brown, Orange Ochre, and a little Cool Gray 70%. Concentrating the Sienna Brown and Cool Gray 70% on the sides and lower chest rounds the form. Cover most of the secondary highlight at the bottom of the body with Sienna Brown, but leave a subtle highlight to separate the body from the tail.

Wing:
Deepen the colors of the wing, going as dark as possible with the Sienna Brown on the under side.

Tail:
Deepen the colors on the tail, especially in the upper portion.

Feet:
With a very sharp Black pencil, deepen the shadows on the feet and draw the claws.

Branch:
To deepen and round the branch, add random clumps of Cool Gray 70%, concentrating them towards the lower edge of the branch.

Background:
Add an Olive Green background, fading away to nothing in an irregular vignette style.

THIRD LAYER – Final Detail, Intensity, and Form

See drawing on page 40

In this final phase, brighten the bird by deepening the shadows and brightening the chest.

Head Details:
1. Add Black to the face to the left of the eye.
2. Add Black to the crest.
3. Add a little Black to the brown areas on the forehead and lower edge of the cheek.
4. Draw a tiny shadow under the eye, forming a lower lid.
5. Add Black shadows to the beak.

Chest:
1. On the chest, brighten the upper portion with Canary Yellow and add a little Poppy Red over the orange areas.
2. Intensify the shadows with more Sienna Brown and Cool Gray 70%.

Wing and Tail:
Add Black to the wing and the tail. On the wing, the lower side is now nearly black. Deepen the upper portion of the tail with Black, and add small areas of Black to the feather tips and to separate the feathers from each other.

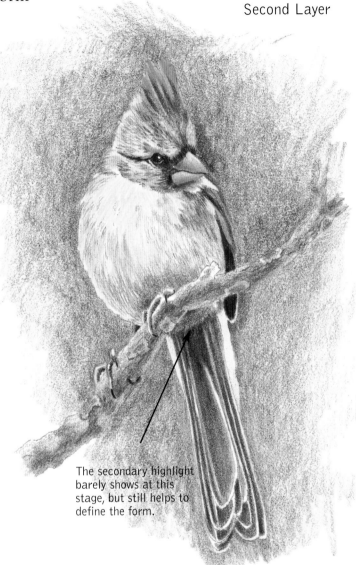

Second Layer

The secondary highlight barely shows at this stage, but still helps to define the form.

Feet:
Deepen the shadows on the feet with even more Black.

Background:
1. Use Peacock Green in addition to more Olive Green on the background. Making the background very dark on the left side brings out the bright left edge of the head and chest. Extend the background into a rectangle, but keep it very light at the edges (except for the upper left).
2. With Olive Green, draw some random vine shapes for visual interest.

Branch:
Return to the branch, adding more shadow of Cool Gray 70% and a little green patches of lichen. Leave a bright highlight along the upper edge of the branch. ❏

FIRST LAYER – Establishing Local Color
Continued from page 45

His Mask:
Fill in his mask with Black.

His Wings, Tail, and Body:
Use Crimson Red on the wings and tail and Poppy Red on the head and body.

His Beak:
The beak is Orange Ochre. By varying the pressure on the pencil, create shadows and highlights.

His Leg and Foot:
Add shadows to the leg and foot with a very sharp Sienna Brown pencil.

Her Mask:
Fill in her mask using Dark Brown.

Her Beak:
As with the male, her beak is Orange Ochre. Carefully leave large highlights.

Her Body:
For the head, chest, belly, and shoulder use a light application of color and soft strokes. Carefully leave large highlights around the eye and on the top of the shoulder.
1. The shoulder is Golden Brown blending to Orange Ochre at the bottom edge, leaving a large highlight along the top.

2. The chest is Golden Brown.
3. Bring a very light application of this same color down the left side of the belly.
4. Use Light Gray on the bottom and right side of the body and along the center line of the chest.
5. A little Orange Ochre brightens the center line of the chest as well as the side of the chest just to the left of the shoulder and upper wing.

Her Head:
1. Use Golden Brown and a little Orange Ochre on the crest.
2. Add small, light Sienna Brown shadows under the cheek and under the crest.

Her Wing:
1. Use light Orange Ochre on the upper row of wing feathers.
2. On the lower row, use Sienna Brown at both ends of the feathers and Orange Ochre in the center.
3. Draw a narrow shadow of Black under one of the center feathers, and darken the underside of the wing tip.

Her Tail:
The base of the tail is Golden Brown shaded with a little Sienna Brown. The upper and lower side of the tail feathers is Orange Ochre.

Her Feet:
The shadows on the feet are Sienna Brown.

Branch:
Shade the branch with Sienna Brown and work the berries with Tuscan Red.

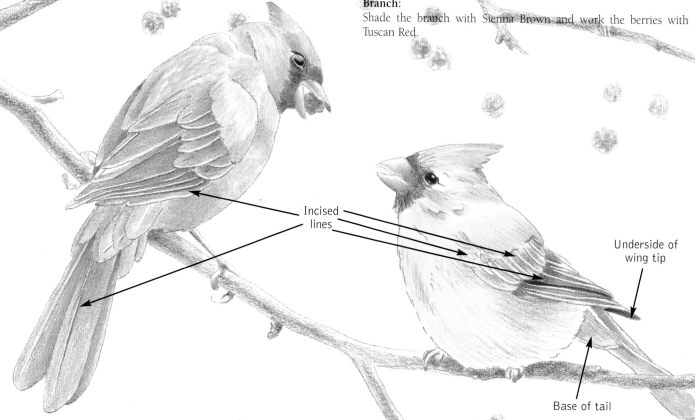

Incised lines

Underside of wing tip

Base of tail

SECOND LAYER – Deepen Color and Build Form

Use soft lead type pencils on the male in this layer, in order to brighten his colors. Continue using hard lead type pencils for the female.

Deepen His Colors:
1. Go over all his plumage colors, usiing soft lead type pencils of the same color.
2. Deepen the shadows on the beak with Crimson Red.

Deepen Her Colors:
1. Deepen her mask with Black and also add the small black marking behind the eye.
2. With Poppy Red, deepen streaks on the crest and add a small patch of color over the eye.
3. Use Terra Cotta to intensify and darken the color at the back of her neck and underneath the highlight below the eye.

Her Shoulder Shadow:
1. Extend the Sienna Brown shadow separating the head from the shoulder.
2. Add a little Terra Cotta along the shoulder's lower edge.

Her Chest:
1. Darken the center line in the chest with Terra Cotta at the top and Warm Gray 20% at the bottom.
2. Add texture strokes of Warm Gray 20% and a very little Terra Cotta in the shadow areas.

3. Deepen the shadow under and to the front of the wing with Sienna Brown and Warm Gray 20%.

Her Wing:
1. Add shadows of Sienna Brown along the upper edges of the upper row of wing feathers.
2. For the lower row, deepen the orange with Crimson Red and deepen the shadows with Black.

Her Tail:
1. Add shadows of Warm Gray 20% on the base of the tail.
2. The shadows on the tail feathers are Dark Brown.

Branch:
1. Deepen the shadows on the branch with Dark Brown and a little Terra Cotta.
2. Add Dark Brown shadows under both bird bodies.

Background:
Use a stylus to incise stems for the berries, then glaze a light gray layer with Light Gray and Warm Gray 20%. Apply the color more heavily along the top and right side, lightly along the bottom, and not at all in the center.

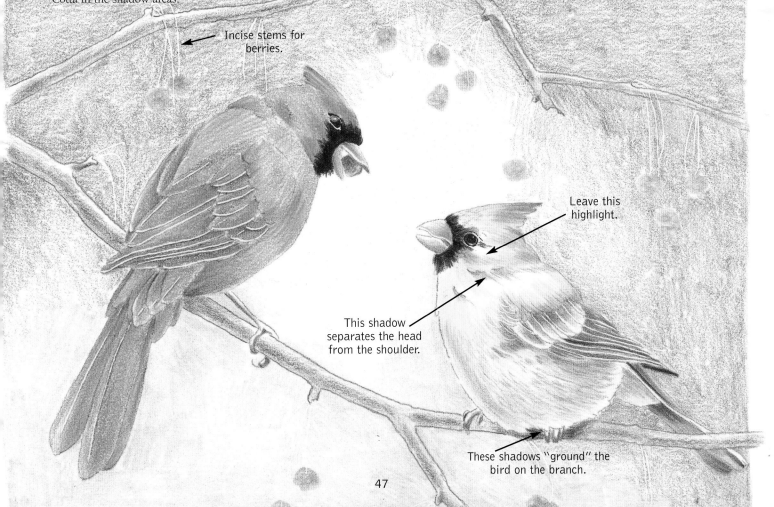

Incise stems for berries.

Leave this highlight.

This shadow separates the head from the shoulder.

These shadows "ground" the bird on the branch.

Pair of Cardinals
Continued from page 47

THIRD LAYER – Final Detail, Intensity, and Form

His Shadows:
Add deep shadows to the male with Tuscan Red, soft lead type pencil.

Her Shadows:
To round her form, add more and deeper shadows, using Umber (medium lead type), Burnt Ochre (soft lead type), VanDyke Brown (medium lead type), and Light Ochre (medium lead type).

Background:
1. To bring out the birds, deepen the background. Use mostly Warm Gray Medium (soft lead type), but also Tuscan Red (hard lead type), and a very little bit of Aquamarine (hard lead type).
2. Suggest background branches and berries with Warm Gray Medium (soft lead type).

Berries:
1. To brighten the berries, add glazes of Rose (soft lead type).
2. Deepen the shadows with Tuscan Red (hard lead type).
3. With a very sharp Tuscan Red hard lead type pencil, parallel the incised lines for the stems. ❏

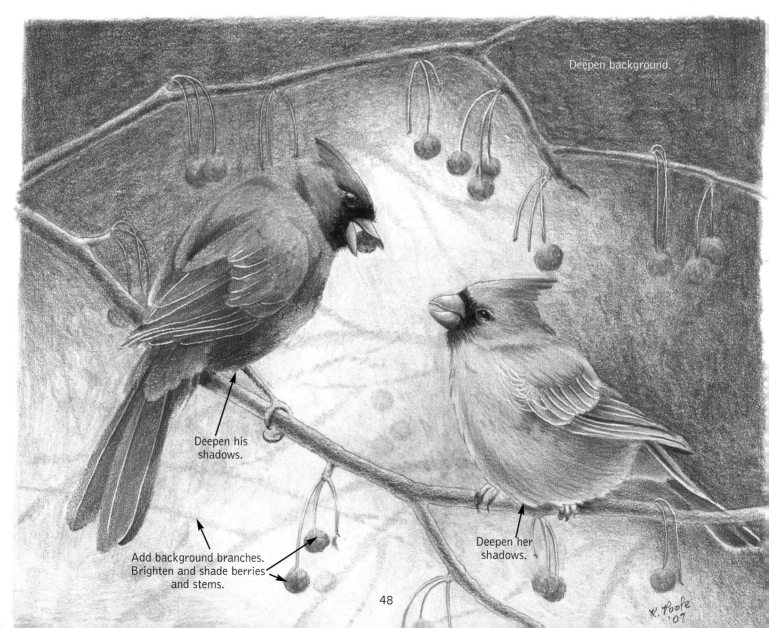

Deepen background.

Deepen his
shadows.

Deepen her
shadows.

Add background branches.
Brighten and shade berries
and stems.

ROBIN

When I was growing up in northern Ohio I eagerly awaited the arrival of the robins, as spring, my favorite season, would soon follow. Now that I live in California, these cheerful birds are with me year round but, to me, they remain a symbol of spring.

Robins are one of the most familiar of North American birds, and when early settlers arrived from England, the robin was familiar to them as well. They named the bird "robin" after the red-breasted robin of their homeland. The two, however, are not related. The English robin is a member of the flycatcher family while the American robin is a thrush.

The adult males and females have similar markings although the female is slightly duller than the male. The juveniles have heavily speckled bellies, and the characteristic orange on the breast develops over time.

A robin hopping along the grass, cocking its head, then pulling up a tasty worm is a familiar sight, and we have come to believe that they are listening for their wriggling prey. Actually, they are looking for prey, not listening for it. Since their eyes are on the sides of their heads, they need to cock their heads to get a clear view of the ground!

Robin with Grub

Instructions begin on page 52

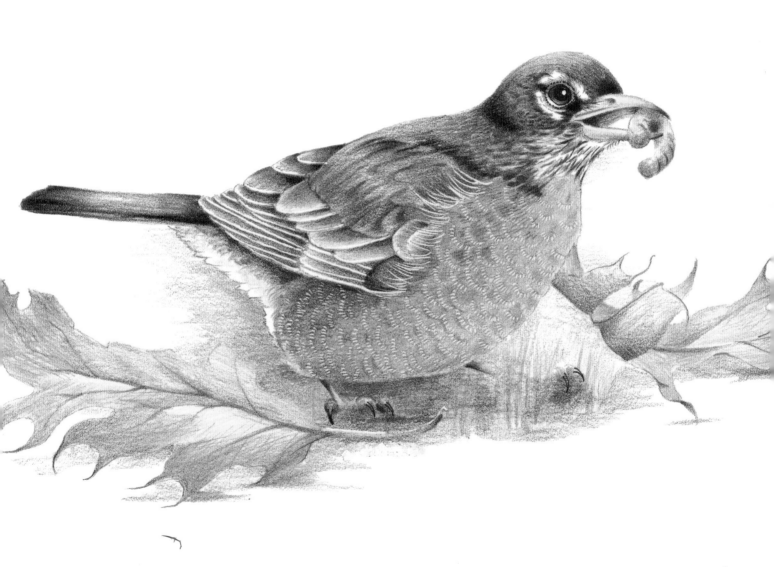

Robin with Grub
Continued from page 51

We so often see this familiar bird walking along the ground looking for worms and grubs. This one's hunt has been successful!

SUPPLIES

Colored Pencils:

Hard Lead Type:

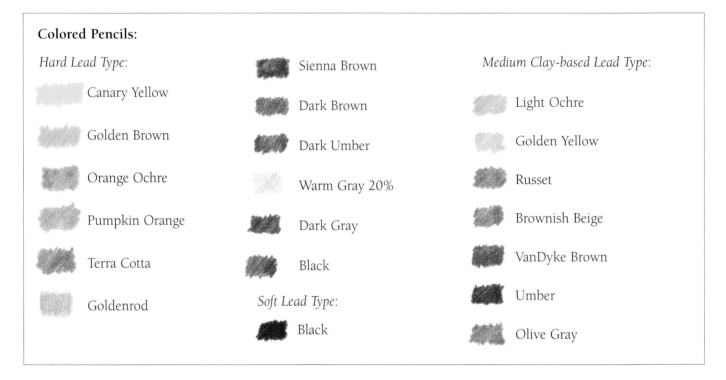

Canary Yellow

Golden Brown

Orange Ochre

Pumpkin Orange

Terra Cotta

Goldenrod

Sienna Brown

Dark Brown

Dark Umber

Warm Gray 20%

Dark Gray

Black

Soft Lead Type:

Black

Medium Clay-based Lead Type:

Light Ochre

Golden Yellow

Russet

Brownish Beige

VanDyke Brown

Umber

Olive Gray

Other Supplies
Drawing paper, white
Size 01 black permanent pen
Stylus

> *Tip:* When posing your bird, use small details to help tell a story. The robin's feet are planted firmly and far apart with the legs slightly bent, suggesting that he had braced himself to pull the grub out of the ground.

FIRST LAYER – Establishing Local Color

Use hard lead type pencils for this first layer.

Eye:
1. Use the permanent pen to outline the eye, the highlight, and the pupil.
2. Ink a small row of dots around the eye indicating the tiny feathers that texture the eyelids.
3. Fill the pupil with black ink.
4. Fill the iris with Sienna Brown, darker at the top of the eye and lighter at the bottom.

Incising Marks:
1. Use the large end of a stylus to incise lines along the edges of the wing feathers.
2. With the small end, incise several curved lines along the left edge of the chest over the forward wing feathers. These lines will become wispy white fluff.
3. Finally, incise curved rows of short lines on the chest, indicating the lower edges of some of the small chest feathers.

Beak:
1. Use Canary Yellow on the outside.
2. Color the inside with Orange Ochre.
3. Deepen the tips with Black.
4. Color the shadow inside the mouth with Dark Umber.

Head, Back, Wings, and Tail:
The first pass at the head, wings (except for the middle row of feathers), and tail is Dark Brown. On the back, wings, and tail, vary the pressure to get lighter and darker areas, and leave curved highlights on the wing. On the back, use short criss-cross strokes, leaving random areas of the paper showing through. Carefully avoid the white patches around the eye.

Wing Feathers:
1. For the middle row of feathers on the wing, first glaze the entire area with a light coat of Golden Brown.
2. Add shadows of Dark Brown over the Golden Brown.

Deepen Dark Areas:
With Black, deepen the areas at the corners of the eyes, the back of the neck, the tip of the tail, and the base of the tail where it tucks under the wing.

Chin:
Add streaks of Dark Brown and Black on the chin.

Chest:
1. Glaze the chest with a light coat of Orange Ochre. The incised feather edges begin to show.
2. Shade under each of these feathers with a darker area of Orange Ochre.

Legs and Feet:
The legs are Black, and the claws are ink.

Leaves:
Glaze the upper sides of the leaves with Golden Brown, and the under sides with Sienna Brown.

Grub:
The grub is Orange Ochre.

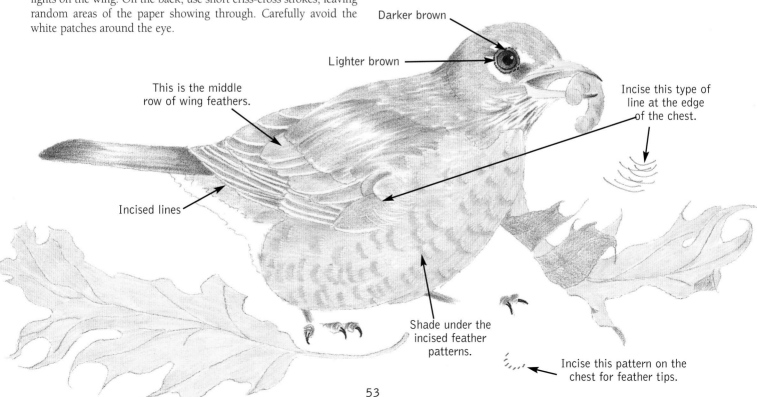

Darker brown

Lighter brown

This is the middle row of wing feathers.

Incise this type of line at the edge of the chest.

Incised lines

Shade under the incised feather patterns.

Incise this pattern on the chest for feather tips.

Robin with Grub
Continued from page 53

SECOND LAYER – Deepen Color and Build Form
Use hard lead type pencils unless noted otherwise.

Eye:
Deepen the iris with Dark Brown at the top and Terra Cotta at the bottom.

Chest:
1. Incise more feathers on the chest.
2. Glaze the entire chest with Pumpkin Orange, increasing the pressure to deepen the color at the bottom.
3. Warm the top area of the chest with a little Goldenrod.

Head, Back, and Wings:
1. Add Dark Gray to the head, back, and wings to make them grayish brown. Use tiny strokes on the head simulating small feathers. Carefully preserve the highlights while deepening the shadows on the wing and tail.
2. Shade the white portion of the rump with Warm Gray 20%.

Beak:
1. To continue developing the beak, darken the tips, adding Golden Brown to the yellow portions, and deepen the inside with Terra Cotta and Dark Gray.
2. Add a narrow line of Terra Cotta a little above the lower edge of the top beak, and the nostril.

Grub:
1. Deepen the grub's color with Pumpkin Orange.
2. Add Dark Gray shadows to develop its curved, lumpy form.

Leaves and Grass:
Use medium lead type pencils for these areas.
1. Add Light Ochre shadows on the top sides.
2. Make VanDyke Brown shadows on the under sides of the leaves.
3. Outline the veins with VanDyke Brown.
4. Add light cross-hatches of Light Ochre here and there.
5. Use VanDyke Brown and Light Ochre to add short leaves of grass to hide much of the feet.

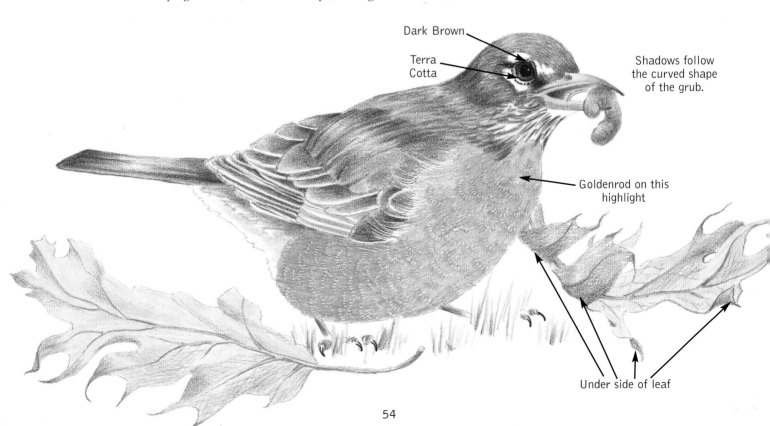

Dark Brown

Terra Cotta

Shadows follow the curved shape of the grub.

Goldenrod on this highlight

Under side of leaf

THIRD LAYER – Final Detail, Intensity, and Form

Use medium lead type pencils for this layer, unless noted otherwise.

Deepening the Black:
The idea now is to add enough Black to give the illusion of a bird with a dark head, back, tail, and wings, but without losing the forms of the individual parts. To accomplish this, begin with hard lead type Black, glazing over all the areas (except for the white patches around the eye, the feather edges, and the middle row of wing feathers). Then use the black pencil to suggest individual feathers on the upper wing.

Deepening the Black More:
Soft lead type Black is a very dark black. Use it to deepen the deepeset shadow areas – the front of the head above the beak, around the eye, the base of the neck, the base of the shoulder, the tail tip and base, and some of the shadows in the wing feathers. Also use soft lead type Black to deepen the shadow in the open mouth and to deepen the streaks on the chin.

Beak:
Brighten the beak with more Goldenrod (hard lead type).

Chest:
1. Use Russet over the mid-tone and shadow areas.
2. Color with Golden Yellow on the highlights.
3. Add Umber in the shadows. The incised edges of the feathers show quite well now.
4. To add more texture to the chest, darken some of the individual feathers with patches of Russet.

Grub:
Finalize the shape of the grub with black shadows.

Leaves:
Glaze leaves with Dark Brown (hard lead type), then add touches of Russet and Olive Gray.

Background Shadows:
The final touch is to add shadows under the bird, leaves, and grass with Brownish Beige and Umber. To make the white on the rump stand out, bring the shadow up around it. ❏

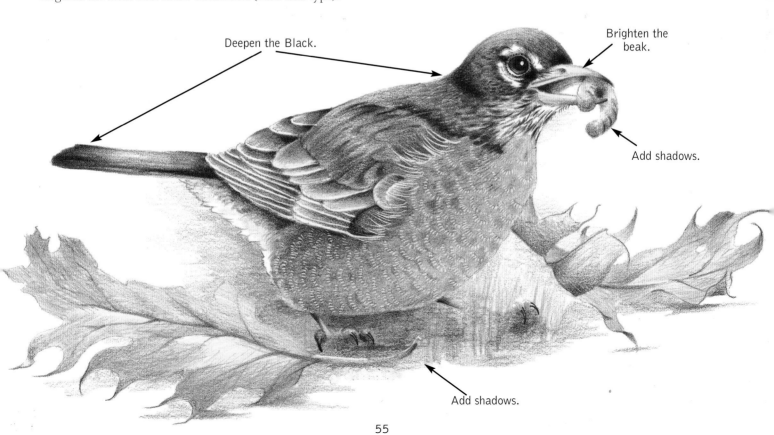

Deepen the Black.

Brighten the beak.

Add shadows.

Add shadows.

Robin & Eggs

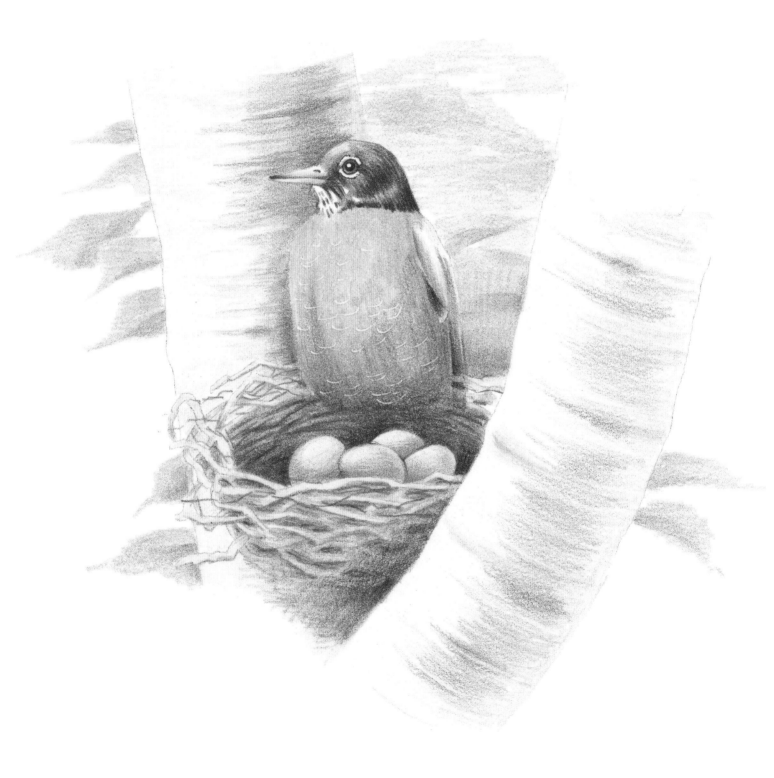

I do not know if there is a more beautiful color than the sublime blue of robins' eggs. It will be fun and a challenge to duplicate this color with glazes of colored pencil. The nest is also a challenge in that it is so complex with all the interwoven material. My strategy is simplification!

SUPPLIES

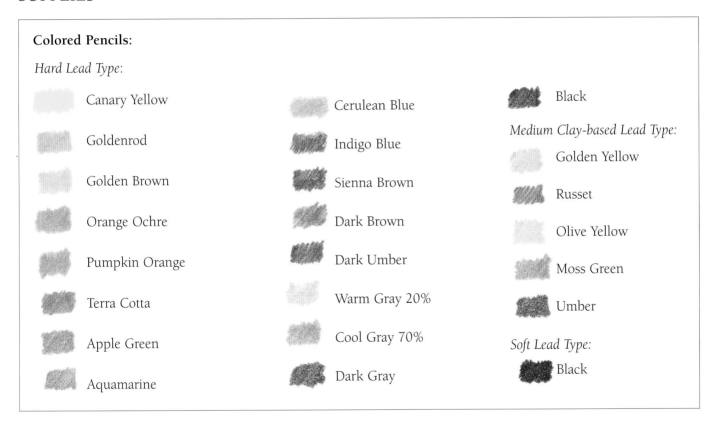

Colored Pencils:

Hard Lead Type:

Canary Yellow

Goldenrod

Golden Brown

Orange Ochre

Pumpkin Orange

Terra Cotta

Apple Green

Aquamarine

Cerulean Blue

Indigo Blue

Sienna Brown

Dark Brown

Dark Umber

Warm Gray 20%

Cool Gray 70%

Dark Gray

Black

Medium Clay-based Lead Type:

Golden Yellow

Russet

Olive Yellow

Moss Green

Umber

Soft Lead Type:

Black

Other Supplies

Drawing paper, white
Size 01 black permanent pen
Click eraser
Stylus

Robin & Eggs
Continued from page 57

FIRST LAYER – Establishing Local Color
Use hard lead type pencils throughout the first layer.

Eye:
1. Using the permanent pen, outline the eye, pupil, and highlight.
2. Fill the pupil with ink, avoiding the highlight, then outline the white patches around the eye with irregular, broken lines.
3. Fill the iris with Sienna Brown.

Head, Wing, and Back:
1. Color the head, wing edge, and back with Dark Brown.
2. Add shadows of Black on the wing and back.
3. Use both Black and Dark Brown for the streaks on the chin.

Beak:
1. Color the beak Canary Yellow, with Dark Umber then Black deepening the tips.
2. Draw the nostril with Black.

Chest:
1. With a stylus, incise small curved lines on the chest to represent the edge of some of the small chest feathers.
2. Glaze the chest with Orange Ochre.
3. Add Pumpkin Orange in the shadow areas.

Nest:
Suggest the complexity of the nest by drawing some individual branches and straws.
1. To begin, glaze the entire nest with Golden Brown.
2. Then use Sienna Brown to deepen the shadow areas between the branches and straws.

3. The inside of the nest is in shadow, so use Sienna Brown, darkening it towards the bottom. A few darker strokes indicate texture on the inside of the nest.

Eggs:
Use a light glaze of Cerulean Blue for the eggs, then lift highlights by erasing with a clean click eraser.

Branches:
1. Work the branches with Warm Gray 20% using wide, curving horizontal strokes that follow the roundness of the branches.
2. Use Cool Gray 70% for the markings, which are darker.
3. Use Cool Gray 70% to darken the shadow behind the bird and underneath the nest.

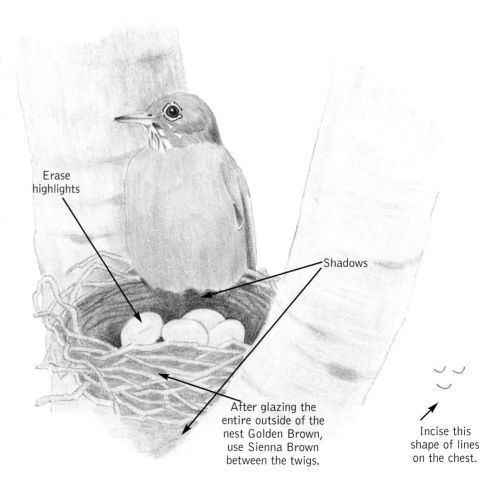

Erase highlights

Shadows

After glazing the entire outside of the nest Golden Brown, use Sienna Brown between the twigs.

Incise this shape of lines on the chest.

SECOND LAYER –
Deepen Color and Build Form

Continue using hard lead type pencils for this layer.

Head, Wing, and Back:
Deepen the head, wing, and back with Dark Gray, varying the pressure and leaving highlights to form the cheek and other details on the head.

Beak:
1. Deepen the beak with Goldenrod, but leave a Canary Yellow highlight on the top edge.
2. Run a very thin line of Black along the lower edge to help differentiate the beak from the background branch as the two are very similar in value.

Chest:
1. To brighten and deepen the chest, use Terra Cotta in the shadow and mid-tone areas and Goldenrod in the highlight areas.
2. Use Terra Cotta and Pumpkin Orange to add random patches of dark for texture.

Eggs:
Working towards a "robins' egg blue" add Aquamarine to the eggs, varying the pressure for shadows to create the forms and separate them from each other.

Nest:
1. Add detail and form to the nest by shading the individual branches and straws where they pass under each other with Dark Umber.
2. Using the same color, deepen the inside of the nest.

Branches:
Dark Gray on the branches deepens the shadows and adds texture. Keep the forward branch lighter than the rear one. Dark Gray also deepens the shadow under the nest.

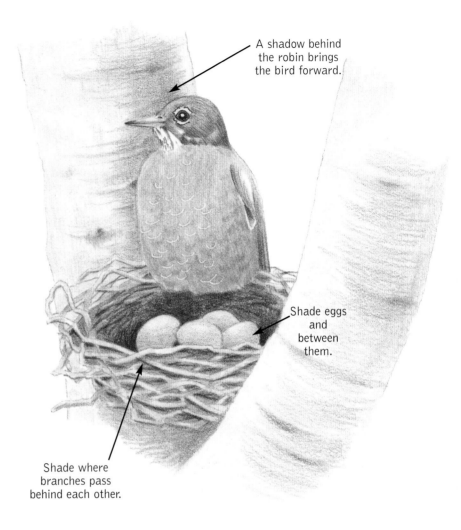

A shadow behind the robin brings the bird forward.

Shade eggs and between them.

Shade where branches pass behind each other.

THIRD LAYER – Final Detail, Intensity, and Form

Refer to finished drawing on page 56.

Deepening Shadows:
Use medium lead type pencils unless noted otherwise.
1. Deepen the head and shadows on the wing with Black (soft lead type).
2. To deepen and brighten the chest, use Russet on the mid-tone and shadow areas and Golden Yellow on the highlight areas.
3. Deepen the darkest shadows at the bottom of the chest with Umber. This shadow should be so dark that the dividing line between the bird and the nest is barely visible. This firmly plants the bird on the nest.

Eggs:
Use hard lead type pencils.
To complete the egg color, add Indigo Blue in the shadow areas, then shadows of Dark Gray.

Nest:
Use hard lead type pencils.
1. To clarify the form of the nest, add Black in the interior shadow areas, shade the right and lower portions of the outside of the nest, and deepen the shadow under the nest.
2. Add texture lines of Black inside the nest.
3. Make a few thin Umber strands around the outside edge.

Branches:
Use hard lead type pencils.
Continue to work the form and texture of the branches with Dark Gray.

Foliage:
To finish the drawing, add a suggestion of foliage with Apple Green (hard lead type), Moss Green (medium lead type), and Olive Yellow (medium lead type). The foliage brings out the bird and also brightens the overall effect. ❏

Fledgling Pair

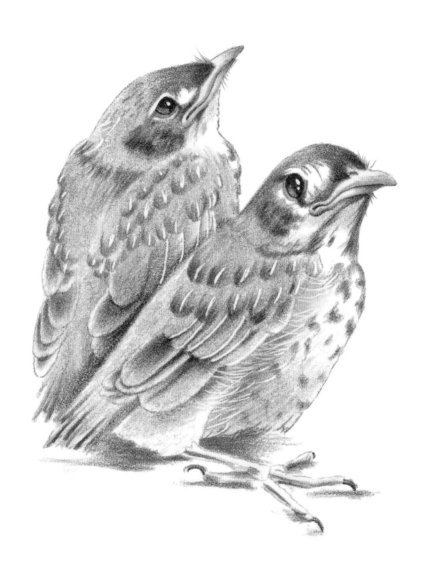

These fledglings seem all feet and beak! The left one is looking hopefully upward, waiting for mom or dad to bring a tasty treat.

SUPPLIES

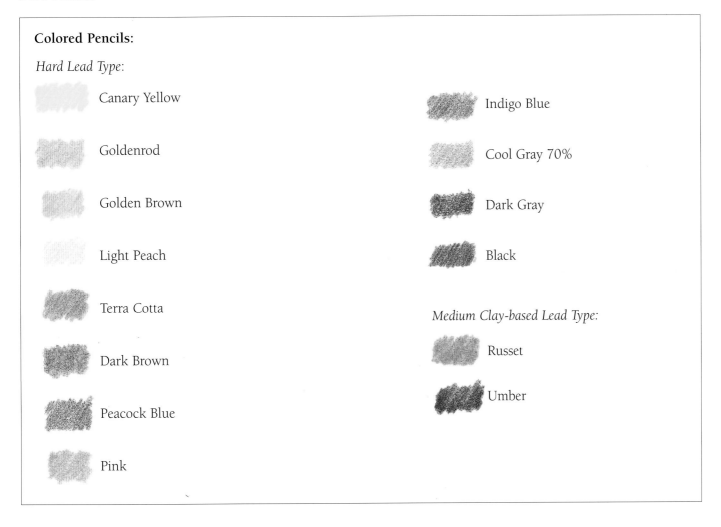

Colored Pencils:

Hard Lead Type:

Canary Yellow

Goldenrod

Golden Brown

Light Peach

Terra Cotta

Dark Brown

Peacock Blue

Pink

Indigo Blue

Cool Gray 70%

Dark Gray

Black

Medium Clay-based Lead Type:

Russet

Umber

Other Supplies
Drawing paper, white
Size 01 black permanent pen
Stylus

Fledgling Pair
Continued from page 61

FIRST LAYER – Establishing Local Color
Use hard lead type pencils for the first layer.

Eye:
1. Use the permanent pen to outline the eyes and highlights.
2. Fill the eyes with ink, avoiding the highlights.

Incising Marks:
With the small end of a stylus, incise the center white streaks on the upper wing feathers, the edges of the middle wing feathers, a few strands of fluff on the nape of the left fledgling's neck, and the fluff at the left side of the right fledgling's chest.

Beaks:
1. Fill the beaks with Light Peach.
2. Deepen the tips with Canary Yellow.
3. For the lines between the upper and lower beaks use a very sharp Dark Gray pencil.

Heads:
For the heads, use Cool Gray 70% for the lighter areas and Dark Gray elsewhere. Be careful to preserve highlights of white.

Chests:
1. The orange color on the chests is concentrated along the sides at this stage of development – use Goldenrod for this first layer.
2. Draw the spots on the chest with Dark Gray.

Wings:
The wings are divided into three sections.
1. On the upper feathers, use Cool Gray 70% and shade with Dark Gray.
2. Glaze an even light tone of Golden Brown over the middle feathers then shade them with Cool Gray 70%.
3. The lower feathers are Cool Gray 70% shaded with Dark Gray, but leave a white edge.

Backs:
The back has a textured look, so fill it with short, broken strokes of Cool Gray 70%.

Tail:
The tail is also Cool Gray 70% shaded with Dark Gray.

Leg and Foot:
Fill the leg and foot with Light Peach, shade it with Dark Gray, then ink two strokes for each claw.

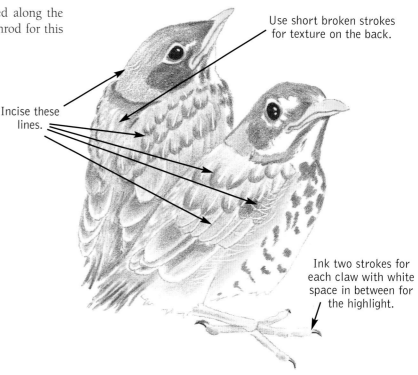

Use short broken strokes for texture on the back.

Incise these lines.

Ink two strokes for each claw with white space in between for the highlight.

SECOND LAYER – Deepen Color and Build Form

Continue using hard lead type pencils.

Beaks, Chests, and Spots:
1. Use Terra Cotta on the shadow areas of the beaks and on the far sides of the chests.
2. On the right fledgling, add a few light Terra Cotta spots.

Darken Shadows:
Use Black to darken the shadow areas of the head, wings, back, and tail.

Highlights:
1. With Goldenrod, lightly add a touch of color to the lower wing feathers.
2. Add the slightest touch of Canary Yellow in the orange areas at the top of the chests.

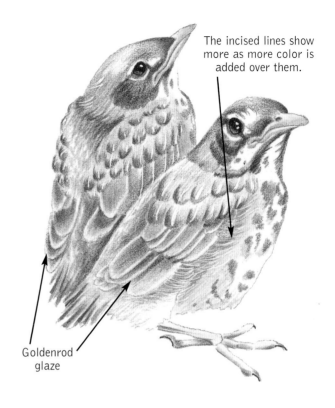

The incised lines show more as more color is added over them.

Goldenrod glaze

THIRD LAYER – Final Detail, Intensity, and Form

Continue using hard lead type pencils until noted otherwise.

Add Black:
Deepen the blacks in the deepest shadow areas.

Wings, Heads, and Tails:
1. Glaze over the wings, heads, and the back and tail of the left fledgling with Dark Brown.
2. Add a very little (hardly noticeable) Peacock Blue to the tails.
3. Glaze a little Pink over the upper wings, then dull it with a little Dark Brown.

Chests:
Add Russet (medium lead type) to the orange areas of the chests to brighten them.

Shadows:
1. Shade the left fledgling where he lies behind the right one with Umber (medium lead type).
2. After lightly shading the lower edge of the right fledgling's chest, add a shadow under the bird with Umber (medium lead type), Peacock Blue, and Indigo. ❏

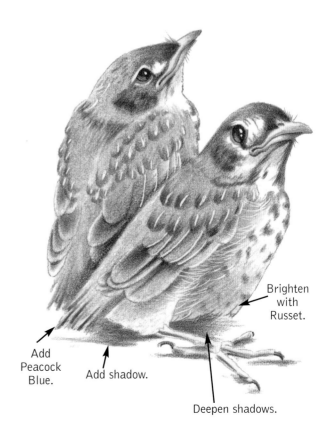

Brighten with Russet.

Add Peacock Blue.

Add shadow.

Deepen shadows.

63

GOLDFINCH

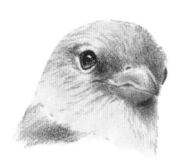

Goldfinch are such bright, active birds. They nearly always travel in groups, and their interactions are entertaining. I have a thistle feeder outside my living room window, and it is usually covered with these tiny birds hanging onto the feeder at every imaginable angle. Others perch in nearby branches intently looking for an opening. Their song is as cheerful as their coloring.

Goldfinch nest later than many other birds, waiting until July to pair off and begin building their nests. Most goldfinch are monogamous, but a few wayward females leave their nests to pair up with another male and begin another brood. The original fledglings are left in the care of the first dad!

Sometimes these birds eat insects or berries, but their main food is seed, and their preferred feast is thistle seed. And they use the thistle down to line their nests.

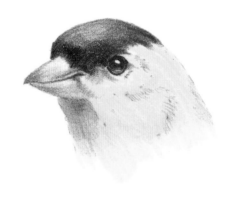

Where I live in rural Northern California there is a very invasive and nasty weed called "star thistle." It has an insignificant yellow blossom, and very significant prickly thorns on hard gangly stems. (I fell into a patch of it once, and it was an unforgettable experience!) It spreads prolifically. Mowing it does not prevent seeding – it seems it will seed on the stubbiest little nub! The California Department of Agriculture gives classes on how to get rid of this weed, but the solutions they offer are few and not spectacularly effective. So we're stuck with this unwanted plant. Its only saving grace is that the goldfinch absolutely love it! So I guess it is true that every cloud has a silver lining – or, in this case, a golden one!

Goldfinch on Thistle

Instructions begin on page 66

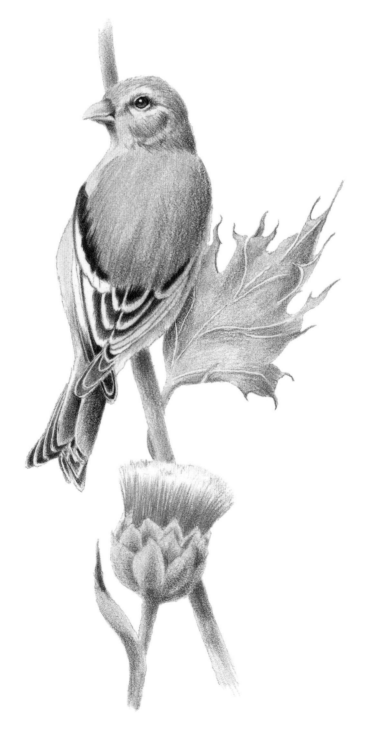

Goldfinch on Thistle
Continued from page 65

I find thistles – except star thistle! – beautiful. And adding to their beauty is their attractiveness to American Goldfinch. This is a portrait of a female sitting on a thistle stem.

SUPPLIES

Colored Pencils:

Hard Lead Type:

Canary Yellow

Goldenrod

Orange

Terra Cotta

Apple Green

Olive Green

Parma Violet

Dahlia Purple

Sienna Brown

Cool Gray 70%

Dark Gray

Black

Soft Lead Type:

Black

Medium Clay-based Type:

Golden Ochre

Light Ochre

Green Ochre

Khaki Green

Dark Green

Malachite Green

Sapphire Blue

Other Supplies

Drawing paper, white
Size 01 black permanent pen
Stylus

FIRST LAYER – Establishing Local Color

Use hard lead type pencils unless noted otherwise.

Eye:
1. With the permanent pen, outline the eye and the highlight. Place the highlight consistent with the light source, which is upper left.
2. Fill the remainder of the eye, but leave a secondary highlight.
3. Fill the secondary highlight with Black pencil, pressing harder at the edges.

Incising Marks:
Carefully incise the edges of the wing and tail feathers with the small tip of a stylus. These incised lines will stay white. Also incise the veins in the thistle leaf.

Head and Back:
Although the head and back have a strong golden tint, at this stage use more neutral colors. Color in with Sienna Brown, Dark Gray, and Cool Gray 70%. Use these colors to begin to form the shapes of the face – the eyelids, cheek, the fluff on the back of the neck, and the shadow under the beak – as well as to shade the back.

Beak:
1. For the beak, shade the right portion of the upper beak and the lower portion of the lower beak with Sienna Brown.
2. Glaze lightly over the entire beak with Goldenrod.
3. With Sienna Brown, add a line between the upper and lower beaks and a shadow in the corner.

Wings and Tails:
1. Use Black for the black areas on the wings and tail, leaving the white areas the white of the paper. This pencil is not dark enough for a vivid black, but is fine for this early stage.
2. Heavily shade the right sides of the tail feathers in a rounded shape.

Body:
Use Light Ochre (medium lead type) for the body areas on both sides of the wings.

Thistle Greenery:
Fill the thistle greenery with Apple Green. Vary the pressure to begin to establish highlight and shadow areas, especially in the leaflets at the base of the thistle blossom.

Thistle Bloom:
Use a sharpened Parma Violet pencil for the thistle bloom, pulling thin strokes upwards from the base of the flower. Because the top is very light, use short, light strokes along the very top.

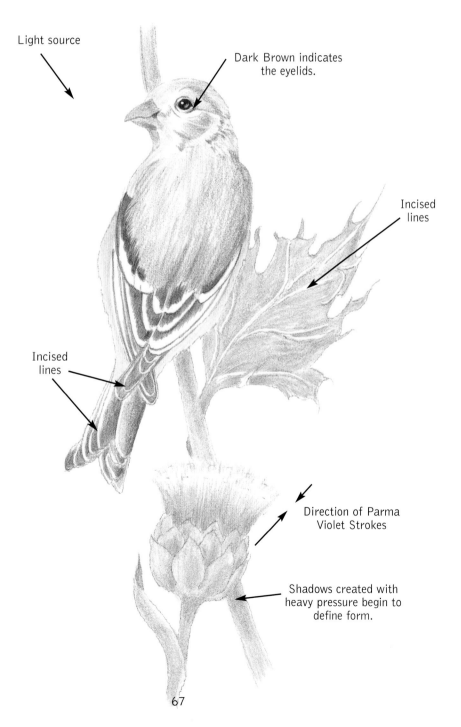

Light source

Dark Brown indicates the eyelids.

Incised lines

Incised lines

Direction of Parma Violet Strokes

Shadows created with heavy pressure begin to define form.

Goldfinch on Thistle
Continued from page 67

SECOND LAYER – Deepen Color and Build Form
Use hard lead type pencils unless noted otherwise.

Back and Head:
1. Glaze Light Ochre (medium lead type) over the back and head except for the areas right around the eye.
2. Brighten the areas around eye with Canary Yellow.

Beak:
1. Brighten the beak with Canary Yellow.
2. Add Orange along the lower beak.
3. Add a thin line of Orange a little bit above the line separating the upper and lower beaks. Leave a line of light between the Orange and the Sienna Brown to give the impression of a thick edge to the upper beak.

Wing Feathers:
Deepen the dark areas in the wing feathers with heavy pressure and Dark Gray.

Shadows:
Develop the forms by adding shadows. For the head and back, use Sienna Brown and Dark Gray. The shadows are placed away from the light source, along the right edges of the head, back, and neck. A shadow at the back of the neck, brings the shoulder forward. Shadows around the eye help "set" the eye in the head. Add shadows on the front of the head just above the beak (keep it narrow) and below the beak.

Body:
1. Shade the shadow (right) portion of the yellow body with Sienna Brown and a little Terra Cotta.
2. Add a little Terra Cotta at the lower portion of the left side of the body.

Feathers:
Glaze over the white portions of the feathers on the right wing with Cool Gray 70% to place it in shadow.

Thistle Greenery:
Add shadows of Olive Green to the thistle greenery. The shadows on the stem below the bird and along the left edge of the leaf behind the bird are critical to bring the bird forward. Shadows on the leaflets at the base of the thistle flower serve two purposes. Shadows form each individual curved leaflet, but it is also important to shade the shape as a whole – that is, the right part should be darker than the left part.

Thistle Blossom:
Enrich the thistle blossom with Dahlia Purple. Concentrate this color towards the top of the flower.

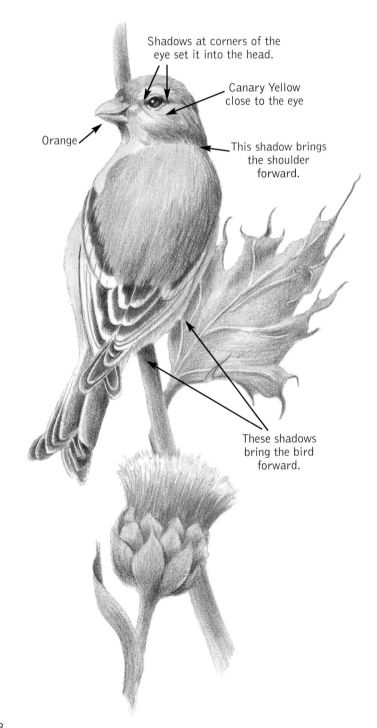

Shadows at corners of the eye set it into the head.

Canary Yellow close to the eye

Orange

This shadow brings the shoulder forward.

These shadows bring the bird forward.

THIRD LAYER – Final Detail, Intensity, and Form

Wing and Tail Feathers:
With soft lead type Black, use heavy pressure to darken the black areas of the wing and tail feathers.

Eye, Body, and Head:
1. The contrast between the black and white on the wings draws the eye and competes with the eye as a focal point. To soften this effect, add more color to the back and head, using glazes of Golden Ochre (medium lead type) on the highlight side and Green Ochre and Khaki Green (medium lead type) on the shadow side.
2. Deepen the shadows on the body, head, and around the eye with Sienna Brown.

Thistle Greenery:
1. Add more color and contrast to the greenery by deepening the shadows with Malachite Green (medium lead type).
2. Use Dark Green (medium lead type) to color the deepest shadows below and behind the birds.

Thistle Bloom:
Round the form of the thistle bloom with a little Sapphire Blue (medium lead type) on the right side. ❑

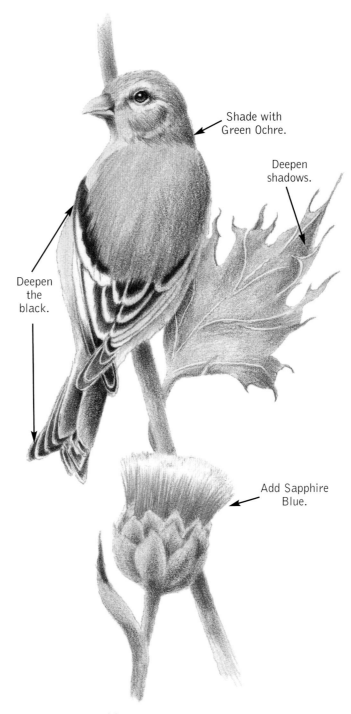

Shade with Green Ochre.

Deepen shadows.

Deepen the black.

Add Sapphire Blue.

Goldfinch Pair in Blackberries

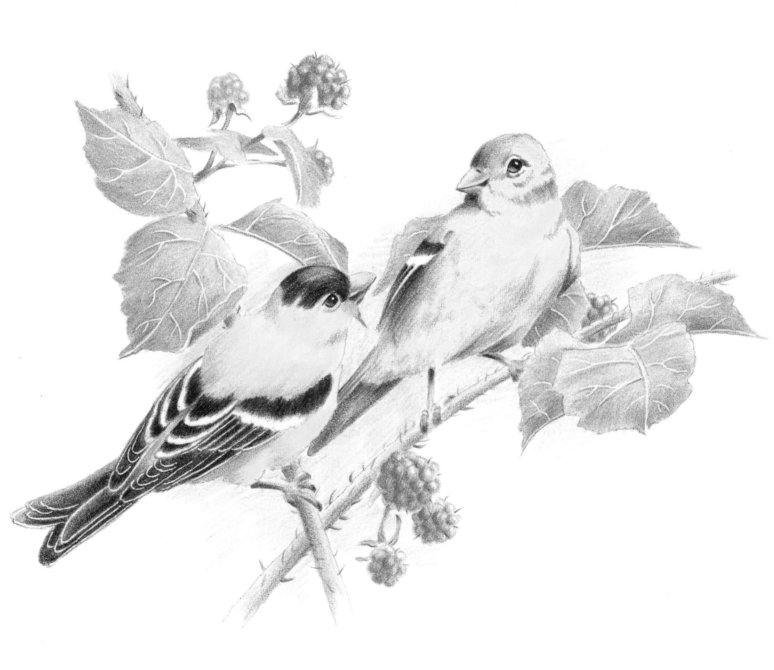

*Beautiful blackberries and their foliage make a lovely
background for a pair of these tiny, colorful birds. Perhaps he is
courting her – she is certainly lovely!*

SUPPLIES

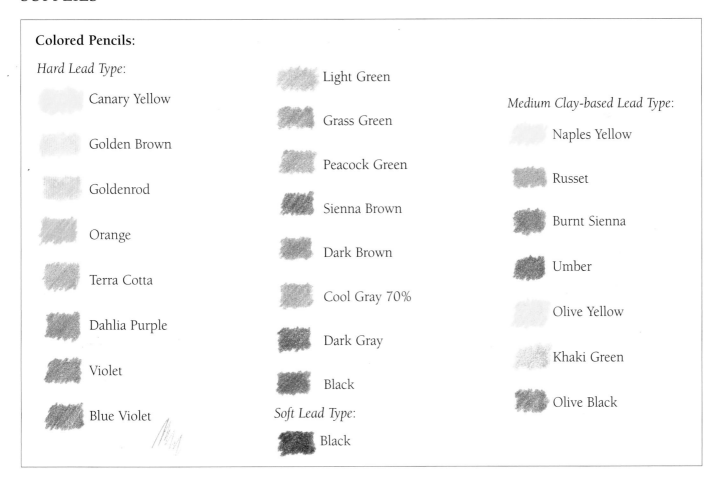

Colored Pencils:

Hard Lead Type:

Canary Yellow

Golden Brown

Goldenrod

Orange

Terra Cotta

Dahlia Purple

Violet

Blue Violet

Light Green

Grass Green

Peacock Green

Sienna Brown

Dark Brown

Cool Gray 70%

Dark Gray

Black

Soft Lead Type:

Black

Medium Clay-based Lead Type:

Naples Yellow

Russet

Burnt Sienna

Umber

Olive Yellow

Khaki Green

Olive Black

Other Supplies
Drawing paper, white
Size 01 black permanent pen
Stylus

Tip: When preparing your initial sketch, it can be difficult to get the birds sized correctly relative to each other. Just draw each bird as you want it, then use a copier to solve your sizing problem. In this drawing, I had the female too big, but felt that the male was the right size. I copied the drawing, reducing by 10%. After tracing my male bird, the berries, and branches, I traced the reduced female. I then had the drawing I wanted, and transferred it to my good paper.

FIRST LAYER – Establishing Local Color

Use hard lead type pencils.

Eyes:
1. Use the permanent pen to ink the eyes, leaving a tiny highlight and larger secondary highlight.
2. Fill the secondary highlight with Black pencil. Carefully place the highlights consistent with the light source, which is the upper right.

Beaks:
1. Glaze the beaks with Goldenrod.
2. Shade them with Sienna Brown. The tiny triangle at the corner of the beak is a dark shadow.

Legs and Feet:
Color in the legs and feet with Terra Cotta, establishing a little shading along the left and lower edges.

Incising Marks:
Incise lines along the edges of the male's tail and large wing feathers and along the veins of the leaves.

His Head, Wings, and Tail:
1. Color the dark patch on his head Black.
2. Establish the pattern in the wings and tail with Black.
3. When coloring, leave the white parts of the body; the white of the paper.
4. Color the yellow parts with Canary Yellow.

Her Wing:
For the female, create the pattern on the left wing with Black.

Her Chest, Eye, and Body:
1. Use Canary Yellow for the highlights on her chest and under her eye.
2. Color the remainder of the "yellow" areas with Goldenrod.

Shading Her:
Shade lightly with Sienna Brown on the forehead, under the chin, under the right wing, and the small shadow areas around the eye and on the cheek.

Her Tail:
Use Black on the upper edge of the tail and Dark Brown on the underneath portion.

Blackberry Stems:
1. Color the shadow sides of stems Sienna Brown.
2. Glaze over the canes, including the brown, with Light Green.

Leaves:
Begin the leaves by incising the veins with the narrow end of a stylus. For this first layer of color, pull strokes of Light Green from the outer edges inwards. Apply an even, fairly light tone, then shade by applying heavier pressure.

Berries:
Using Dahlia Purple for the ripe berries, and Light Green for the immature berries, draw the berries as a series of small circles. Shade each tiny circle, leaving a highlight at the upper right.

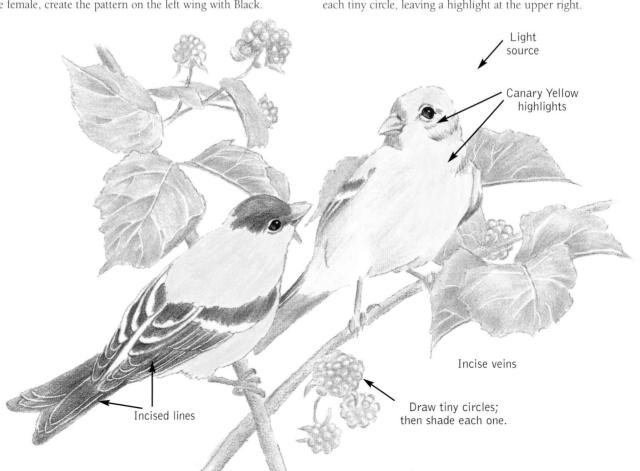

Light source

Canary Yellow highlights

Incise veins

Incised lines

Draw tiny circles; then shade each one.

SECOND LAYER – Deepen Color and Build Form

Use hard lead type pencils unless noted otherwise.

Beaks:
1. Brighten the beaks with Canary Yellow and add a little Orange in the shadow areas.
2. Deepen the shadows with Sienna Brown.

Legs:
Shade the legs with Sienna Brown.

Intensifying His Color:
1. For the male, darken the "black" areas with Dark Gray.
2. Shade the yellow area with Goldenrod and a little Orange.

Intensifying Her Color:
1. Deepen the Canary Yellow areas on the female bird.
2. Add Golden Brown over the Goldenrod.
3. Shade with Sienna Brown, using this opportunity to build the forms.

Her Wing and Tail:
1. Deepen the "black" areas on the wing and tail with Dark Gray.
2. Deepen the under side of the tail with Sienna Brown, leaving a highlight in the middle.

Leaves and Stems:
Use medium lead type pencils for all the colors on the leaves and stems in this layer.
1. Glaze the under sides of the leaves with a light coat of Russet.
2. On the upper sides, use Olive Yellow in the highlight areas, Khaki Green in the mid-tone areas, and Olive Black in the shadow areas.
3. Deepen the shadows on the canes with Russet.

Berries:
With Violet, add a second coat in the same manner as the first. Lightly shade the left and lower sides. Also use Violet on the immature green berries, but do not apply the violet to the highlight areas.

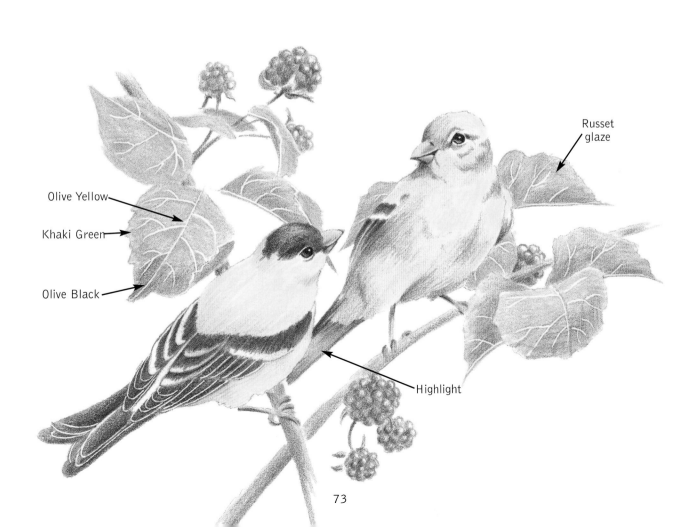

Russet glaze

Olive Yellow

Khaki Green

Olive Black

Highlight

Goldfinch Pair in Blackberries
Continued from page 73

THIRD LAYER – Final Detail, Intensity, and Form
Use hard lead type pencils unless noted otherwise.

Beaks and Legs:
1. Darken the shadows on the beaks with a little more Sienna Brown.
2. Deepen the shadows on the legs with Dark Gray.

Intensify His Colors:
1. Deepen the black areas with Black (soft lead type).
2. Except for the highlights on the shoulder and chest, glaze the yellow areas with Naples Yellow (medium lead type), achieving a nice deep, bright color.
3. Shade the shadow areas with a light application of Burnt Sienna (medium lead type).

Intensify Her Colors:
1. Deepen the shadows on her with Burnt Sienna (medium lead type).
2. Continue intensifying with Umber (medium lead type) on the darkest shadow areas at the front of the head, under the chin, under both wings, and on the lower side of the tail.

3. Add small, very light patches of Umber (medium lead type) randomly on the chest to indicate fluffiness.

Berries:
Add a layer of Blue Violet, leaving the highlight areas alone and deepening the shadows.

Leaves:
1. Add a final layer of Grass Green to the leaves, emphasizing their forms by deepening the shadows.
2. In the deepest shadow areas to the right of her chest, add Peacock Green.

Background:
Fill in the background with Light Green.

Thorns:
Draw the tiny thorns on the canes and berries with very sharp Terra Cotta and Sienna Brown pencils. ❑

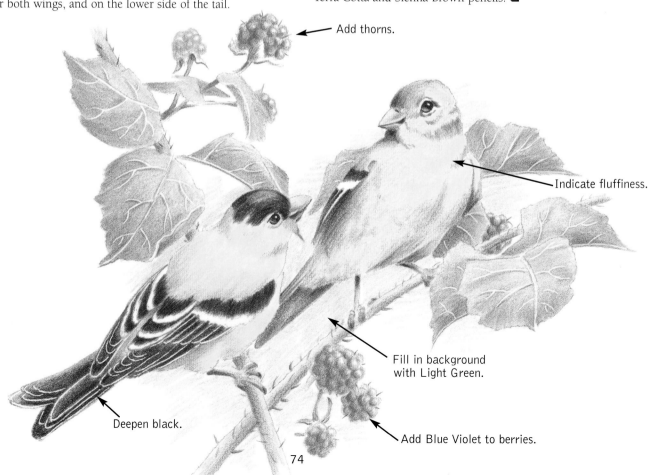

Add thorns.

Indicate fluffiness.

Fill in background with Light Green.

Deepen black.

Add Blue Violet to berries.

Male Goldfinch with Wild Oats

Instructions begin on page 76

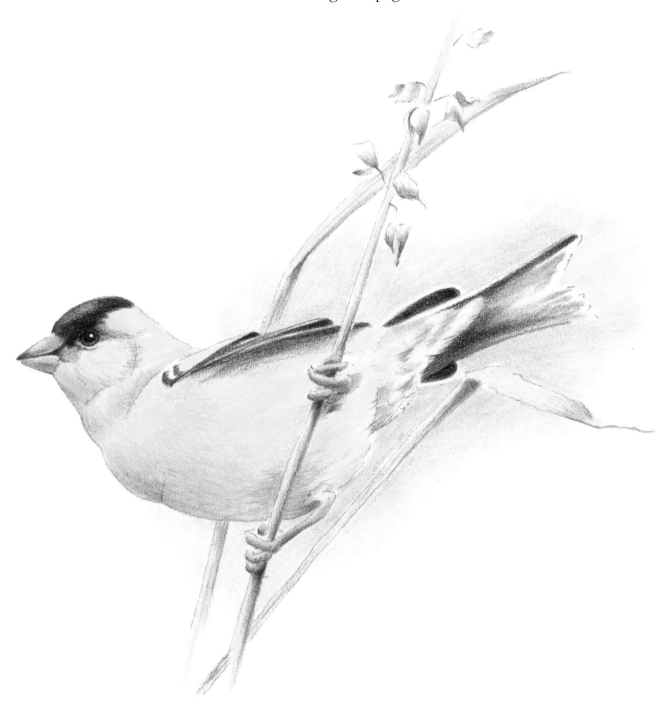

Male Goldfinch with Wild Oats
Continued from page 77

SECOND LAYER – Deepen Color and Build Form
Use hard lead type pencils throughout the second layer.

Head, Wings, and Tail:
1. Darken the black markings and shadows on the head, wings, and tail with Dark Gray, remembering that the darks on the underside of the tail aren't black feathers, but shadows.
2. Begin to bring out the complex shapes on the light parts of the underside of the tail by shading with Cool Gray 70%.

Beak:
1. Build color on the beak by adding Mineral Orange. Carefully preserve the highlights.
2. Deepen the tips and corner with Sienna Brown.

Shading:
To begin the shading on the yellow parts, use Cool Gray 70%. The shadow under the wing is smooth, but for the shadows on the face, chest, and belly, use tiny stokes to build up texture as well as shading.

Legs:
Shade the legs with thin areas of Terra Cotta to make them light and warm in color.

Grasses and Oats:
Shade the grasses and oat husks with Sienna Brown.

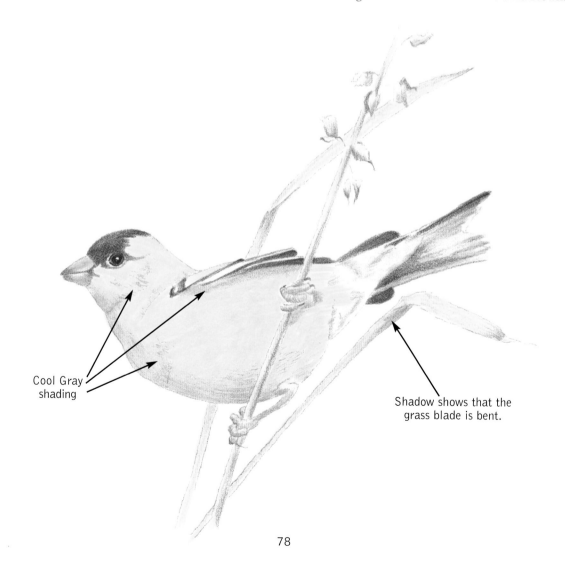

Cool Gray shading

Shadow shows that the grass blade is bent.

THIRD LAYER – Final Detail, Intensity, and Form

Use hard lead type pencils unless noted otherwise.

Head, Wings, and Tail:
Deepen the black markings and tail shadows with Black (soft leaded type), but leave a highlight on the top of the head, and go easy on the underside of the tail.

Beak:
Add a little Rose to the beak to brighten it.

Body:
Apply Golden Yellow (medium lead type) over most of the yellow areas, but leave the major highlights on the top of the neck, top of the wing, shoulder, and cheek untouched. Also, the rear part of the belly is lighter yellow, so do not put much Golden Yellow there.

Shadows:
1. For the deepest shadow areas above the eye and on the chin and chest, lightly apply a little Reddish Orange (medium type). This is a strong color, so go easy.
2. Add more Cool Gray 70% in the shadow areas to finish the form.

Legs:
Add shadows of Sienna Brown on the legs to intensify the contrast between the light and dark areas and better define their forms.

Tail:
1. To warm up the underside of the tail, add a light glaze of Sienna Brown in the darker areas.
2. Add a very small amount of Rose on the lower part of the tail tip.

Wing, Eye, and Beak:
Deepen the shadow under the wing, the shadow behind the eye, and the area between the eye and beak with Sienna Brown.

Grasses:
Deepen the shadows on the grasses where they bend with a little Dark Gray.

Background:
Add a soft background of Cerulean Blue. Concentrate it towards the back of the bird for two reasons. First, this background brings out the white edges of the tip of the tail, the edges of the wing feather tips, and the light fluff at the base of the tail. But also, the asymmetrical background adds to the sense of imminent motion. ❑

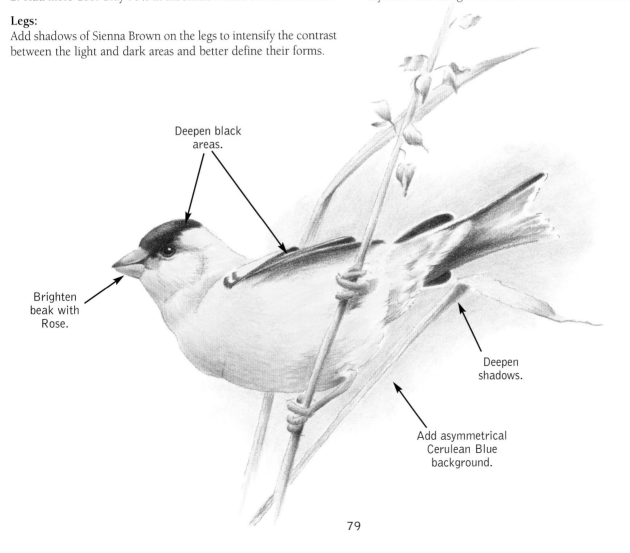

Deepen black areas.

Brighten beak with Rose.

Deepen shadows.

Add asymmetrical Cerulean Blue background.

HUMMINGBIRDS

Hummingbirds are often called "flying jewels," and anyone who has seen these little birds' iridescent plumage reflecting the sunlight knows that this nickname is apt.

Hummingbirds are found only in the Western Hemisphere, but within the hemisphere there are species found nearly everywhere – from Argentina to Alaska, and from California to Nova Scotia. There are nearly 340 species of hummingbirds, making them one of the most diverse of the bird families. A myriad of species are found in South America and the Caribbean, but there are only 23 species within the continental United States.

Besides being incredibly beautiful, hummingbirds are engineering marvels. Their tiny hearts beat 500 times a minute – about five times as fast as ours! In flight, they beat their wings 80 times a second. They use their tails like paddles, steering expertly in three dimensions.

Hummingbirds are fiercely territorial, and their squabbling over position at a feeder is one example of this behavior. I have often wondered how the energy they get from the feeder nectar can possibly make up for the energy they expend bullying each other!

Although the hummingbird's flight is captivating, I most enjoy seeing one at rest. I find the juxtaposition of the long needle beaks and the tiny round bodies and stubby tails purely charming.

Costa's Hummingbird in Mimosa Tree

Instructions begin on page 82

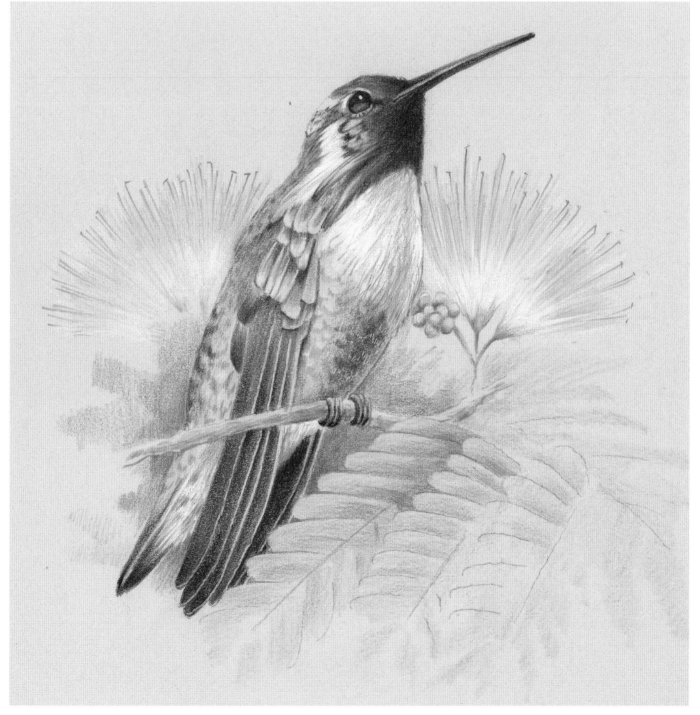

Costa's Hummingbird in Mimosa Tree
Continued from page 81

These beautiful hummingbirds frequently nest in the mimosa tree in my parents' backyard in Arizona where they are welcome visitors.

SUPPLIES

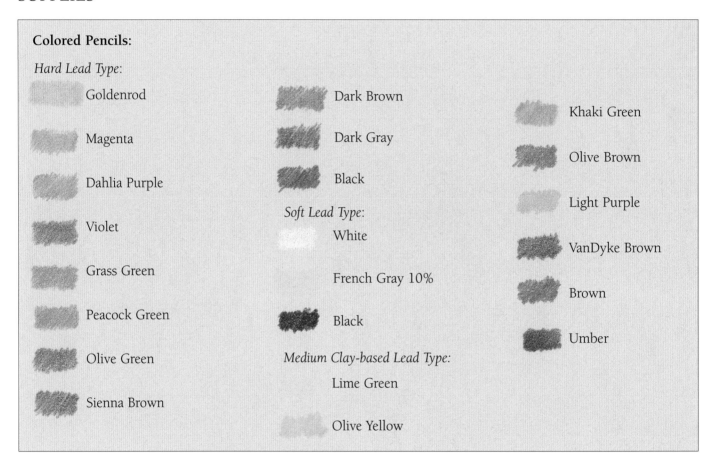

Colored Pencils:

Hard Lead Type:

Goldenrod

Magenta

Dahlia Purple

Violet

Grass Green

Peacock Green

Olive Green

Sienna Brown

Dark Brown

Dark Gray

Black

Soft Lead Type:

White

French Gray 10%

Black

Medium Clay-based Lead Type:

Lime Green

Olive Yellow

Khaki Green

Olive Brown

Light Purple

VanDyke Brown

Brown

Umber

Other Supplies
Drawing paper, fawn
Size 01 black permanent pen
Stylus

> **Tip:** Be sure that the scale of the objects in your drawing is consistent. In my first attempt at this sketch, I made the flowers too small. With small flowers, the hummingbird appeared to be the size of a robin! Enlarging the flowers corrected the problem.
>
> I have decided to use an off-white paper to help emphasize the white markings on this bird's head and chest. Colored papers can be tricky because the color of the paper inevitably shows, at least a little bit, through the pencil. So it is important to choose a paper color that won't compete with the subject. Fawn colored drawing paper is a lovely, warm beige.

FIRST LAYER – Establishing Local Color

Use hard lead type pencils unless noted otherwise.

Eye:
1. With the permanent pen, ink the eye, avoiding the primary and secondary highlights.
2. Fill the secondary highlight with Black pencil.

Beak:
With the permanent pen, ink the center line on the beak.

Incising Marks:
Use the large end of a stylus to incise lines along the forward edges of the long wing feathers.

White Markings:
1. Apply a heavy coat of White (soft lead type) on the chest, lower belly, and rump as well as the cheek patch and a small area behind the eye. Apply heavy pressure and a couple of coats to make the white as opaque as possible.
2. Apply white on the highlight areas of the purple chin and head. This will make the purple brighter when I apply it over the white.

Head:
Using Dahlia Purple, cover the chin, upper cheek, top of the head, and patch behind the eye, but carefully leave the beige of the paper showing above and below the eye. Also leave a small band stretching to the back of the head from the area above the eye.

Neck, Chest, and Back:
1. Color the nape of the neck with Dark Brown.
2. For the lower chest, side, and back, use Olive Yellow (medium lead type) then blend into Olive Brown (medium lead type) at the front of the chest and rear of the back.

Wing, Small Feathers:
1. Color the small center feathers at the top of the wing with Olive Yellow, medium lead type.
2. Use Dark Brown to color the forward feathers.
3. Use Black to draw the rear feathers. Use varying pressure to create shadow areas between and below the brown feathers.

Wing, Long Feathers:
Use medium lead type pencils for all the colors of the long wing feathers in this layer.
1. Use long smooth strokes for the long wing feathers, placing Umber at the bottom, blending to Brown further up.
2. The feathers of the far wing are colored completely Umber.
3. The underside of the tail tip is Umber and the upper side is Brown, blending into the Olive Yellow.

Feet:
Color the feet Black, using heavy pressure for shadows between the toes and along the bottom edges.

Branch:
Treat the branch very simply with an even coat of French Gray 10% (soft type).

Flowers:
1. Form the flowers with sweeping strokes of White (soft lead type), beginning at the base and easing pressure towards the top. The bases should be very white.
2. Add Light Purple (medium lead type) in long back and forth strokes along the tops and sides.

Leaves and Bud:
Add a light glaze of Khaki Green to the leaves and bud.

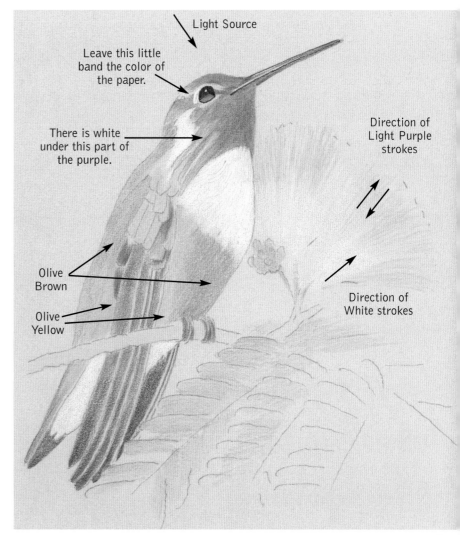

Light Source

Leave this little band the color of the paper.

There is white under this part of the purple.

Direction of Light Purple strokes

Olive Brown

Olive Yellow

Direction of White strokes

Costa's Hummingbird in Mimosa Tree
Continued from page 83

SECOND LAYER – Deepen Color and Build Form
Use hard lead type pencils unless noted otherwise.

Head:
1. Deepen the Black on the beak.
2. Add a heavy coat of Violet over the purple, but carefully avoid the bright highlights.
3. With a very sharp pencil, draw tiny Violet feathers in the purple highlight areas.

Face:
Using Dark Brown, deepen the face at the corners of the eyes. Also, draw the edge of the lower lid, then texture it with tiny dots giving the appearance of minute feathers. Softening the edge of the tiny white patch behind the eye along the edge of the eye indicates the small shadow which sets the eye into the head.

Back, Neck, and Long Wing Feathers:
To warm the color, use Goldenrod to glaze over the brown on the back and neck and also the upper half of the long wing feathers.

Texture:
With heavy Dark Brown and small back and forth strokes, add texture to the back of the neck. Also add feather patches on the back and chest. Use larger, roundish patches over the Olive Brown (medium lead type) and smaller "U" shaped patches over the Olive Yellow leaving more of the bright color showing.

Wings and Tail:
1. On the wings and tail, darken the Umber (medium lead type) areas with Black.
2. Darken the Brown areas with Sienna Brown.

Shadows:
Add shadows of Dark Gray to the lower belly, rump, and upper chest. On the chest, use fine, straight strokes. On the other areas, use a dull lead and random strokes to suggest fluffy feathers.

Feet:
Darken the feet with Black.

Branch:
1. Add a rough shadow area to the branch with Dark Gray.
2. With a very sharp Dark Gray lead, lightly outline the bottom of the branch.
3. Add a little White (soft type) along the top edge for a highlight.

Flowers:
Add more flowers behind the bird to balance the composition, following instructions for the flower in the first layer. Proceed with the flowers by adding strokes of Magenta. Use a very sharp pencil and pull strokes from top to bottom, easing the pressure as you go. This gives a stroke that is darker at the top, and lighter and tapering at the bottom. End the strokes above the base of the flowers, leaving white patches at the bottoms.

Flower Details:
1. To detail the bud, add White (soft type) to the highlight areas.
2. Deepen the shadows with Olive Brown (medium type).
3. Also use Olive Brown at the base of the flowers and for their stems.

Foliage:
1. Develop the foliage by adding Grass Green shadows and Lime Green highlights to delineate the leaflets.
2. Add Grass Green around and behind the bird in random texture. Notice that there is no foliage above the flowers!

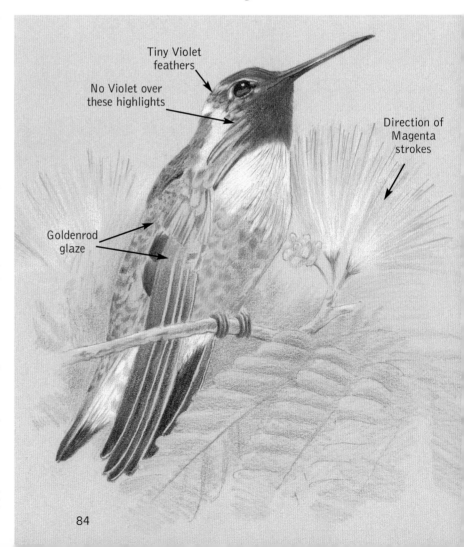

Tiny Violet feathers

No Violet over these highlights

Direction of Magenta strokes

Goldenrod glaze

THIRD LAYER – Final Detail, Intensity, and Form

Use hard lead type pencils unless noted otherwise.

Deepen Shadows:
1. Use Black (soft lead type) over the deep shadow areas of the purple.
2. Also use Black to deepen the beak, the tips of the wing feathers, the wing feathers on the far wing, and the underside of the base of the tail.

Wing Feathers:
With a very sharp pencil point and Sienna Brown, deepen the incised lines along the front edges of the wing feathers.

Texture and Details:
With VanDyke Brown, add a little dark texture along the edge of the lower back. Also deepen the front of the lower chest, but leave slightly lighter areas at the front edge. Add a narrow shadow on the chest in front of the wing, and add shadows to differentiate the small feathers on the upper wing. Use VanDyke Brown also to deepen the lower tip of the upper side of the tail.

White Areas:
Using Dark Gray and light pressure, add more texture and shadows to the white areas to round the forms.

Feet:
Further darken the feet with Black.

Branch:
Using Sienna Brown, add more texture and color to the lower portions of the branch and add small shadows on the branch around the feet.

Flowers:
1. Add a light glaze of Magenta over the top portion of the flowers.
2. Develop the bases and buds with shadows of Dark Gray.

Foliage:
Deepen the shadow areas of the foliage with Peacock Green, then Olive Green over the Peacock. ❑

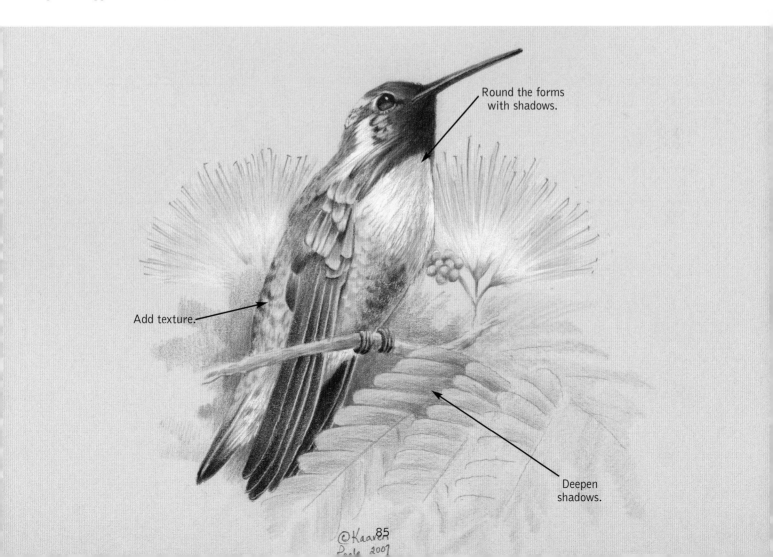

Round the forms with shadows.

Add texture.

Deepen shadows.

©Kaaren
Poole 2007

Rufous Resting

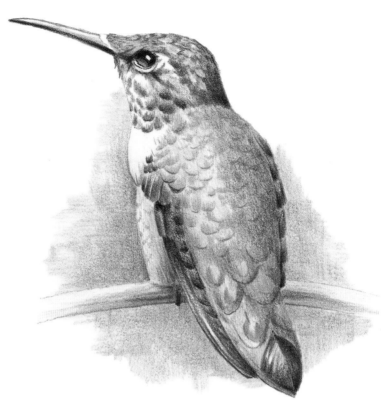

I always enjoy seeing a hummingbird at rest – it gives me a really good look at him – and this one is simply too cute to resist. Portraying iridescence is a challenge! It requires paying very close attention to tiny areas of color. Layer colors to achieve the rich beauty of this bird's plumage.

SUPPLIES

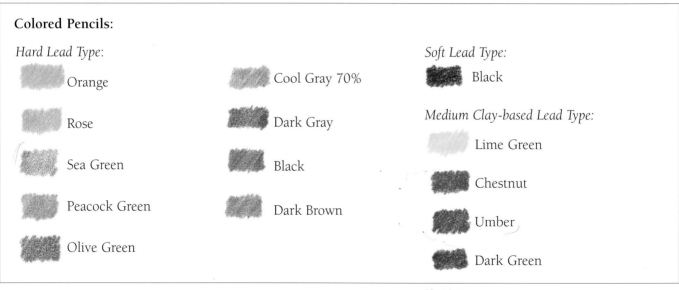

Colored Pencils:

Hard Lead Type:

Orange

Rose

Sea Green

Peacock Green

Olive Green

Cool Gray 70%

Dark Gray

Black

Dark Brown

Soft Lead Type:

Black

Medium Clay-based Lead Type:

Lime Green

Chestnut

Umber

Dark Green

Other Supplies
Drawing paper, white
Size 01 black permanent pen

Layered Colors:

 Orange over Chestnut over Rose

 Lime Green over Peacock Green over Sea Green

FIRST LAYER – Establishing Local Color

Use hard lead type pencils throughout this layer.

Eye:
1. Use the permanent pen to ink the eye. The hummingbird's eye is comparatively large, and the shape is distinct – relatively flat across the top. Outline a primary highlight.
2. Fill the eye with ink, avoiding the primary highlight and leaving a large secondary highlight at the bottom.
3. Fill the secondary highlight area with Black pencil, darkening the color next to the ink for a smooth transition.
4. Ink a line underneath the eye, from "4 o'clock" to "7 o'clock."

Beak:
With a very sharp Black pencil, carefully outline the beak then darken a thicker line along the lower edge. It is important to leave a highlight along the upper part.

Head and Neck:
1. Draw a few tiny spots of Peacock Green on the top and back of the head.
2. Switching to Dark Brown, add color to the back, top, and forehead. At the base of the neck, the color is dark and fairly even. Working upward and forward, switch to short criss-cross strokes so that some white shows through, and carefully avoid placing brown over the green spots.

Black Markings:
With the Black pencil and a light touch, add the markings on the chin and in front of and beneath the eye. Carefully leave a white area between the pencil and ink beneath the eye.

Wing Feathers and Tail:
Continuing with the Black pencil, draw the wing feathers and tip of the tail, leaving plenty of highlights.

Rose Markings:
Lightly glaze the belly with Rose. There is also a small Rose feather at the base of the neck. The lower tail feathers are Rose. Use heavy pressure on the right half of these feathers for a deeper tone, careful to draw around the spots in their centers.

Stem:
Glaze the stem Rose, shading slightly darker along the lower edge.

Back and Tail Feathers:
1. Draw the back feathers and spots on the lower tail feathers Sea Green. Keep it light.
2. With Cool Gray 70%, draw curved feather tips over the back. Each curve is a tiny series of up and down strokes placed side by side. Leave an area in the center untouched.

Foot:
Draw the foot with Black.

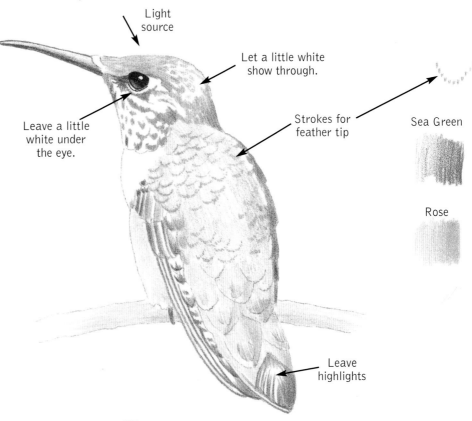

Light source

Let a little white show through.

Leave a little white under the eye.

Strokes for feather tip

Sea Green

Rose

Leave highlights

Rufous Resting

Continued from page 87

SECOND LAYER – Deepen Color and Build Form

Use hard lead type pencils unless noted otherwise.

Beak:
Add Cool Gray 70% to most of the highlight on the beak, but leave white towards the tip.

Head and Neck:
1. Deepen the brown area on the head by adding Umber (medium lead type) in the same manner as the Dark Brown in the first layer.
2. Deepen the nape of the neck with Dark Gray.
3. Add very light Umber to enlarge the spots on the rear of the cheek.
4. Intensify the chin spots with heavy Dark Gray.

Black Markings:
With Dark Gray, deepen the black areas on the wings and tail tip, but still leave white highlights.

Rose Markings:
Glaze Chestnut (medium lead type) over the rose areas of the bird. On the belly, apply it heavily at the right (shadow) side, and very lightly on the highlight side. Then add a few curved feather tips. On the rose neck feather, the Chestnut is darker at the bottom. For the tail feathers, the color is darkest at the right and lower edges. As before, avoid getting this color in the spots.

Back:
On the back, lightly glaze Peacock Green over the Sea Green, keeping the color very light in these highlight areas. In the highlight areas, add small irregular patches of light Peacock Green, and also add a few curved feather tips here and there.

Tail Feathers:
Add Peacock Green to the spots on the lower tail feathers, having high contrast between areas within the spots, especially on the left (highlight) side.

Shading the Back:
Shade the right (shadow) side of the back by glazing it with Dark Gray.

Breast Shadow:
Add a small shadow of Cool Gray 70% at the lower edge of the white breast to curve it inwards.

Branch:
Add "ribs" to the branch with Rose and heavy pressure.

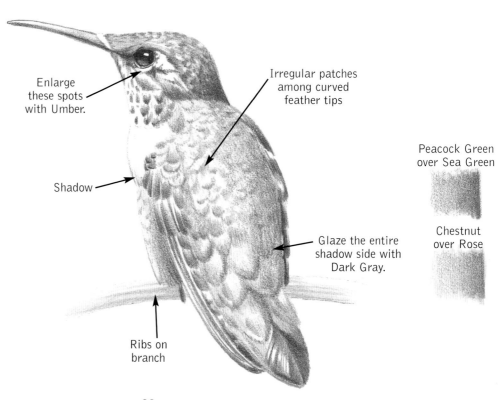

Enlarge these spots with Umber.

Irregular patches among curved feather tips

Shadow

Glaze the entire shadow side with Dark Gray.

Ribs on branch

Peacock Green over Sea Green

Chestnut over Rose

THIRD LAYER – Final Detail, Intensity, and Form

Use hard lead type pencils unless noted otherwise.

Deepen Black Areas:
With the soft lead type Black pencil, deepen the lower edge of the beak and darken some of the spots on the chin and cheek. Also darken the shadow areas on the wing feathers and tail tip, still preserving the light highlights.

Head and Neck:
1. On the head, further deepen the nape of the neck, then add more texture to the top and forehead with a very sharp Umber (medium lead type) pencil.
2. Enlarge the spots on the right side of the cheek with Umber.
3. Shade the same area by glazing over it with Cool Gray 70%.

Rose Markings:
1. Lightly glaze the Rose/Chestnut areas with Orange. This is a very bright color, so add it slowly until satisfied.
2. Deepen the shadow areas on the tail feathers by adding more Chestnut, and outline their edges with a very sharp pencil point.

Green Markings:
1. Glaze over the green feathers on the head, highlight side of the back, and spots on the lower tail feathers with Lime Green. This really brightens it up!
2. Shade the right (shadow) side of the back with layers of Peacock Green and Cool Gray until it is dark enough.
3. Add a little Dark Green (medium lead type) in the darkest areas.

Stem:
Shade the stem, especially on the shadow side, with Olive Green.

Foot:
Darken the foot with Black (soft lead type).

Stem Shadow:
Add a Dark Gray shadow underneath the belly on the stem.

Background:
To bring out the light color of the chest and right side of the belly, add a graduated background of Olive Green. ❏

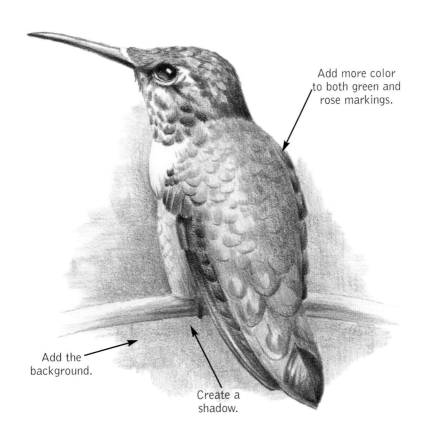

Add more color to both green and rose markings.

Add the background.

Create a shadow.

Ruby Throated Hummingbird

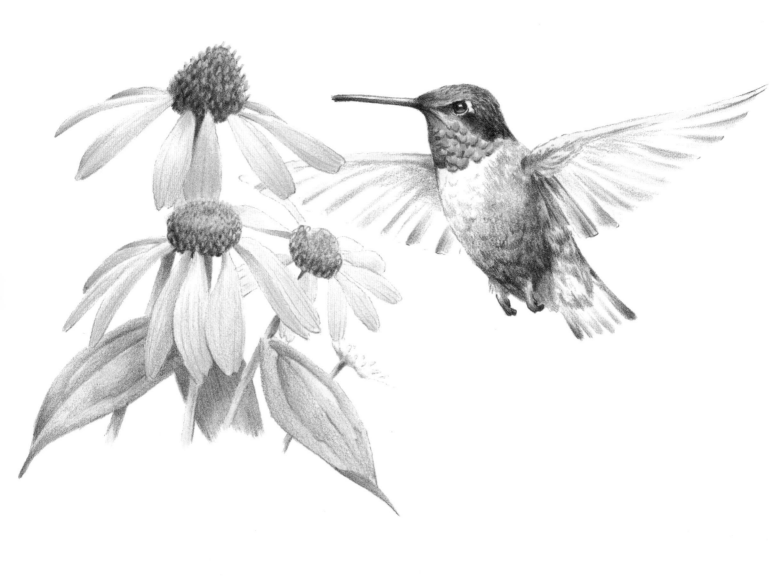

SUPPLIES

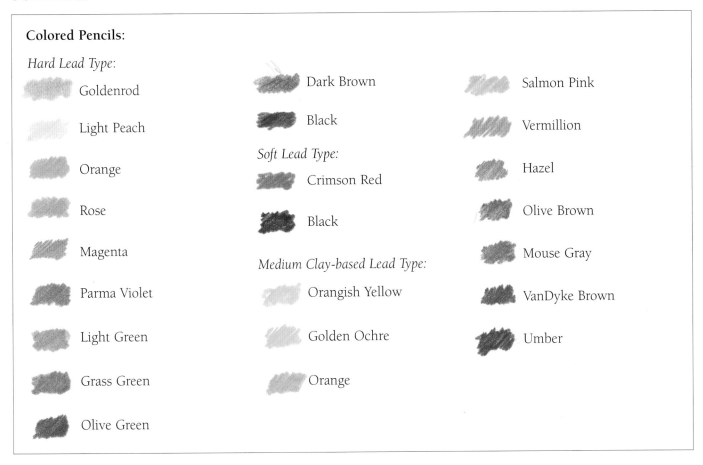

Colored Pencils:

Hard Lead Type:

- Goldenrod
- Light Peach
- Orange
- Rose
- Magenta
- Parma Violet
- Light Green
- Grass Green
- Olive Green

- Dark Brown
- Black

Soft Lead Type:

- Crimson Red
- Black

Medium Clay-based Lead Type:

- Orangish Yellow
- Golden Ochre
- Orange

- Salmon Pink
- Vermillion
- Hazel
- Olive Brown
- Mouse Gray
- VanDyke Brown
- Umber

Other Supplies

Drawing paper, white

Size 01 black permanent pen

It amazes me that hummingbirds can get enough sustenance from flower nectar to compensate for all the energy they expend. Coneflowers are among their favorite entrees!

FIRST LAYER – Establishing Local Color

Use hard lead type pencils throughout the first layer.

Eye:
1. With the permanent pen, ink the eye. Outline the eye and primary highlight.
2. Fill the eye with ink, but leave a large secondary highlight at the bottom of the eye.
3. Fill the secondary highlight area with Black pencil.

Beak:
1. Ink a line along the bottom edge of the beak.
2. Draw a thin Black pencil line along the upper edge of the beak.
3. Soften the upper edge of the ink line with Black colored pencil.

Feet:
1. Outline the feet with ink.
2. Fill the feet with Black pencil but leave highlights.

Markings:
1. The patches in front of the eye and on the cheek is Dark Brown.
2. Use Rose to color the chin as well as the little triangle at the base of the tail.
3. On the chin, outline the edges of small, curving feathers with Dark Brown, and shade the chin directly under the beak.

Head, Neck, and Body:
Glaze the upper part of the head, the neck, the top edges of the wing, and the right side of the body with Goldenrod. This is the highlight color. On subsequent layers you will darken around the highlights.

Continued on next page

FIRST LAYER – Establishing Local Color
Use hard lead type pencils throughout the first layer.

Body and Chest:
1. The lower part of the body is darker and is also in shadow. Draw it with Dark Brown, lightening the pressure as you move upward to make a smooth transition to the white of the chest.
2. On the upper chest, draw the lower edges of a few small, curved feathers with Dark Brown.

Wing and Tail Feathers:
Continuing with the Dark Brown, suggest the wing and tail feathers with strokes moving from the tip of the feathers upwards, decreasing pressure as you go.

Cone Flowers:
The centers of the cone-flowers are quite dark, but are covered with bright orange spikes.
1. For this first layer, simply color the centers Orange.
2. The petals are quite light. Color the petals with Rose. Keep the application light except in the shadow areas.

Leaves:
The leaves are close to a true green. For this first layer use Light Green. By varying the pressure on the pencil, create the highlights and shadows resulting from the deep veining of the leaves.

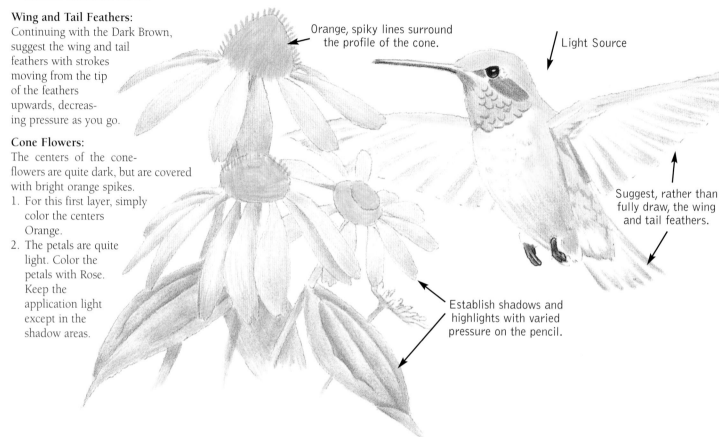

Orange, spiky lines surround the profile of the cone.

Light Source

Suggest, rather than fully draw, the wing and tail feathers.

Establish shadows and highlights with varied pressure on the pencil.

SECOND LAYER – Deepen Color and Build Form
Use hard lead type pencils unless noted otherwise.

Head:
1. Deepen the cheek patch and small triangle at the front of the eye with Umber (medium lead type).
2. With a sharp pencil, draw the texture on the head with Hazel.
3. Add shadows at the base of the neck and where the head meets the beak with Hazel.

Chin:
1. Glaze over the chin with Magenta.
2. Shade the left side with Umber (medium lead type).

Body:
1. To develop the form of the body, begin at the bottom with Umber (medium lead type). Above that, transition into Hazel (medium lead type).

2. Draw the lower edges of chest feathers with a series of tiny upwards strokes using Umber over the Hazel area and a little Hazel into the white area.
3. The area at the base of the tail is pinkish brown rather than pink, so glaze over the Rose with Hazel.

Wings and Tail:
1. Add a little texture on the fleshy part of the wing and the upper tail with Umber (medium lead type).
2. Deepen the tips of the tail feathers and some of the wing feathers with Umber.

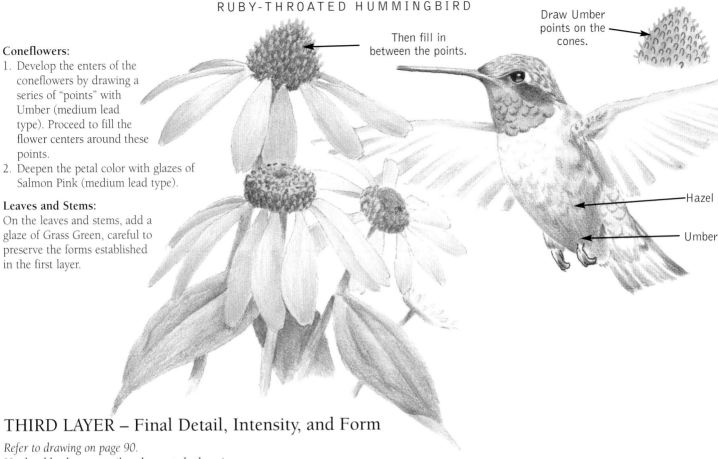

Then fill in between the points.

Draw Umber points on the cones.

Hazel

Umber

Coneflowers:
1. Develop the enters of the coneflowers by drawing a series of "points" with Umber (medium lead type). Proceed to fill the flower centers around these points.
2. Deepen the petal color with glazes of Salmon Pink (medium lead type).

Leaves and Stems:
On the leaves and stems, add a glaze of Grass Green, careful to preserve the forms established in the first layer.

THIRD LAYER – Final Detail, Intensity, and Form

Refer to drawing on page 90.
Use hard lead type pencils unless noted otherwise.

Beak:
Deepen the beak with Black (soft lead type) but carefully leave a highlight along the upper edge.

Head, Neck, and Chin:
The head has many colors and a lot of texture.
1. Deepen the cheek patch with Black (soft lead type), but still preserve some variation of value within the area.
2. Add color to the top of the head and neck. Use Orangish Yellow (medium lead type) and Golden Ochre (medium lead type) on the front and top.
3. Use Hazel (medium lead type) to color the remainder.
4. Create texture on the top and front with Hazel.
5. Add texture along the back with Black (soft lead type).
6. Deepen the triangle in front of the eye and the shadow on the chin with Black.

Chin:
1. For the ruby throat, shade the bottom edges of the feathers with Crimson Red (soft lead type).
2. Deepen the shadow at the left edge with Umber (medium lead type) and Black (soft lead type).

Back and Wing:
1. Add Golden Ochre to the right side of the back and the upper side of the wing.
2. Add texture with Umber (medium lead type).

Body:
Use medium lead type pencils on the body in this layer, except where noted.
1. The body needs value contrast. Accordingly, use Black (soft lead type) and Umber along the lower parts .

2. Color with VanDyke Brown in the middle area.
3. To complete the transition to the white of the chest, use Mouse Gray.
4. With these same colors, emphasize the edges of the small chest feathers, adding texture.
5. Add texture to the base of the tail and the fleshy part of the wing with Umber and Hazel.
6. Shade the white areas with Mouse Gray.

Wings and Tail:
The following colors refer to medium lead type pencils.
1. Emphasize the tips of some of the wing and tail feathers with Umber and Hazel.
2. On some of the feathers, add a very light glaze of Olive Brown.

Coneflower Centers:
The following colors refer to medium lead type pencils.
1. In the flower centers, deepen the lower portions of the background color with Umber.
2. Glaze over the upper portions with Orangish Yellow in the highlight areas.
3. Glaze with Orange in the mid-tone areas.
4. Glaze with Vermillion in the shadows.

Coneflower Petals:
1. Draw the veins in the petal with a very sharp Magenta pencil.
2. Deepen the darkest shadows with Crimson Red (soft lead type).
3. Lightly glaze over some areas with Parma Violet to cool the petals.

Leaves:
On the leaves, add a little Olive Green in the shadow areas. ❑

BLUEBIRDS

Bluebirds are in the thrush family, and are related to robins. There are three species of bluebirds in the United States. All of the bluebirds are most colorful in flight when the glorious wing feathers are fully visible. Fledglings have speckled breasts and very little color.

*1) **The Eastern Bluebird** has a blue head, back, wings, and tail and a lovely peach chest fading to cream at the rump. The female has the same basic coloring, but is somewhat duller.*

*2) **The Western Bluebird** is very similar to his eastern cousin, but the peach of the breast extends over the shoulders.*

*3) **The Mountain Bluebird** is all blue – deep blue on the head, wings, back, and tail, and pale blue on the chest. The female is gray with pale blue feathers on the wings and tail.*

In the early and mid twentieth century, our bluebird population was severely threatened – reduced by 90% in many areas! Bluebirds nest in cavities, so environmental changes severely threatened their existence. As forests were cleared, urban areas pruned, and rural wooden fence posts were replaced with modern metal ones, nesting sites were removed or destroyed and the bird population suffered.

Several associations formed to address this problem, notably the North American Bluebird Society. They mounted a public education campaign, encouraging the provision of artificial nesting spots. In response, millions of "bluebird houses" were erected all across the country. The Society recommended "trails" of houses where several would be mounted along fences about 100 yards apart. The bluebirds responded enthusiastically, and today they are relatively common visitors in open farmlands, woodlands, and backyards.

Despite their impressive come-back, they still face fierce competition for nesting sites, particularly from Starlings and Wrens. They nest fairly early in the season, and have two broods a year. Often, a youngster from the first brood will help feed the babies from the second brood.

I have several bluebird houses on my property. The bluebirds occupy about half of them, with green and violet swallows in the remainder. They are most welcome!

Male Bluebird & Apple Blossoms

Instructions begin on page 96

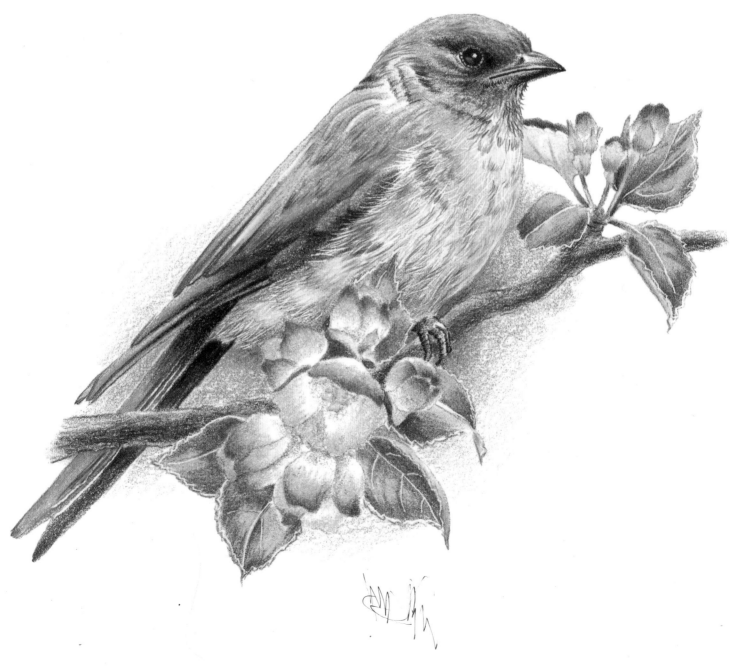

Male Bluebird & Apple Blossoms
Continued from page 95

SUPPLIES

Colored Pencils:

Soft Lead Type:

Pumpkin Orange

Salmon Pink

Yellow Orange

Jasmine

Cream

Beige

Raspberry

Pink

French Grey 50%

White

Cold Grey Dark

Black

Dark Green

Kelly Green

Celadon Green

Jade Green

Limepeel

Pale Sage

Indigo Blue

Terra Cotta

Ultramarine

Denim Blue

Blue Lake

Blue Slate

Hard Lead Type:

Black

Dark Umber

Dark Gray

Other Supplies:
Vellum Finish Drawing Paper, white
Size 01 black permanent pen
Colorless Blender
Stylus

This drawing is a lesson in Nature's palette. Ordinarily, I wouldn't pair the warm oranges of the bird's breast with the cool pinks of the blossoms, but, somehow, Nature's palette always seems to work!

FIRST LAYER – Establishing Local Color

Eye:
1. Use the micron pen to outline the eye and the tiny primary highlight.
2. Fill the top portion of the eye with ink, avoiding the primary highlight and leaving a large secondary highlight at the bottom.
3. Ink a tiny row of circles around the eye, portraying the minute feathers that surround the eye.
4. Fill the secondary highlight with Black (hard lead pencil). The pencil is lighter than the ink and the effect gives a transparent looking eye.

Beak:
1. With the micron pen, draw the line separating the upper and lower beaks.
2. Color in the beak with Black (hard lead type pencil), using heavy pressure on the lower part and lighter pressure on the upper part. As you work, leave tiny highlight lines on both sides of the ink line between the upper and lower beaks.
3. Draw the nostril with a Black comma shape, with the tail sweeping down and to the left.

96

Incising Marks:

1. With the small end of the stylus, incise gently curving texture strokes over the top and front of the chest.
2. Incise gently curving strokes from the left edge of the chest over the right edge of the wing.
3. Incise the veins and outer edges of the leaves.

Head:

1. Use tiny strokes of Blue Slate on the crown and back of the head, leaving little bits of white showing between the strokes for texture.
2. Heavily mottle the lower cheek with small strokes of Blue Slate.
3. Make a Black area between the eye and beak to set the eye into the head.
4. Add lines of tiny Cold Grey Dark strokes to define the shadows of rings under the eye and running back from the back corner of the eye.
5. Draw the shadows in folds of plumage at the base of the neck with Cold Grey Dark.

Back, Wing, Upper Tail:

1. Glaze the back, wing, and upper tail with Blue Slate, but leave small areas on the shoulder the white of the paper.
2. Shade same areas with Indigo.
3. Color in the under side of the tail with French Gray 50%.
4. Brighten the tips of the tail feathers with a little Pumpkin Orange.

Chest:

1. Use soft colors to color in the first layer of the chest. Add a glaze of Cream over the entire area, then add Beige along the front, Salmon Pink in the orangish areas, and along the "folds" on the lower body.
2. Shade the bottom of the belly above the visible foot with French Gray 50%.

Foot:

Begin to define the foot by shading it with Black.

Leaves & Flowers:

1. Glaze the leaves with Kelly Green on the under sides and Pale Sage on the upper sides. As you work, the edges and veins of the leaves stay white because of the earlier incising.
2. Draw the stems and calyxes of the buds with Kelly Green.
3. To begin the flowers, add Pink to the petals except for the small areas at their bases.
4. Tip the petals with Raspberry.
5. Blend the Raspberry into the Pink with a Colorless Blender.

Branch:

Begin the branch with a layer of Terra Cotta, varying the pressure on pencil for shadows and highlights.

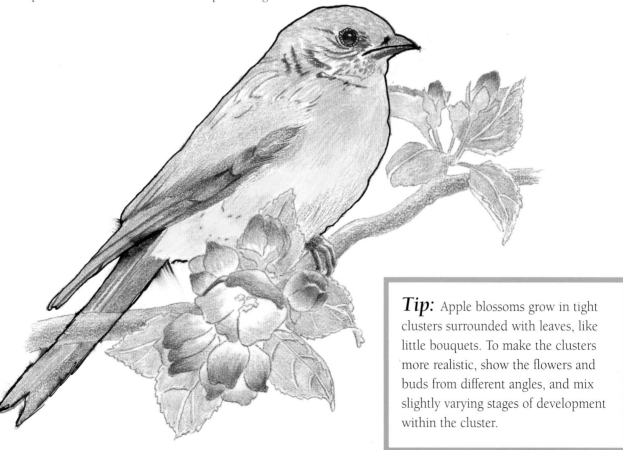

Tip: Apple blossoms grow in tight clusters surrounded with leaves, like little bouquets. To make the clusters more realistic, show the flowers and buds from different angles, and mix slightly varying stages of development within the cluster.

Male Bluebird & Apple Blossoms
Continued from page 97

SECOND LAYER – Deepen Color and Build Form

Head, Wing, Tail:
1. Glaze over the blue areas with Blue Lake.
2. Add texture strokes of heavily applied Blue Lake on the head and upper wing.
3. Deepen the shadow areas with Denim Blue and brighten them with Ultramarine.
4. Apply a heavy glaze of Denim Blue to deepen the underside of the tail.

Chest:
1. Brighten the chest by applying more Salmon Pink.
2. Add texture on the chest and chin with tiny strokes of Dark Umber (hard lead type) and Dark Gray (hard lead type).

Beak:
Brighten the beak by adding a touch of Yellow Orange over the white highlights left on either side of the center ink line.

Branch:
Add shadows of Cold Grey Dark, but leave a thin area along the lower edge untouched - this is the "reflected light."

Leaves & Flowers:
1. Use Dark Green to deepen the upper sides of the leaves
2. Use Celadon to deepen the lower sides. As I add the color I vary the pressure on my pencil to create shadows and highlights.
3. Add a little more Raspberry on the darkest tips of the flowers.
4. In the single open flower, add Jasmine stamens (the ring of dots) and a Pale Sage pistil (the central staff that eventually becomes the apple!).

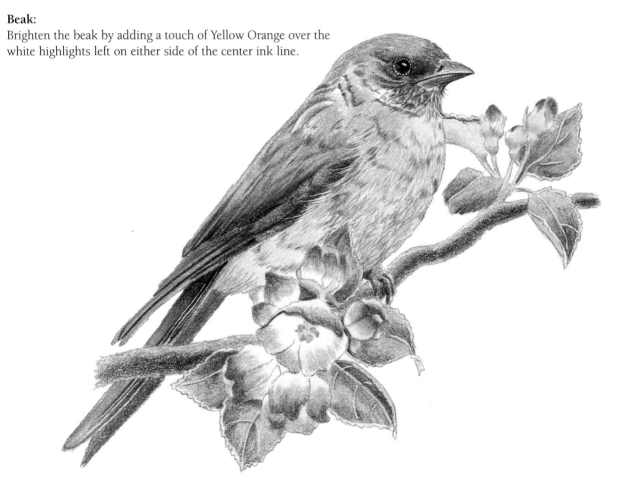

THIRD LAYER – Final Detail, Intensity, and Form

Bird's Feathers:

1. Striving for more value contrast, dramatically deepen the shadows on the blue plumage with Cold Grey Dark.
2. With a very sharp point on the Black (hard lead type) pencil, add more texture strokes to the chin, chest, and body, clustering these strokes to suggest tufts of small feathers.
3. Shade the bottom of the chest with a light glaze of Dark Gray (hard type).
4. Brighten the orange areas with a little Pumpkin Orange.

Leaves & Flowers:

1. The leaves should be brighter, so glaze the upper sides with Limepeel.
2. Further intensify the tips of the petals with more Raspberry.
3. Shade the lighter portions with a very light application of Dark Gray (hard lead type) to define their forms.

Deepen Shadows:

1. Deepen the shadow on the branch with French Grey 70%.
2. To better integrate the bird and branch, first glaze the lightest possible touch of Pumpkin Orange randomly over the pink parts of the flowers.
3. Add a little Jade Green in the background between the bird and branch and below the branch, leaves, and flowers.

Highlights:

1. Lighten a few highlights with White where needed.
2. Use the White pencil on the front of the chest and crown of the head. ❑

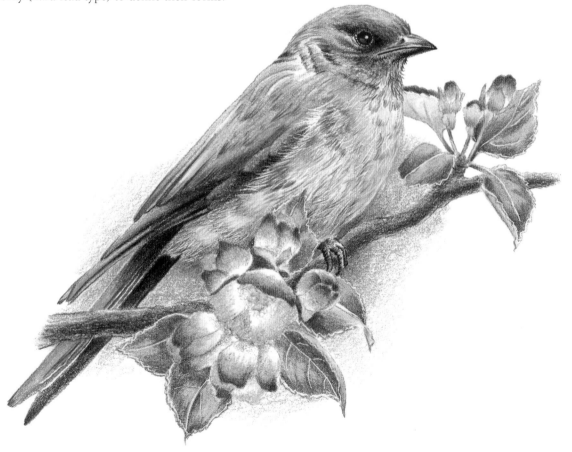

A Loving Dad

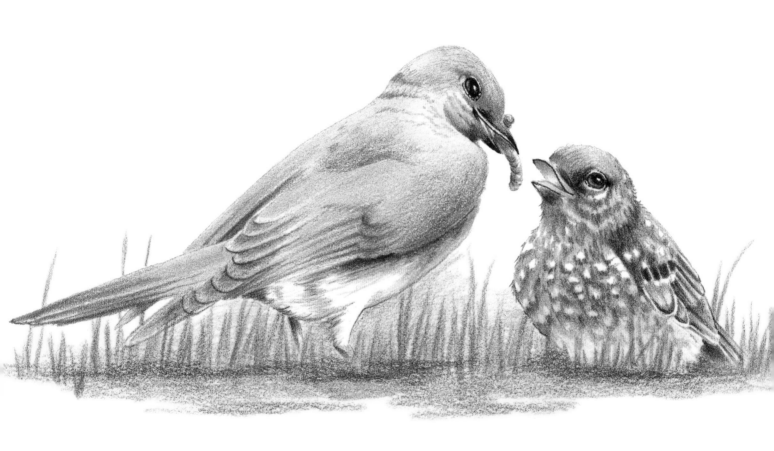

Bluebirds are attentive moms and dads, and if they live close to you, this tender scene will be a familiar sight. Visually, I like the contrast between the dad's smooth colorful plumage, and the baby's fluffy, drab plumage.

SUPPLIES

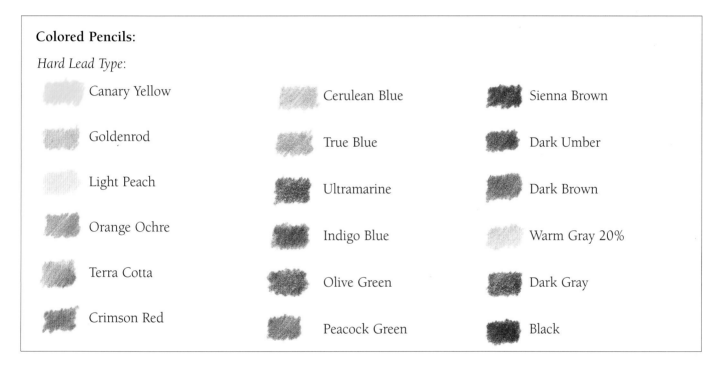

Colored Pencils:

Hard Lead Type:

Canary Yellow	Cerulean Blue	Sienna Brown
Goldenrod	True Blue	Dark Umber
Light Peach	Ultramarine	Dark Brown
Orange Ochre	Indigo Blue	Warm Gray 20%
Terra Cotta	Olive Green	Dark Gray
Crimson Red	Peacock Green	Black

Other Supplies

Drawing paper, white

Size 01 black permanent pen

FIRST LAYER – Establishing Local Color

See drawing on page 102.

Eyes:
1. With the permanent pen, outline the eyes and a tiny highlight in the pupil.
2. Fill the dark sides of each pupil with ink – the right 2/3 for the adult and the upper 2/3 for the baby – leaving the highlight untouched.
3. With a Black pencil, fill the left third of the adult's eye and the lower third of the baby's eye. By using very heavy pressure next to the ink and lighter pressure elsewhere, smooth the transition between the pencil and the ink.

Beak:
1. Use the permanent pen to outline the lower edge of the upper beak on both birds.
2. Fill in the beaks with Black, leaving a highlight along the edges of the upper and lower halves.

Male Bird:
1. Use a light layer of Cerulean Blue on the head, back, wing, and tail, leaving white highlights on the shoulder and the edges of the large wing feathers.

Continued on page 102

A Loving Dad
Continued from page 101

FIRST LAYER – Establishing Local Color

2. Use a darker color, Ultramarine, for the shadows.
3. On the chest and chin, use Orange Ochre, fading into Light Peach at the boundary between the blue and orange on the chin.
4. Leave the lower part of the body the white of the paper, then add a few texture strokes of Warm Gray 20%.

Worm:
Use Terra Cotta on the worm, but leave a white highlight along the right edge and at the upper tip.

Baby Bird:
1. On the baby's beak, add lines of Canary Yellow at the edges.
2. Shade the remainder of the beak with Black.

3. Apply Goldenrod lightly to the inside of the upper beak.
4. Apply Cerulean Blue to the blue patches on the lower wing feathers and the top tail feather.
5. Use Dark Brown for the head and wings, using heavier or lighter pressure to establish the shadows and shapes.

Baby Bird's Spots:
The goal on the chest is simply to lay the foundation of the spots. The shoulder and upper chest are dark with white spots whereas the lower part of the body is white with dark spots. To portray this, use Dark Umber to outline spots on the shoulder and upper chest and to fill spots on the lower body. Then fill in around the spots on the upper portion.

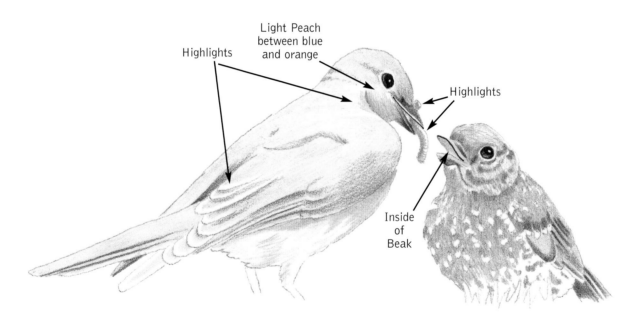

Highlights

Light Peach between blue and orange

Highlights

Inside of Beak

SECOND LAYER – Deepen Color and Build Form

Male Bird Blue Areas:
1. Begin by intensifying the blues on the adult. Add Indigo Blue in the deepest shadows along the lower part of the far wing, above the beak, behind and above the eye, in the creases on the back of the neck, and along the lower portion of the shoulder.
2. Deepen the remainder of the blue area with a light layer of Ultramarine, but leave the brightest highlight areas untouched.
3. Add Sienna Brown to the tips of the long wing feathers.

Male Bird Remaining Areas:
1. Deepen the shadow areas of the orange markings with Terra Cotta.
2. Add thin Sienna Brown shadows directly under the wing and along the front of the chin. To add a little texture to the chin, draw several tiny Sienna Brown strokes.
3. Shade the legs with Sienna Brown.
4. Add a Sienna Brown glaze to the tips of the long wing feathers.

Worm:
A little Crimson Red in the shadow areas makes the worm even more tempting.

Baby Bird Dark Areas:
1. On the baby, darken the corner of the mouth with Terra Cotta. Add Terra Cotta to the tip of the underside of the upper beak.
2. Add a little Sienna Brown at the very tip of the beak.
3. Deepen the Black shading on the beak and add a little Black behind the eye, in the center of the tiny upper wing feathers, and to the deep shadow areas between the wing feathers.

Baby Bird Blue Markings:
1. Intensify the blue on the wing feathers and upper side of the tail feather with Ultramarine.
2. Shade the lower side of the tail and under the beak with Indigo Blue.

Baby Bird Shading:
On the head, use Sienna Brown to deepen the shadows and intensify the markings on the cheek and back of the neck. Also add a Sienna Brown shadow on the shoulder underneath the neck.

Baby Bird Chest:
1. On the baby's chest, add dark patches of Sienna Brown underneath the white patches.
2. With Warm Gray 20%, smooth the transition between the upper and lower parts of the chest.

Grass:
Sketch in the grass with Olive Green. First use horizontal strokes to establish the "ground," then pull vertical strokes from the ground upwards for the individual blades of grass.

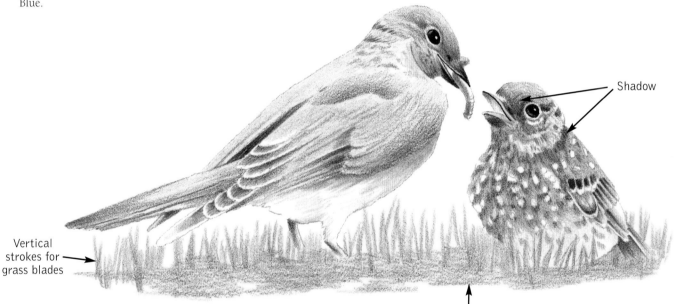

Shadow

Vertical strokes for grass blades

Horizontal strokes for mass of grass

THIRD LAYER – Final Detail, Intensity, and Form

See drawing on page 100

Male Bird Blue Areas:
1. Brighten the blue areas of the adult with a glaze of True Blue.
2. Further deepen the shadows with more Indigo Blue.

Male Bird Remaining Areas:
1. Deepen the shadows on the chin and body of the adult with Sienna Brown.
2. Use Dark Brown along the rear edge of the rump and upper leg to shade the white areas, then deepen the shadows on the legs.

Worm:
Deepen the shadows on the worm with Dark Brown.

Baby Bird:
1. Further deepen the colors on the baby by deepening the shadows and markings on the head and wing with darker Sienna Brown.
2. Glaze a little Light Peach on the light areas of the cheek.
3. Intensify the blues on the wing with a little True Blue.
4. Add Dark Gray markings and shadows to the chest.

Grass:
1. To finish the grass, add shadows under the birds with Dark Gray.
2. Make additional grass strokes with Peacock Green.

Background:
Glaze between the lower portions of the birds and beneath the adult's tail with Peacock Green. This glaze sets off the white plumage on the adult's chest, rump, and leg. ❑

Bluebird Pair
Continued from page 104

FIRST LAYER – Establishing Local Color

Her Eye:
1. Outline her eye with the pen.
2. Fill it with ink except for a tiny highlight dot and a large secondary highlight in the lower right.
3. With Black pencil. outline her eye with a row of tiny dots.
4. Fill the secondary highlight with Black pencil.

His Beak:
1. Use Black for the dark corners and under side as well as for the nostril dots.
2. Lightly shade the sides of the top with Blue Lake.

His Blue Markings:
1. Fill the blue markings with Blue Lake.
2. Shade the markings with Indigo Blue, leaving highlights of the white paper.

His Chest:
The chest is light at the bottom, so leave that area untouched.
1. Glaze the upper chest with Pumpkin Orange in the darker orange areas.
2. Glaze with Mineral Orange in the lighter ones.
3. Begin to build the rounded form by shading with French Gray 10% for the lightest shadows, French Gray 30% for the mid-tone shadows, and Lt. Umber in the darker areas.

His Feet:
Outline his feet with the permanent pen.

Birdhouse:
Darken the birdhouse opening with Indigo Blue to establish a deep tone behind the female's face.

Incising Marks:
Use the stylus to incise lines on the edges of her wing and tail feathers.

Her Face and Beak:
1. Draw her beak with Black, leaving a large highlight on the upper edge.
2. Use Sandbar Brown for her crown, neck, and cheek, varying the pressure for shadows and highlights. Carefully leave white highlights underneath her eye and on her forehead.
3. Deepen the curved line directly under her eye with Dark Brown.
4. The stripe angling downwards from the corner of her beak is Dark Brown, with Mineral Orange on either side.
5. There is also a small spot of Mineral Orange above the forward portion of her eye.

Her Back:
The coloring on her back is subtle.
1. Apply a light application on the upper right portion of Mineral Orange.

2. Glaze the remainder of her back with Blue Lake.
3. Shade the "V" between the wings with Indigo Blue.
4. To dull the color, add a light glaze of Light Ochre over the areas above both wings.

Her Wings:
1. Glaze the outer feathers of both wings with Blue Lake.
2. Shade between the feathers with thin lines of Indigo Blue.
3. The remaining wing feathers are Light Umber. Leave white edges and deepen shadow areas where one feather overlaps another.

Her Tail Feathers:
1. Draw the overall feathers in the same way as the wing feathers, but use Blue Lake and Indigo for the shadows.
2. Tip the feathers with Light Ochre.

Wood Grain:
The wood looks more complicated than it actually is, however, it will take some time. The key is to place all the pencil strokes parallel to the grain of the wood.
Use Sienna Brown for the grain and work with long strokes parallel to the edge of the wood. Notice how the grain is angled along the top to follow the angled edge. Use long strokes back and forth and move slightly left or right randomly. In some places, draw an isolated pointy oval patch, then add grain lines that curve around it. Work the roof, side edge of roof, and front in this manner.

Birdhouse Side and Roof Edge:
The right side of the birdhouse is in shadow, so use a dark tone of Sienna Brown and do not worry about the grain texture. The front edge of the roof is the end grain of the wood. Portray it with a series of tiny, closely set rings of Sienna Brown.

Birdhouse Front:
1. The front of the birdhouse is in medium light, so add more color by glazing the entire surface with Flesh.
2. Add a shadow of Sienna Brown under the roof overhang.
3. The edge of the hole is also Sienna Brown, very dark at the top where it is in shadow, blending smoothly to a lighter color on the side.

Birdhouse Screw Heads:
Outline the screw heads and notches with French Gray 10%.

Leaves:
Use Kelly Green on the upper sides of the leaves and Jade Green on the undersides. Work the leaves with long smooth strokes radiating from the point where the stem meets the leaf. Leave the veins the white of the paper and create shadows and highlights by varying the pressure on the pencil. Leaving a few white highlights makes the leaves appear shiny.

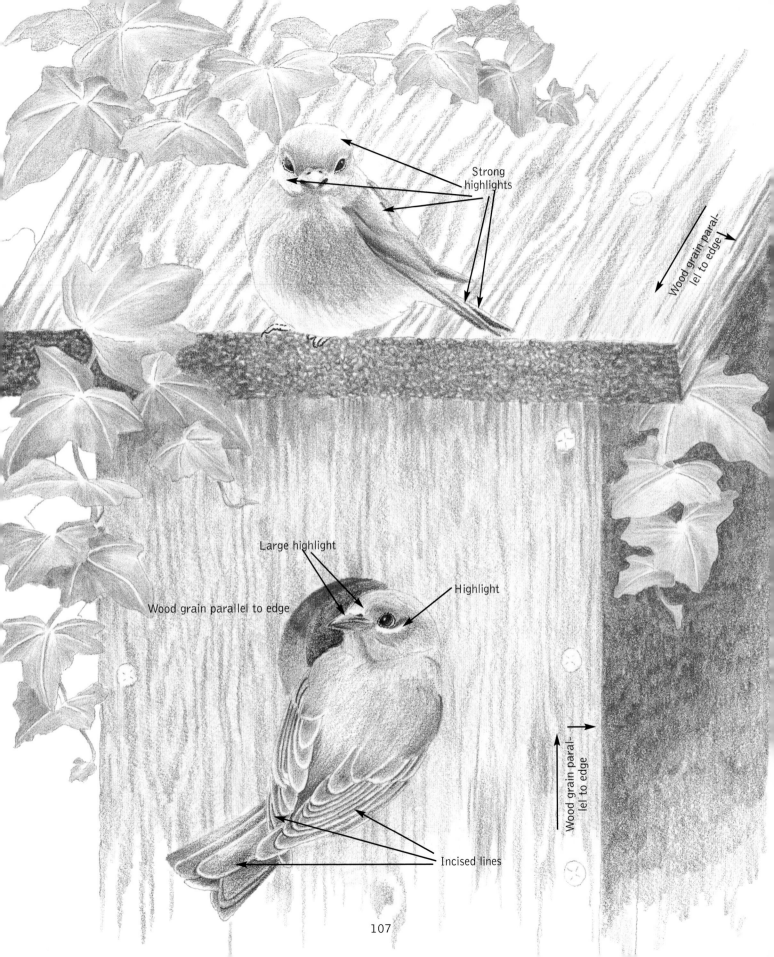

Strong
highlights

Wood grain paral-
lel to edge

Large highlight

Highlight

Wood grain parallel to edge

Wood grain paral-
lel to edge

Incised lines

107

Bluebird Pair
Continued from page 107

SECOND LAYER – Deepen Color and Build Form

Male Bird:
1. Intensify the blue markings on the male bird with Ultramarine Blue.
2. Intensify the orange part of the chest with Pumpkin Orange.
3. Deepen the shadows with Dark Brown and French Gray 90%.

Female Bird:
Using the same colors as in the first layer, deepen the colors and shadows on the female. Brighten the orange areas with Pumpkin Orange and darken the shadows with French Gray 90%.

Shadows on the Wood:
Create shadows under the male, under the roof overhang, and under and behind the leaves with French Gray 90%.

Leaves:
Add a second layer to the leaves with Dark Green, deepening the shadows to help distinguish the leaves from each other.

THIRD LAYER – Final Detail, Intensity, and Form
Refer to finished drawing on page 105.

Intensify Colors:
1. Working with the same colors as in the second layer, deepen the colors on the birds, increasing the value range.
2. In the deepest shadows, use a little Dark Brown to darken the shadow.
3. Add a light shadow to the lower edge of the male by glazing with French Gray 10%.
4. Further deepen the shadow under him with Black.

Her Shadow and Shading:
Add a shadow behind the female with French Gray 90% and Dark Brown. Also shade the right side of the entire bird to round her form.

Leaves:
1. Brighten the leaves with glazes of Marine Green in the shadow and mid-tone areas.
2. Use Limepeel to brighten the highlight areas of the upper sides of the leaves.

3. Deepen the undersides of the leaves with French Gray 10% and Jade Green.

Birdhouse:
1. On the wood, further deepen the shadows with Dark Umber.
2. With Sienna Brown, randomly darken the wood grain here and there, then wash the front of the birdhouse with Sand.

Birdhouse Entrance:
1. To further emphasize the female bird's face, darken the hole behind her with Black.
2. Color the wood edge of the hole with Dark Umber.

Background:
Add a suggestion of sky along the left side of the birdhouse with Cloud Blue. ❑

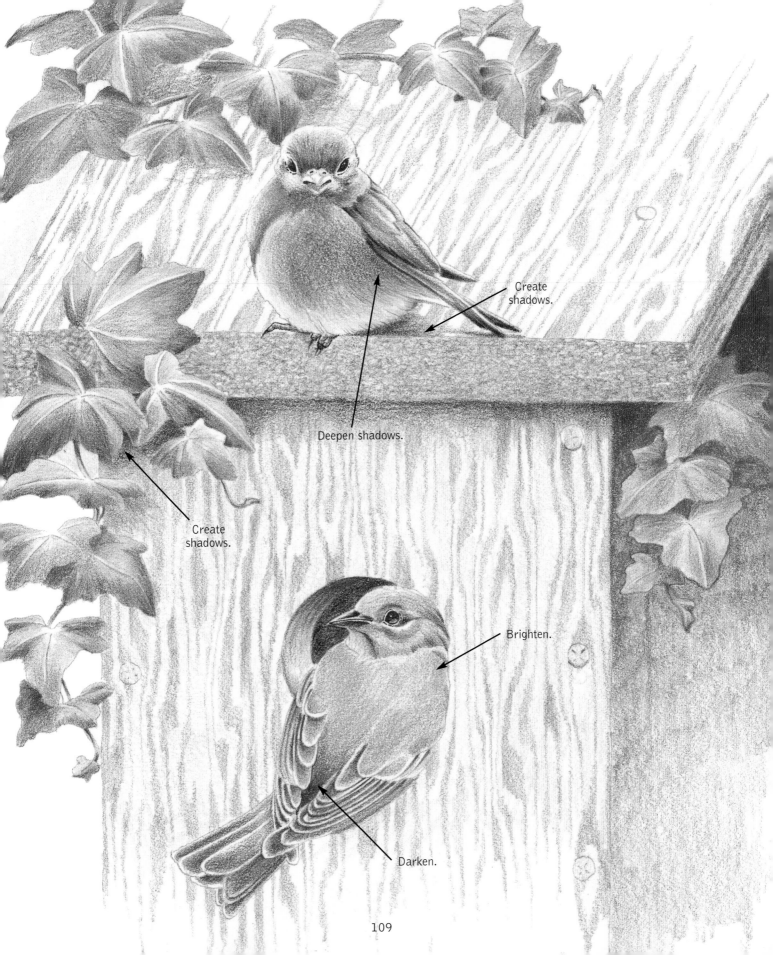

Create
shadows.

Deepen shadows.

Create
shadows.

Brighten.

Darken.

109

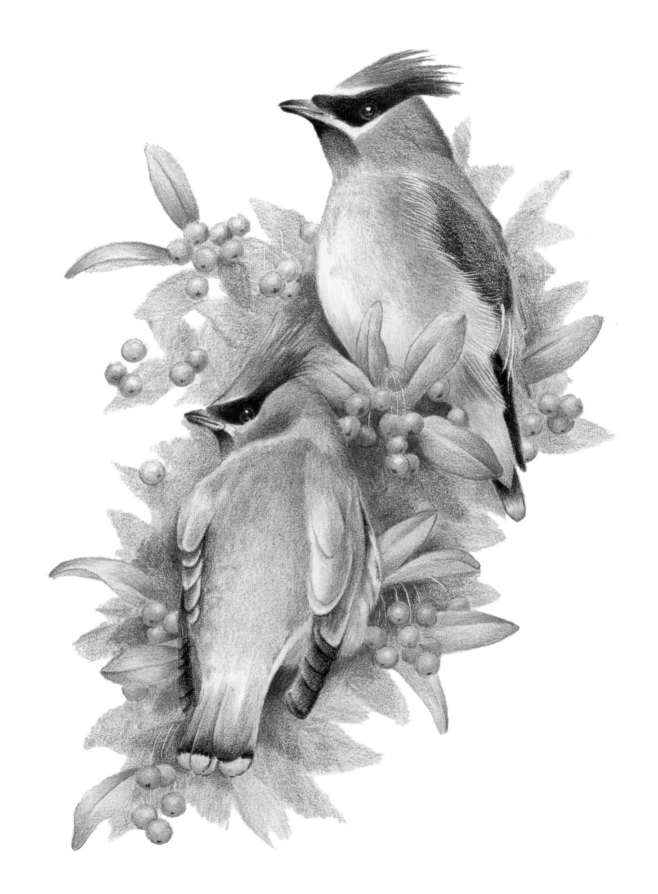

Cedar Waxwings

How well I remember these beautiful birds from my childhood in Ohio. What attracted me most to them was their smooth plumage. Every fall, flocks of Cedar Waxwing would vie for the abundant pyracantha berry crop.

> ***Tip:*** Use contrast to emphasize a key feature of the birds. The plumage of these birds is so smooth! To emphasize this unique feature, I created a rough uneven texture in the background pyracantha.

SUPPLIES

Colored Pencils:

Hard Lead Type:

Goldenrod
Terra Cotta
Olive Green
Peacock Green
Dark Brown
Warm Gray 20%
Cool Gray 70%
Black
Dark Gray

Soft Lead Type:

White
Cool Dark Gray
Black

Medium Lead Type:

Primrose Yellow
Burnt Sienna
Deep Vermillion
Light Ochre

Medium Clay-based Lead Type:

Orangish Yellow
Golden Yellow

Reddish Orange
Green Ochre
Khaki Green
Olive Brown
Moss Green
Empire Green
Mahogany
Cinnamon
Brownish Orange
Umber
Mouse Gray

Other Supplies

Drawing paper – cream, Size 01 black permanent pen, Stylus

FIRST LAYER – Establishing Local Color

Use medium lead type pencils unless noted otherwise.

Eyes:
The irises show very slightly.
1. With the permanent pen, outline the pupils, the primary highlight, and the entire eye.
2. Fill the pupil with ink, avoiding the highlight.
3. The iris is Dark Brown (hard lead type).

Mask and Beaks:
1. Fill the masks with Black (hard lead type).
2. Also use Black for the beaks, but leave areas for the highlights.

Continued on page 112

Cedar Waxwings
Continued from page 111

FIRST LAYER – Establishing Local Color
Use medium lead type pencils unless noted otherwise.

Heads:
1. Because of the off-white paper, lighten the white areas on the faces with White (soft lead type).
2. Use Terra Cotta (hard lead type) on the foreheads, then switch to Dark Brown (hard lead type) as you work back towards the crest. Be careful to achieve a smooth transition between the two colors.
3. Use the same colors on the cheeks and back of the necks.

Incising Marks:
1. On the top bird, use the small tip of a stylus to incise several curving lines across the line that divides the breast from the side and wing.
2. Also incise a series of lines along the dark areas of the upper part of the tail, and use the large tip to incise three strong lines curving from the edge of the gray part of the wing over the dark part.

Top Bird's Chest:
The top bird's chest is a smooth gradation of color. Use a very light coat of Light Ochre on the upper chest, leave the paper showing for the highlight, and Primrose Yellow on the lower belly.

Top Bird's Wing and Tail:
1. The gray feathers on the upper wing are not distinguishable from each other. Glaze them with Cool Gray 70% (hard lead type), smoothly transitioning to Dark Brown (hard lead type) on the back and to Dark Gray (hard lead type) on the lower part of this first section of the wing.
2. Color the gray portion below it and to the right with Cool Gray 70%.
3. For the low section of the wing as well as for the lower portion of the tail, use Black (hard lead type).
4. Add Orangish Yellow at the tail tip.

Bottom Bird's Wing, Back, and Tail:
1. Work the wings, back, and tail of the bottom bird with Warm Gray 20% (hard lead type) in the highlight areas, Cool Gray 70% (hard lead type) in the midtone areas, and Dark Gray (hard lead type) in the shadows and on the dark wing feathers and lower tail feathers.
2. Color the tail tips with Orangish Yellow.

Waxwings:
Cedar Waxwings are named for the red waxy-appearing points on the feathers. Use a very sharp pointed pencil of Deep Vermillion to create them.

Leaves:
1. For the leaves, use Khaki Green on the upper sides and Olive Brown on the lower sides.
2. Sketch in the berries with Light Ochre.

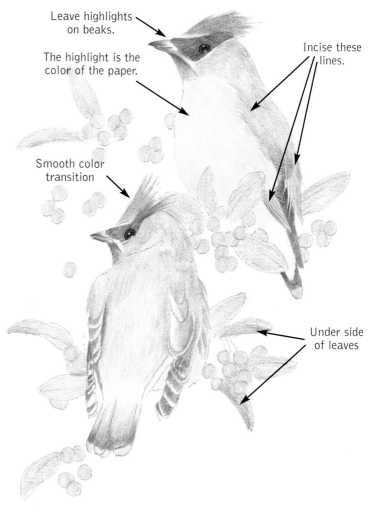

Leave highlights on beaks.

The highlight is the color of the paper.

Incise these lines.

Smooth color transition

Under side of leaves

SECOND LAYER - DEEPEN COLOR AND BUILD FORM

Use medium lead type pencils unless noted otherwise.

Heads:
1. To deepen the color on the face, use Dark Gray (hard lead type) over the mask, beak, and chin.
2. With a light glaze of Goldenrod (hard lead type), brighten the light areas immediately above and below the mask.
3. Blend in Mahogany where you placed the Dark Brown in the first layer.

Top Bird's Chest:
1. On the top bird, deepen the darker areas of the chest with a light glaze of Cinnamon.
2. Darken the Primrose Yellow at the bottom.

Top Bird's Wing and Tail:
1. To deepen the back and upper portion of the wing, use a light glaze of Umber.
2. Deepen the dark areas of the lower wing and tail with Dark Gray (hard lead type).
3. Glaze Dark Brown (hard lead type) over the yellow at the base of the tail.

Bottom Bird's Wing, Back, and Tail:
1. On the bottom bird, deepen the upper back and upper wing feathers with glazes of Cool Gray 70% (hard lead type).
2. Deepen the shadow areas, the dark wing feathers, and lower tail feathers with Dark Gray (hard lead type).
3. To add color to the lower back, add a light glaze of Cinnamon.

Leaves:
Deepen the leaves with Moss Green (upper side) and Green Ochre (lower side). Working with the moss green, create shadows and central veins by varying the pressure on the pencil.

Berries:
Shade the berries with Burnt Sienna. To shade the berries, apply the color heavily around the bottom, more lightly around the top, and not at all over the highlight.

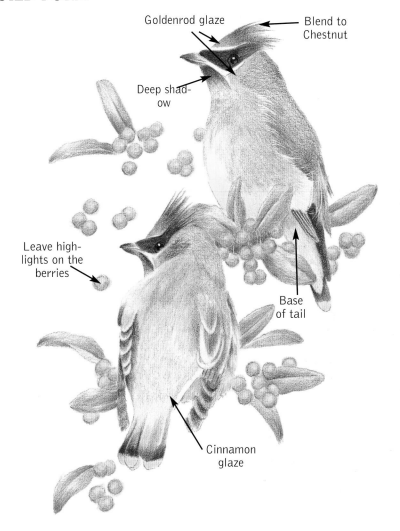

Goldenrod glaze

Blend to Chestnut

Deep shadow

Leave highlights on the berries

Base of tail

Cinnamon glaze

THIRD LAYER – Final Detail, Intensity, and Form

Refer to finished drawing on page 110.

Note: This third layer looks quite different from the second layer one, but you will do very little new here. Working one area at a time (the top bird, the bottom bird, then the background), use the same colors as in the second layer, darkening them in the shadow areas to better define the forms.

Additional Colors:
In addition to the second layer colors, add the following:
1. Black (soft lead type) and Cool Dark Gray (soft lead type) in the darkest black and dark gray areas;
2. Brownish Orange on the cheek and right side of the chest of the top bird and on the forehead, back of the neck, and very lightly on the lower back of the bottom bird;
3. Mouse Gray on the light wing feathers and upper portion of the tail feathers of the bottom bird;
4. Golden Yellow on the tail tips of both birds.

Shadows:
To "push back" the light areas that are in shadow, such as the underside of the top bird's tail or the body of the bottom bird showing along the right edge and beneath the tail, glaze with Dark Brown (hard lead type).

Background:
Fill in around the leaves, birds, and berries with Olive Green (hard lead type), varying the deepness of color, and suggesting leaf shapes around the edges.

Leaves:
1. Brighten the upper sides of the leaves with Empire Green.
2. Lightly outline them with very thin lines of Peacock Green (hard lead type).

Berries:
1. To vary the colors from berry to berry, shade some with Golden Yellow, others with Reddish Orange, and others with more Burnt Sienna. In general, the forward berries in a cluster are brighter than the rear ones.
2. For the berries tilting towards the viewer, add a tiny Dark Brown (hard lead type) dot on the end. ❏

Cactus Wren

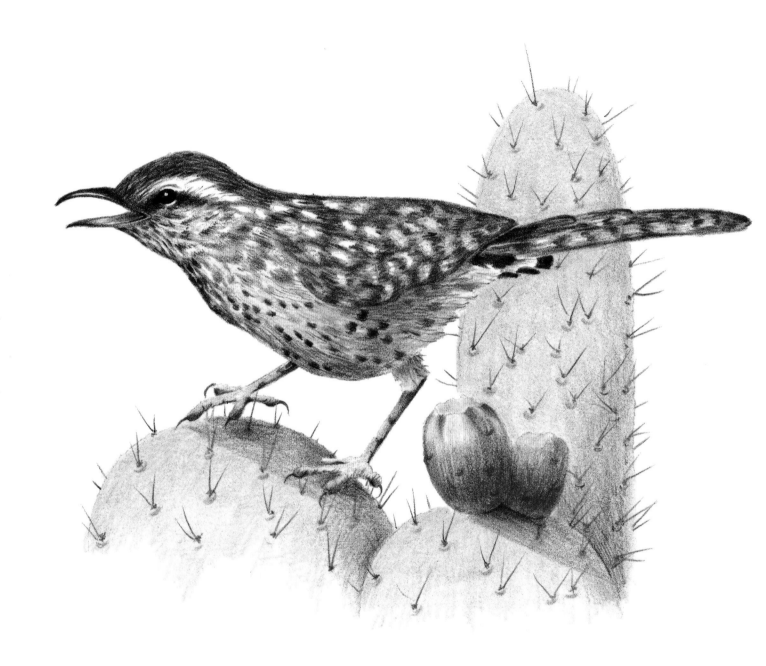

My parents retired to Arizona and when I visited them, I enjoyed seeing the Cactus Wrens in their garden. These are lively, loud birds that show a lot of personality in their stances. Amazingly, they often perch atop the spines of cactus. The one in this drawing is a prickly pear, but they will alight on cactus that seem nothing but thorns. They must have very tough feet!

SUPPLIES

Colored Pencils:

Hard Lead Type:

Goldenrod

Orange

Terra Cotta

Tuscan Red

Light Green

Warm Gray 20%

Cool Gray 70%

Dark Gray

Dark Brown

Black

Medium Lead Type:

Chocolate

Medium Clay-based Type:

Lime Green

Moss Green

Dark Green

Beige

Brownish Beige

Burnt Sienna

Russet

Brown

Black

Other Supplies
Drawing paper, white
Size 01 black permanent pen

Tip: Pay attention to detail. It is the small details that add believability. With all the thorns, the bird does no perch on the cactus itself, but on its thorns. The bird appears to be floating slightly above the cactus. Stretch color to integrate your drawing. The cactus fruit is actually more purple than I have shown it. However, I used many of the same colors on the fruit as on the wren's belly (but in different proportions) to integrate the elements of the drawing.

Continued from page 115

FIRST LAYER – Establishing Local Color
Use hard lead type pencils throughout the first layer.

Eye:
Begin by outlining and filling the eye with the permanent pen, carefully leaving a white highlight dot.

Beak:
1. Outline the top part of the beak with a very sharp Black pencil, then fill it, but leave a white highlight all along the lower edge.
2. Draw the lower edge of the lower beak with Black, but use Cool Gray 70% at the tip and along the upper edge.
3. Since the beak is open, fill the bottom beak with a light application of Tuscan Red.

Speckles:
The speckles on this bird are pretty complex, but work in layers to build the color and texture as you go.
1. For this first layer, use Dark Brown on the head, wing and back, tail, throat, and upper chest. Carefully leave the white patches untouched.
2. Add Black at the base of the tail to differentiate it from the wing.
3. Additionally, there are small feathers on the underside of the tail base that are tipped with Black.

Underside:
1. Lightly glaze the breast, belly, underside of the tail, and upper part of the right leg with Goldenrod.

2. Add Orange over the side and upper part of the leg.
3. Using Dark Brown, draw the patches over the Goldenrod and Orange. Most are fairly round, but the ones at the side of the throat are quarter-moon shaped.

Legs and Feet:
Use Dark Brown for the legs and feet, applying heavier pressure in the shadow areas for a darker tone. Note that the feet seem to float above the cactus. This is because the bird is actually perched on the thorns!

Cactus:
Lightly glaze the cactus Light Green.

Cactus Fruit:
1. Use Terra Cotta on the fruit, sweeping the strokes from the base to the tip and curving them to suggest the roundness of the form. Work with heavy pressure at the bottom to begin the shadows, and use light pressure for the highlights. Small darker areas at the top suggest a scalloped edge.
2. The open top of the larger fruit is Goldenrod.

This shadow separates the wing from the tail.

Quarter moon shaped patches

The feet seem to float above the cactus because they are actually resting on the thorns.

Direction of strokes on the fruit

SECOND LAYER – Deepen Color and Build Form

Use hard lead type pencils throughout the second layer.

Beak:
Use a Dark Gray pencil to deepen the darks on the beak and add a shadow in the corner of the open mouth.

Head, Wing, Back, Tail, and Throat:
With Dark Gray, apply texture strokes over the Dark Brown areas of the head, wing, back, tail, and throat. These are small, slightly criss-crossed strokes going generally in the direction the feathers grow, leaving some of the Dark Brown showing through, giving more variation to the plumage.

Shading and Shadows:
1. Use Dark Gray to add more patches to the throat and shade the bottom of the chest and belly. Also, darken the shadows on the legs and feet and add a little texture to indicate the horny plates.
2. Add the claws with a very sharp Dark Gray pencil.

Cactus:
1. Dull the color of the cactus with a glaze of Warm Gray 20%.
2. Add random, small splotches of Dark Brown on the spots where the thorns will grow.

Cactus Fruit:
To deepen the fruit, add a layer of Tuscan Red, continuing the shading and highlighting of the first layer.

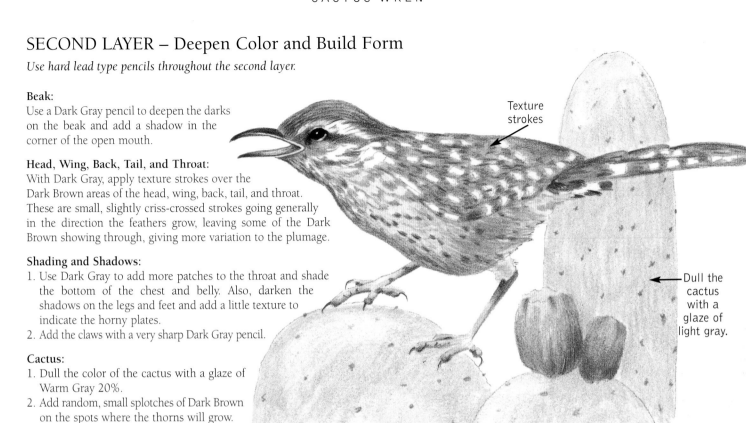

Texture strokes

Dull the cactus with a glaze of light gray.

THIRD LAYER – Final Detail, Intensity, and Form

Refer to finished drawing on page 114.
Use medium lead type pencils throughout the third layer.

Beak:
1. Deepen the top beak and the tip of the lower one with Black.
2. Add a little Russet to the inside of the mouth, working darkest in the corner.

Eye:
Use Black at the corners of the eye to set them into the head, careful to preserve the highlight on the lower lid.

Head, Wing, Back, Tail, and Throat:
1. On the head, wing, back, tail, throat, and upper chest, add texture strokes of Chocolate.
2. Color in a little Brown on the lower edge of the tail, crown of the head, and randomly on the tail.

Shading:
Deepen the rusty areas of the body with Russet, Burnt Sienna, then a little Brown in the darkest areas.

Legs and Feet:
On the legs and feet, deepen the shadows with Chocolate.

Cactus:
The cactus are flat paddle shapes so they do not need a lot of shading and highlighting.
1. Add a light glaze of Lime Green on the highlight areas (the upper left on each "leaf").
2. Glaze the shadows on the right sides Beige.
3. Add a glaze of Moss Green over the Beige.
4. Create the deepest shadows with Dark Green.

Cactus Fruit:
1. Deepen the forms of the fruit with Burnt Sienna, and pull pairs of thorns from each splotch on the cactus. Also add thorns around the edge of the cactus (those that would originate from splotches just on the other side and out of sight).
2. As a finishing touch, add tiny curved shadows under the splotches with Moss Green in the highlight and mid-tone areas and Dark Green in the deepest shadow areas.

Shadows:
The desert sun casts harsh shadows. Draw the shadows of the fruit and bird with Brownish Beige then add Chocolate to the deepest shadows between and directly under the fruit and under the feet. Because the cactus are shaped like flat paddles, the shadows do not curve much. ❑

Chickadee

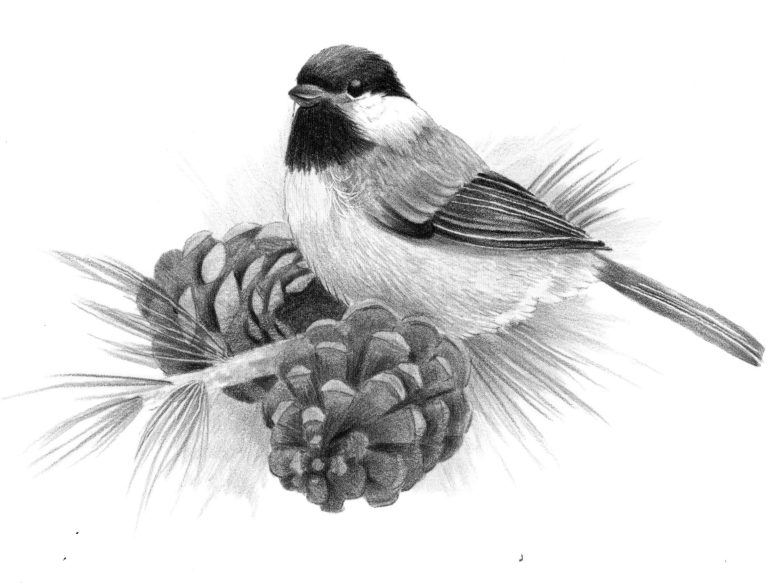

Chickadees have a large fan club. Their markings are distinctive and they display such a bright attitude. They are often found around pine trees, so I decided to place my bird on a pair of pine cones. Pine cones seem like pretty complex structures, but they are basically egg shapes with the "petals" coming from a central "spine." To simplify drawing them, I focus on the value changes to suggest their forms.

SUPPLIES

Colored Pencils:

Hard Lead Type:

Goldenrod

Terra Cotta

Olive Green

Peacock Green

Cool Gray 70%

Dark Gray

Dark Brown

Black

Medium Clay-based Lead Type:

Light Ochre

Cinnamon

Brown Ochre

Mouse Gray

Bluish Gray

Umber

Black

Other Supplies

Drawing paper, white
Size 01 black permanent pen
Stylus

Continued from page 119

FIRST LAYER – Establishing Local Color

Use hard lead type pencils unless noted otherwise.

Eye:
Begin by inking the eye with the permanent pen. After outlining it, fill the lower half with ink, then fill the remainder with Black pencil.

Beak:
Draw the beak with Black, careful to leave highlight areas as the highlights are what makes the beak appear hard and shiny.

Black Markings:
The crown, and chin are all Black. On the crown and chin, work tiny close strokes in the direction the feathers grow. Most of this area will end up deep black, but in this lighter layer establish light areas that will later become subtle highlights.

Incising Marks:
1. Use the large end of a stylus to incise lines along the feather edges on the wing.
2. Incise a few lines along the tail.
3. Use the small end of the stylus and incise a few curved fluff lines at the upper right edge of the chest.

Wing:
1. Fill the wing with long smooth strokes of Black parallel to the incised lines. The incised lines now appear as white.
2. Fill the feathers on the upper part of the wing with Cool Gray 70%, except for the forward one which is Black. Use varying pressure to shade between the gray feathers.

Back and Shoulder:
Use small criss-cross strokes of Cool Gray 70% to create texture on the back and shoulder.

Tail:
For the tail, use long strokes of Cool Gray 70%, bringing out the lines incised earlier.

Cheek:
1. To begin to form the cheek, add a few shading strokes of Terra Cotta along the lower edge and also create a small curve beneath and behind the eye.
2. Use a little Black under the eye to define the lower lid.

Underside:
Glaze the chest, belly, and underside of the tail with a light application of Goldenrod.

Incising Pine Needles:
Some of the pine needles cross in front of the rear pine cone. Since green will not show over brown, use the stylus to incise the lines for the needles. They will stay white while you work the cones, then you can add green to them later for the needles.

Branch:
Draw the branch with Cool Gray 70%. Its texture is rough, so use short, uneven strokes.

Pine Cones:
The tips of the pine cone "petals" are a light glaze of Dark Brown and the rest of the cones are Cinnamon (medium lead type). To accomplish this, first lightly glaze Dark Brown over the entire cones, then draw around the tips of the "petals" with Cinnamon.

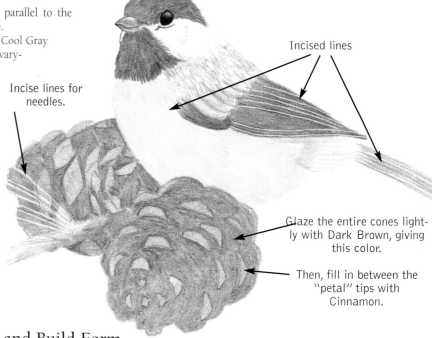

Incise lines for needles.

Incised lines

Glaze the entire cones lightly with Dark Brown, giving this color.

Then, fill in between the "petal" tips with Cinnamon.

SECOND LAYER – Deepen Color and Build Form

Use hard lead type pencils throughout the second layer.

Black Markings and Beak:
Deepen the black areas on the bird with Dark Gray. Work the crown and chin as before, and darken the beak, still leaving highlights. After deepening the single black feather in the upper row of wing feathers, darken the lower wing feathers.

Lower Wing:
In the first layer, there is a large section of the lower wing colored solid Black. In this second layer, work this same section in long smooth strokes, leaving some of the first layer showing between the strokes. This gives the impression of more feather edges, but they are less defined than the incised ones.

Tail:
Darken the base and tip of the tail with Black and add a few long strokes from base to tip, giving the appearance of several tail feathers.

Upper Wing:
Deepen the color of the upper wing feathers with Cool Gray 70% and in the process increase the value difference between the shadow and highlight areas.

Back and Shoulder:
1. Add more "texture" strokes in the back and shoulder area with Cool Gray 70%,
2. Add more texture with a very sharp Dark Brown pencil.

Cheek:
On the white cheek, add texture strokes of Cool Gray 70%, placing them in the shadow at the bottom and in curved rows around the eye.

Underside:
For the chest, belly, and base of the tail, deepen color and add texture by working texture strokes over the entire area.
1. Place light Terra Cotta strokes on the front of the upper chest and on the flank beneath the lower wing.
2. In the shadow areas at the bottom of the body and on the base of the tail, use Cool Gray 70% and Dark Brown. By placing these strokes close together, create darker areas.
3. With Dark Brown, add a narrow shadow beneath the wing.

Branch:
Add another layer of Cool Gray 70% to the shadow areas of the branch.

Front Pine Cone:
1. On the front pine cone, use a Dark Brown pencil to sketch lines from each side of

the tips of the "petals" towards the center of the cone. These lines define the sides of the "petals."
2. Then use Dark Brown to deepen the areas between the "petals" and at their bases.

Rear Pine Cone:
On the rear cone, darken the bottom (the area just to the left of the bird), then deepen areas "behind" each of the cone "petals" with Dark Brown.

Needles:
Add clusters of needles with Peacock Green and Olive Green, pulling pencil strokes from the branch outward.

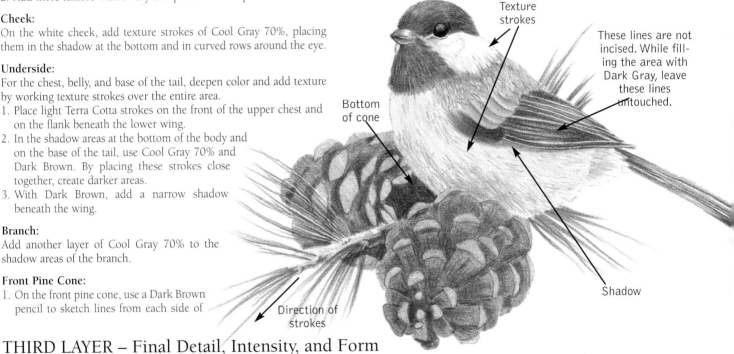

Texture strokes

These lines are not incised. While filling the area with Dark Gray, leave these lines untouched.

Bottom of cone

Shadow

Direction of strokes

THIRD LAYER – Final Detail, Intensity, and Form

Refer to finished drawing on page 118. Use medium lead type pencils unless noted otherwise.

Black Markings and Beak:
Use Black to deepen the head, beak, and wing feathers, leaving highlights on the beak, crown of the head, and center of the lower wing feathers.

Shoulder:
Deepen the texture of the shoulder with short strokes of Mouse Gray.

Cheek:
Use Mouse Gray to create a small shadow under the white cheek. A small shadow of Mouse Gray to the left of the eye helps form the head, and set the eye.

Back:
A light glaze of Goldenrod (hard lead type) brightens the highlight on the back.

Wing and Tail:
To liven up the gray of the upper wing feathers and tail, add a light glaze of Bluish Gray.

Underside:
The chest still needs form and texture.

1. Glaze over the upper chest and flank (beneath the lower wing) with Light Ochre.
2. Add texture strokes of Mouse Gray.
3. Use Brown Ochre to color the shadow areas at the bottom of the body and in the base of the tail. Add glazes of these two colors to deepen the shadows even more. Also use these two colors on the narrow shadow beneath the wing.

Pine Cones:
1. Deepen the shadows on the cones with Umber.
2. Darken the upper part of the large shadow area on the rear cone with Black.
3. Glaze Umber over the lower portion of each cone to shade the overall forms.

Needles:
1. Add more pine needles with Peacock Green (hard lead type) and Olive Green (hard lead type).
2. Set off the bird with light glazes of Peacock Green (hard lead type), making the color deeper beneath the bird and branch and lighter by the back and chest. ❏

Quail

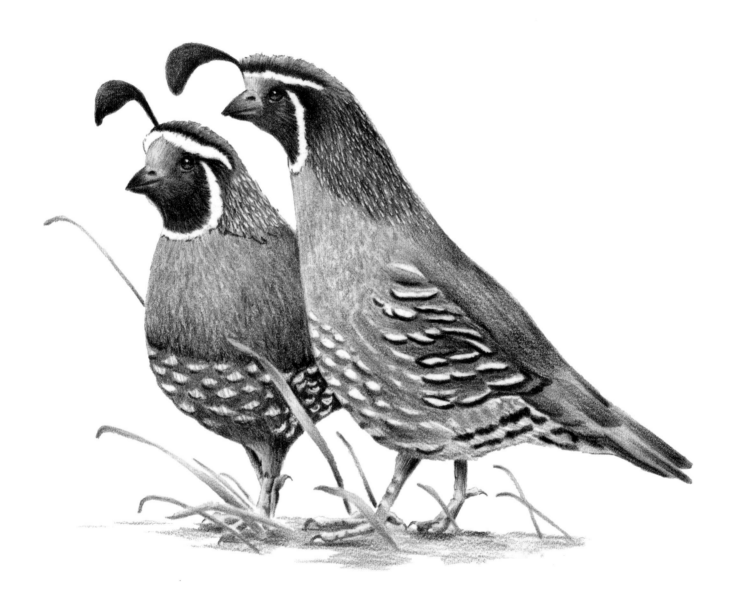

Quail are such family oriented birds! Late last spring I was driving to town when I stopped for a family of quail, crossing the road in front of me. Mom headed the procession, followed by nearly a dozen tiny babies. Dad brought up the rear. There was a deep ditch on the side of the road they were crossing to and one of the little ones was having trouble scaling the bank. It was such fun to give the little guy a gentle boost.

This drawing is of two adult males "walking the walk."

SUPPLIES

Colored Pencils:

Hard Lead Type:

Golden Brown

Dark Brown

Pink

Parma Violet

Cerulean Blue

Warm Gray 20%

Cool Gray 70%

Dark Gray

Black

Medium Clay-based Lead

Olive Gray

Cinnamon

Brownish Beige

Cocoa

Umber

Mouse Gray

Grayish Black

Black

Other Supplies

Drarwing paper, white

Size 01 black permanent pen

Stylus

FIRST LAYER – Establishing Local Color

Use hard lead type pencils throughout the first layer.

Eyes:
The quails' eyes are bright but the irises do not show.
1. With the permanent pen, ink the outline of the eye and the outline of the highlight.
2. Fill the upper half with ink, avoiding the highlight.

3. Fill the lower half with Black pencil for a secondary highlight.

Beaks:
Use Black for the beaks, leaving plenty of highlights.

Continued on page 124

Continued from page 123

FIRST LAYER – Establishing Local Color

Black Markings:
Use Black for the "helmet plumes," bottom edge of the crown just above the white band, chin, neck, side of the face, and the "V" shaped area behind the white band ringing the face. Lay strokes in the direction the feathers go. On the crown they are tiny up and down strokes.

Foreheads:
1. Add a little Golden Brown to the foreheads.
2. Pick up Dark Brown and use this to blend into the Golden Brown as you move towards the eye.
3. Color the upper portion of the crown with Dark Brown..

Incising Marks:
1. There is a lot of small pattern on the back of the neck and upper back. Using the large end of a stylus, incise several short strokes representing the light tips of the small neck feathers. Press the ball of the stylus into the paper, then ease pressure in a short, upward stroke.
2. On the left bird, incise the "U" shaped feather tips on the rump.

Neck and Back:
Go over the back of the neck and upper back with Cool Gray 70%, stroking the pencil parallel to the incised lines.

Left Bird:
1. Use Cool Gray 70% to tone the right edge of the left bird's body which is in shadow.
2. Tone the remainder of the bird, the chest and belly, with Warm Gray 20%, working around the white feather tips on the front of the belly.

Right Bird:
1. For the right bird, work the back and tail with Cool Gray 70%, varying pressure to define the individual feathers on the tail with shadows and highlights.
2. Work the chest, belly, and wing with Warm Gray 20%, working around the white feather tips.
3. On the wing, add Black under the white patches. The dark patches on the underside of the tail and the rump are Black.
4. The feather fluff above these black areas is Cool Gray 70%.

Legs and Feet:
1. Color the legs and feet with Warm Gray 20%.
2. Add a little shading with Cool Gray 70%.

Grasses:
The grasses are Golden Brown.

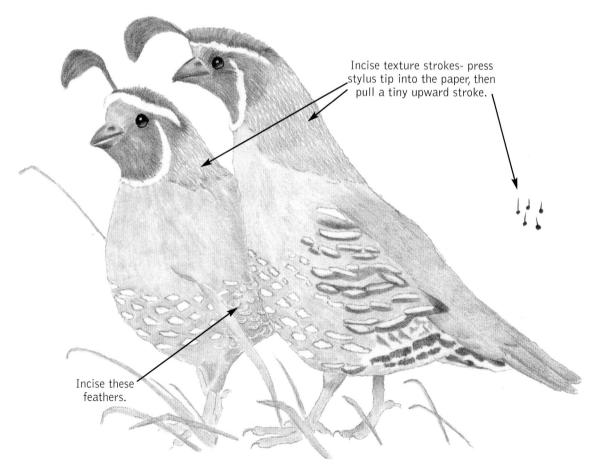

Incise texture strokes- press stylus tip into the paper, then pull a tiny upward stroke.

Incise these feathers.

SECOND LAYER – Deepen Color and Build Form

Use hard lead type pencils throughout the second layer.

Heads:
1. For the heads, deepen the black portions with Dark Gray, once again leaving highlights on the beak.
2. Darken the Dark Brown areas with more Dark Brown, and layer Dark Brown over most of the Golden Brown, leaving only the leftmost areas untouched.

Incised Areas:
Glaze Dark Gray over the incised areas on the necks and upper backs, and continue into the shadow areas on the left bird's right side and on the right bird's back and tail.

Left Bird:
1. Lightly glaze Parma Violet over the highlight area on the chest (the upper and center left).
2. Use Cerulean Blue over the rest of the chest and the back.
3. Go over the lower portion of the belly and side with Dark Gray, once again avoiding the white feather tips.

Right Bird:
1. Lightly glaze Pink over the highlight at the upper left of the chest.
2. Use Cerulean Blue over the rest.
3. Darken the left part of the belly with Cool Gray 70% (avoiding the white feather tips).
4. Darken the mid- and dark-tones on the wing with Dark Gray.

Incised texture lines are more distinct as more color is added.

A glaze of another color brightens the grays.

Legs and Feet:
Add shadows to the legs and feet with Dark Gray to better define their forms.

Grasses:
Add Dark Brown accents and shadows to the grasses.

THIRD LAYER – Final Detail, Intensity, and Form

Refer to finished drawing on page 122. Use medium lead type pencils unless noted otherwise.

Heads:
1. On the heads, deepen the black areas with Black.
2. Add a little more Dark Brown (hard lead type) to the crown and shadow side of the Golden Brown foreheads. Leave tiny highlights under the eyes to represent the lower lids.

Incised Areas:
On the incised portions of the neck, first glaze with Umber, then rework the areas with small criss-cross stokes of Grayish Black. The Grayish Black adds both texture and depth.

Left Bird:
1. Work over the chest and side with small up-and-down squiggly strokes, using Mouse Gray in the highlight areas and Grayish Black in the shadows.
2. On the lower, patterned belly, work around the white feather tips with Cinnamon on the upper left portion, Umber on the lower left portion, and Black on the right portion.
3. Then lightly shade the white feather tips with Brownish Beige.

Right Bird:
1. For the right bird, work over the chest with light up-and-down squiggly strokes of Mouse Gray.
2. Deepen the back and tail with Grayish Black.
3. Work the gray areas of the belly with Mouse Gray, and darken directly beneath the white feather tips with Grayish Black.
4. Deepen the gray areas on the wing with Umber and the dark areas under the white patches with Black.
5. Also add more "fluff" on the under side of the tail with Mouse Gray.

Legs and Feet:
To detail the legs and feet, darken the shadows with Umber then Black in the darkest areas.

Grasses:
1. Add Olive Gray to the grasses, smoothing the transition between the Golden Brown and the Dark Brown.
2. Use Olive Gray horizontal strokes between the grasses.
3. Color in Cocoa for shadows underneath the feet. ❑

Indigo Bunting

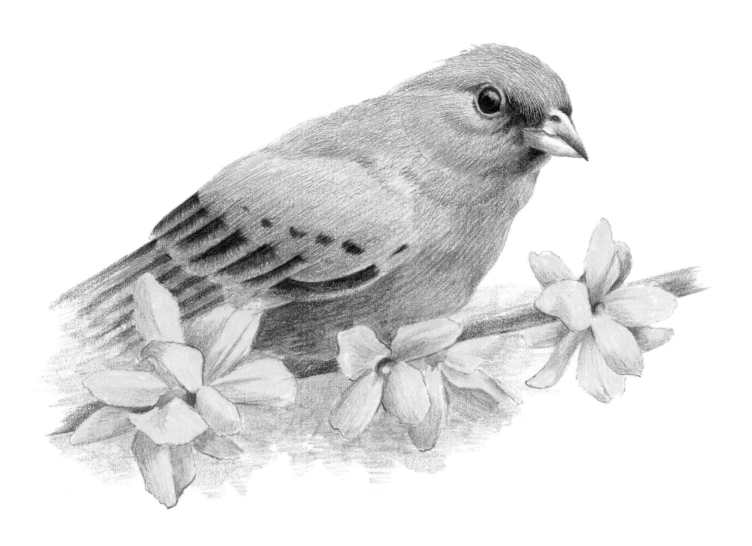

I am sad to say that I have never seen an Indigo Bunting, although I spent my childhood within their range. I do not know whether one would ever actually perch on a branch of blooming forsythia, but I hope it happens, because these colors are so beautiful together.

SUPPLIES

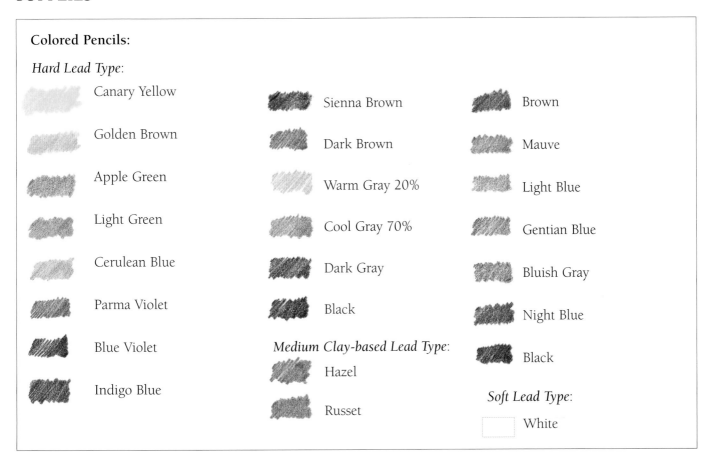

Colored Pencils:

Hard Lead Type:

Canary Yellow

Golden Brown

Apple Green

Light Green

Cerulean Blue

Parma Violet

Blue Violet

Indigo Blue

Sienna Brown

Dark Brown

Warm Gray 20%

Cool Gray 70%

Dark Gray

Black

Medium Clay-based Lead Type:

Hazel

Russet

Brown

Mauve

Light Blue

Gentian Blue

Bluish Gray

Night Blue

Black

Soft Lead Type:

White

Other Supplies

Drawing paper, cream
Size 01 black permanent pen
Stylus

Continued from page 127

FIRST LAYER – Establishing Local Color
Use hard lead type pencils unless noted otherwise.

Eye:
1. This eye has a large highlight at the top of the eye. Ink the outline of the eye and the lower outline of the pupil with the permanent pen. Then fill the pupil, leaving an irregular edge at the top.
2. Fill the lower part of the iris with Dark Brown, and the remaining portion with Black, but apply the black lightly.

Beak:
1. Before deepening the beak, place White (soft lead type) on the highlight areas on both the upper and lower beaks. As the paper is cream, this highlight is lighter than the paper, but only slightly.
2. Then place the shadows with Cool Gray 70% and the midtones with Warm Gray 20%. Establish the shape mostly with the shadows along the lower edge of the upper beak and in the nostril.

Plumage:
1. The plumage is pretty simple – blue! Use Cerulean Blue everywhere but the lower wing feathers, varying pressure to create highlights and shadows.
2. Deepen the darkest shadows with Indigo Blue.

Wing Markings:
Once the blue is established, draw the dark markings on the wing with Black, and sketch in the upper sides of the lower wing feathers. This drawing is a vignette, so fade these feathers to nothing at the far left.

Forsythia Blooms:
1. Fill the forsythia blooms with Canary Yellow.
2. Color in the calyxes with Light Green.

Branch:
1. Draw the branch with Dark Brown, varying the pressure for a shadow along the bottom edge.
2. Then use the large end of the stylus to impress small circles along the branch which will show as light areas in later layers.

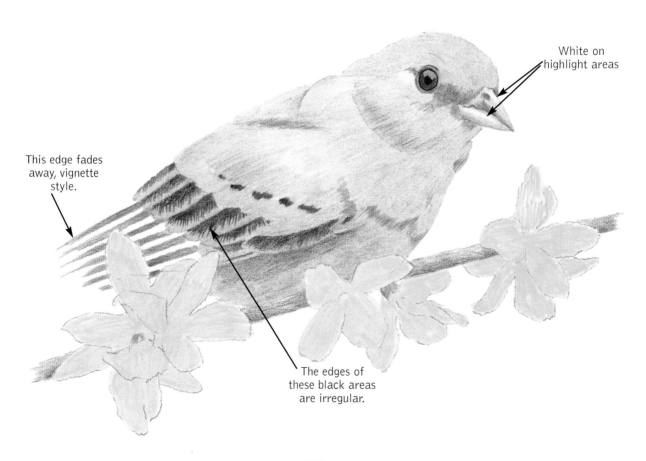

White on highlight areas

This edge fades away, vignette style.

The edges of these black areas are irregular.

SECOND LAYER – Deepen Color and Build Form

Use hard lead type pencils throughout the second layer.

Eye:
Deepen the lower portion of the iris with Sienna Brown and Black. Soften the upper edge of the eye with Black.

Beak:
Increase the value contrast in the beak by adding Dark Gray to the shadow areas and Cool Gray 70% to the midtones.

Incising Marks:
From this view, we do not see many large, defined feathers, but a soft overall texture formed by the tiny feathers of the head, neck, and chest. Use the small end of a stylus to incise texture on the head, neck, back, and shoulder. On the head, neck, and back, use small, slightly criss-crossing strokes, and on the shoulder use long sweeping strokes. All of the strokes run in the direction the feathers grow. These incisions will become light lines when you apply more color later.

Plumage:
Apply tiny texture lines over the same areas (just incised) and with the same types of strokes.
1. On the head, neck, and back, use Parma Violet in the highlight areas and Blue Violet in the shadows.
2. On the shoulder, use Cerulean Blue in the highlight areas and Indigo Blue in the shadows.

3. Use Indigo Blue on the chin, chest, and belly.
4. Deepen the shadow under the wing with a dark glaze of Indigo Blue.

Tail Feathers:
On the lower tail feathers, deepen the Black and add Indigo Blue between the black stripes.

Forsythia:
1. Shade the flowers with Golden Brown.
2. Shade the calyxes with Apple Green.
3. Shade the branch with Sienna Brown.

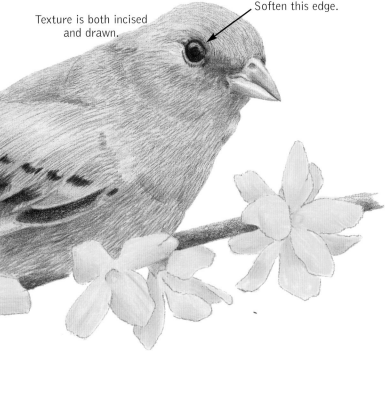

Texture is both incised and drawn.

Soften this edge.

THIRD LAYER –
Final Detail, Intensity, and Form

Refer to finished drawing on page 126.
Use medium lead type pencils unless noted otherwise.

Plumage:
1. Glaze mauve over the Parma Violet areas.
2. For the remainder, use Gentian Blue over the highlights.
3. Apply Bluish Gray over the midtones.
4. Use Night Blue in the shadows.
5. Strengthen the darkest shadows between the eye and beak, under the beak, and under the wing with Black.

Forsythia:
1. On the flowers, shade with Hazel.
2. Add a little Russet to the deepest shadow areas.
3. Shade the branch with Brown.

Background:
Add a background of Cool Gray 70% (hard lead type) in the lower portion of the drawing. ❑

Warbler

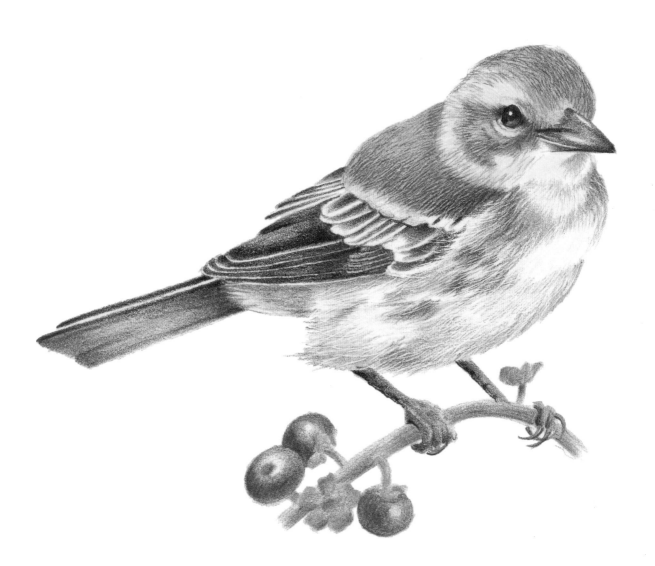

*There are many species of warbler throughout the country.
They are small, sparrow-sized birds, often with touches of yellow,
and all with beautiful voices. This one is perched on a cluster
of choke-cherries.*

SUPPLIES

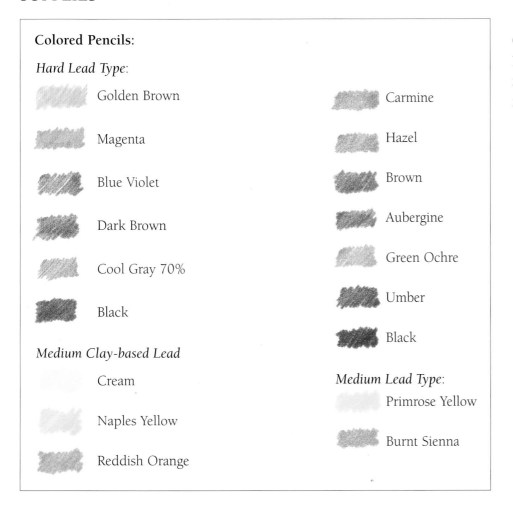

Colored Pencils:

Hard Lead Type:

Golden Brown

Magenta

Blue Violet

Dark Brown

Cool Gray 70%

Black

Medium Clay-based Lead

Cream

Naples Yellow

Reddish Orange

Carmine

Hazel

Brown

Aubergine

Green Ochre

Umber

Black

Medium Lead Type:

Primrose Yellow

Burnt Sienna

Other Supplies
Drawing paper, white
Size 01 black permanent pen
Stylus

FIRST LAYER – Establishing Local Color

*Use hard lead type pencils unless noted otherwise.
See drawing on page 132.*

Eyes:
The quails' eyes are bright but the irises do not show.
1. With the permanent pen, ink the outline of the eye and the outline of the highlight.

2. Fill the upper half with ink, avoiding the highlight.
3. Fill the lower half with Black pencil for a secondary highlight.

Continued on page 132

Continued from page 131

FIRST LAYER – Establishing Local Color

Beak:
Use Black for the beak. Heavy pressure gives the darkest tones. Use a very light pressure for the highlight along the lower edge of the upper beak, and leave the bright highlight along the top the white of the paper. The highlights give the appearance of shine.

Brown Markings:
The orange/brown portions of this bird are actually comprised of several colors. For the base, use a heavy application of Golden Brown, followed with a lighter application of Burnt Sienna (medium lead type). This yields a pretty brownish gold on the shoulder, cheek patch, crown, and forehead.

Yellow Markings:
1. Fill the yellow on the cheek and around the eye with Naples Yellow (medium lead type).
2. Fill the chin with a softer Primrose Yellow (medium lead type).

Incising Marks:
1. With the large tip of a stylus, incise the edges on the long wing feathers.
2. Incise curved, criss-crossing lines over the entire chest with the small end of the stylus.

Wing Feathers:
The wing feathers are black with white edges, with the exception of a small cluster of feathers towards the middle of the wing which are completely black. Use Black on all the wing feathers, avoiding the white edges. The white areas on the upper feathers are the largest.

Tail:
1. Use Black on the upper edge of the tail.
2. The underside of the tail is dark, and the feathers are undifferentiated. Use Umber (medium lead type) at the ends, blending into Hazel (medium lead type) in the center.

Legs and Feet:
Use Black for the legs and feet, varying pressure to establish the shadow and highlight areas.

Chest:
The coloring on the chest is very subtle with a lot of texture.
1. Add texture strokes of Dark Brown at the sides of the throat and downwards onto the side.
2. Use Hazel (medium lead type) directly below the light area under the chin and along the bottom of the forward chest.
3. Use Cool Gray 70% at the bottom between the legs.
4. Fill the light areas with Cream (medium lead type).
5. Use irregular strokes of Cool Gray 70% to suggest the fluff at the base of the tail.

Choke-Cherries:
1. Fill the berries with Aubergine (medium lead type), but leave highlight areas.
2. Fill the rest with Carmine (medium lead type).

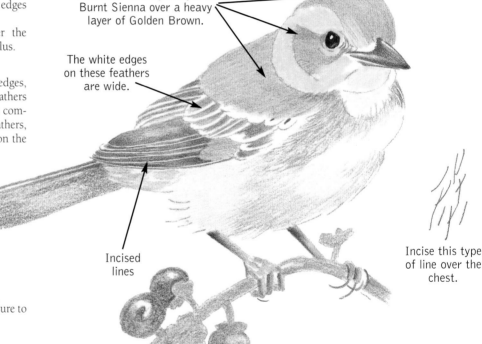

This color is a light layer of Burnt Sienna over a heavy layer of Golden Brown.

The white edges on these feathers are wide.

Incised lines

Incise this type of line over the chest.

SECOND LAYER – Deepen Color and Build Form

Use hard lead type pencils unless noted otherwise.

Incising Marks:
With the small end of a stylus, incise tiny lines over the golden brown areas, running the lines in the direction the feathers grow.

Brown Markings:
Go over the golden brown areas with a very sharp Dark Brown pencil, using small criss-crossing texture strokes, and working heavier in the shadow areas.

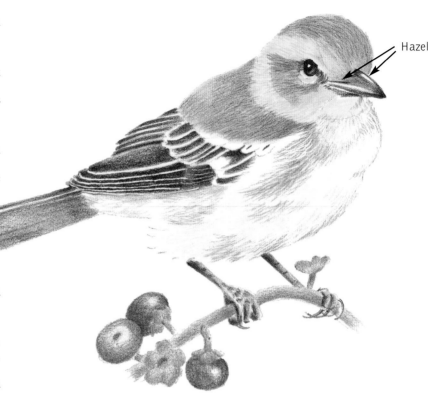

Hazel

Yellow Markings:
Similarly, add texture to the yellow areas with tiny criss-cross strokes of Golden Brown.

Eyes and Beak:
1. Deepen the corners of the eyes and the beak with Black (medium lead type).
2. A little Hazel (medium lead type) brightens the area just above the beak.

Wing and Tail:
1. Deepen the colors of the wing and tail with Black (medium lead type).
2. Use Umber (medium lead type) to deepen the color on the under side of the tail.

Underside:
With Dark Brown, add a small shadow under the wing and more texture stokes on the chest.

Legs and Feet:
Deepen and add texture to the legs and feet with Black (medium lead type).

Choke-Cherries:
1. Blue Violet intensifies the color of the berries. Wash this color very lightly over the highlights.
2. Shade the branch with Magenta.
3. Glaze over the shading on the branch with Blue Violet.

THIRD LAYER – Final Detail, Intensity, and Form

Refer to finished drawing on page 130.
The task at this stage is to add final color and be sure that the highlights and shadows are sufficient to define the form.
Use medium lead type pencils unless noted otherwise.

Eye:
To set the eye into the head, use Black (hard lead type) to darken both corners, and define the lower lid and folds around the eye with shadows.

Face:
1. "Punch up" the color on the face with a little Reddish Orange to the front of the eye, both above and below the beak.
2. Use Hazel and Umber to make the brownish patch under the eye a little more irregular in shape.

Brown Markings:
1. Turning to the gold brown areas, add tiny strokes of Umber to deepen the shadow areas.
2. These areas should have a very slightly greenish tint, so glaze over all but the highlights with a thin application of Green Ochre.

Wing and Tail:
Make a final check to see if you need to deepen any of the black areas, then glaze over the underside of the tail with Brown.

Chest:
The chest needs more definition.

1. Add more dark areas of criss-cross strokes of Umber.
2. Use Hazel and Brown to define the rounded areas under the chin and on the front of the chest.
3. With the same colors, as well as Cool Gray 70% (hard lead type), add glazes of color and criss-cross texture lines to the lower and rear edges to darken these areas and make the belly appear more round. Be careful to leave a highlight area above the left leg. This highlight defines a rounded area around the top of the leg.

Underside:
Add a little Dark Brown (hard lead type) and Blue Violet (hard lead type) to the base of the tail which is in shadow.

Legs and Feet:
Deepen the legs and further define the claws with a very sharp Black pencil.

Choke-Cherries:
1. To finish the berries, add a layer of Black, then some Dark Brown (hard lead type) in the shadows.
2. Tone down the pink color of the stem by glazing over it with Dark Brown. Use this same color for shadows. ❏

Kestrel

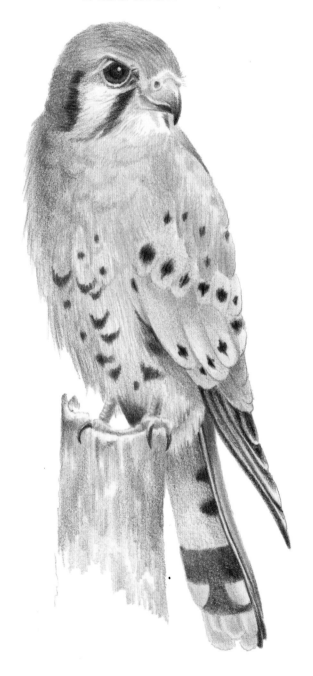

Kestrels are small falcons, also known as "sparrow hawks." I often see them perched patiently on telephone wires, their gorgeous rust and blue-gray plumage in full view. We were fortunate enough to attract a nesting pair to a house we built and mounted to kestrel specifications. I never saw the parents delivering "sparrows" to their brood, but cheered them on as they harvested over-fed tomato worms from our garden.

SUPPLIES

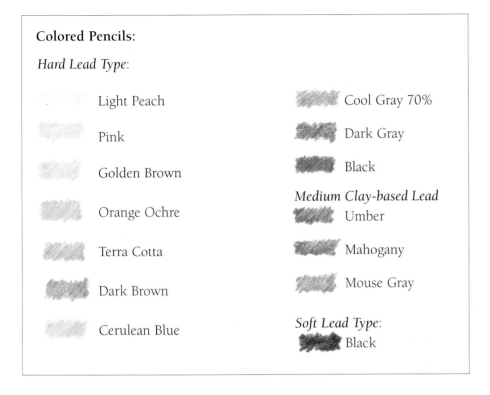

Colored Pencils:

Hard Lead Type:

Light Peach

Pink

Golden Brown

Orange Ochre

Terra Cotta

Dark Brown

Cerulean Blue

Cool Gray 70%

Dark Gray

Black

Medium Clay-based Lead

Umber

Mahogany

Mouse Gray

Soft Lead Type:

Black

Other Supplies

Drawing paper, white

Size 01 black permanent pen

FIRST LAYER – Establishing Local Color

Use hard lead type pencils throughout the first layer.

Eye:
The iris shows slightly on this bird.
1. Use the permanent pen to outline the eye, the pupil, and the primary highlight. Ink the pupil, avoiding the highlight.
2. Fill the iris with Dark Brown.

Beak:
The beak is hard and shiny and it is important to preserve highlights.
1. Use Cool Gray 70% to fill most of the beak, but leave a strong highlight up the curved right edge and along the lower edge of the top half.
2. With Black, deepen the tip, lightly outline the right edge, and draw the center line.
3. Fill the nostril with Dark Brown.
4. Color in the yellow area around the nostril and over the top of the beak with Golden Brown.

Head's Black Markings:
The markings on the head are quite distinctive. Draw the black patches around the cheek with parallel, approximately horizontal strokes of Black. A very narrow portion of the forward black cheek stripe from the other side of the head shows under the beak at the right side of the chin.

Eye Markings:
In the white areas in front of and beneath the eye, use Cool Gray 70% to draw and texture the eyelids and the corners of the eyes.

Head's Rust and Gray Markings:
Build the complex rusts and grays of the head by layering color. For this initial layer, use Terra Cotta on the rust areas and Cool Gray 70% on the gray areas. For both, use short side-by-side strokes to give a little texture. These strokes follow the direction of feather growth, curving up over the top of the head and back across the side.

Chin:
There is a little warmth at the lower side edge of the white chin. Add a little Golden Brown here.

Continued on page 136

Continued from page 135

Chest:
1. On the chest, use long strokes of Cool Gray 70% and Orange Ochre, working fairly lightly.
2. The tiny area of the back showing at the upper right is Terra Cotta.

Wing:
1. Form the feathers of the top section of the right wing with Terra Cotta, shading lightly to form the individual feathers.
2. Work the middle wing section in a similar manner with Cool Gray 70%.
3. Add Black on the long feathers of the lower wing.

Black Markings:
Add the dark markings with Black. Form each marking with a series of parallel strokes rather than outlining spots.

Tail Base:
1. The base of the tail is light, so begin with a little Golden Brown, but leave a white edge.
2. Then shade the shadow portion with Dark Brown.

Top Side of Tail:
1. There are several colors and markings on the tail. Fill the top side with Orange Ochre.

2. Delineate the edge of the wing feathers on the right side with two long smooth strokes of Black separated by a line of the white of the paper.

Underside of Tail:
1. The underside of the tail is in deep shadow, but begin by adding a light, warm color, Golden Brown, to the upper portion. As you deepen this area in subsequent layers it will retain a warm cast because of this base color.
2. Draw the lower part of the tail with Black and Cool Gray 70%.

Legs and Feet:
1. Use Light Peach for the legs and feet.
2. Outline the claws with Black.

Branch:
The branch is very rough. For this first layer use rough, uneven strokes of Dark Brown.

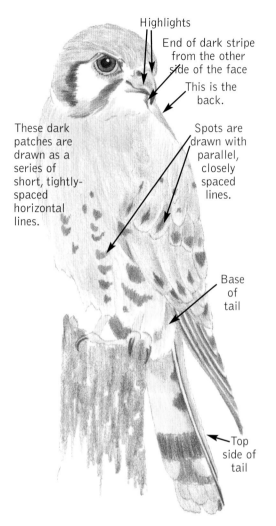

Highlights

End of dark stripe from the other side of the face

This is the back.

These dark patches are drawn as a series of short, tightly-spaced horizontal lines.

Spots are drawn with parallel, closely spaced lines.

Base of tail

Top side of tail

SECOND LAYER – Deepen Color and Build Form

Use hard lead type pencils unless noted otherwise.

Head:
1. Deepen the iris with more Dark Brown.
2. Deepen the darker areas of the beak with Dark Gray.
3. Darken and extend the dark areas shading the beak with Dark Gray, but continue to preserve the highlights.
4. The yellow area around the nostril is shaded with very narrow shadows of Dark Brown.

White Markings:
Add texture strokes on the white of the cheek and chin with tiny strokes of Cool Gray 70%.

Head's Rust and Gray Markings:
1. To deepen and enrich the rusts and grays of the head, add Mouse Gray (medium lead type) over the gray.
2. Add Mahogany (medium lead type) over the rust. As in the first layer, work in small, parallel strokes for texture.

Back:
Use Mahogany (medium lead type) to deepen the lower part of the small part of the back showing at the upper right over the wing.

Chest:
Along the gray area at the left side of the chest, use long strokes with a sharp Mouse Gray (medium lead type) pencil. This both darkens the color and adds texture.

Orange Markings:
1. For the orange part, first glaze Golden Brown over the highlight at the top right, then use a sharp Terra Cotta pencil to indicate the edges of several feathers on the top half of the chest. Draw each feather edge with a series of very short parallel strokes placed in a curved pattern. Lower down, the strokes are long and straight.
2. Add similar strokes of Cool Gray 70% to deepen the color in the shadow areas.

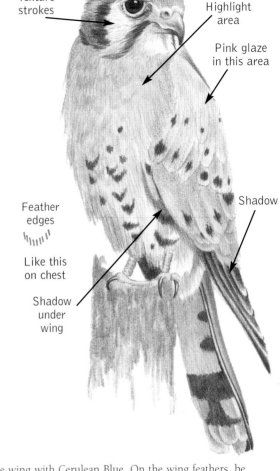

Texture strokes

Highlight area

Pink glaze in this area

Feather edges

ɰɰɰɰ

Like this on chest

Shadow under wing

Shadow

Top of the Wing:
1. For the top (orange) section of the wing, begin by glazing over the area very lightly with Pink, simply to slightly change the color of the orange.
2. Then add texture strokes with Terra Cotta.

Middle of the Wing:
Add Mouse Gray (medium lead type) over the middle, gray section of the wing, deepening the color in the shadow areas and going very slowly over the highlights at the tips of the feathers.

Lower Wing:
Deepen the darks in the lower wing feathers with Dark Gray. Add gray towards the top to form the narrow shadow where the middle wing section laps over the lower wing. Also use Dark Gray for the shadow the wing casts on the side of the belly, and to darken the far wing that shows between the legs.

Tail:
1. Using Dark Brown, deepen the shadows on the base of the tail.
2. Glaze over the Golden Brown on the lower side of the tail.
3. In this area, deepen the blacks with Dark Gray and the grays with Cool Gray 70%.
4. Shade the upper part and a narrow right edge of the upper side of the tail with Cool Gray 70%.

Legs and Feet:
1. For the legs and feet, use Terra Cotta to both deepen and texture them.
2. Deepen the claws with Dark Gray.

Branch:
Add a second layer of Dark Brown on the branch.

THIRD LAYER – Final Detail, Intensity, and Form

Refer to finished drawing on page 134.
Use hard lead type pencils unless noted otherwise.

Eye:
1. Deepen the upper part of the iris with Black. At this point, the iris and pupil are nearly indistinguishable.
2. Form the shadows in the corners of the eye with Dark Gray.

Beak:
1. Brighten the color of the beak with a glaze of Cerulean Blue, avoiding the highlights. The blue suggests a reflection of the sky, adding to the impression of shininess.
2. Deepen the dark areas with Black (soft lead type).
3. To warm up the corner of the beak, add just a little very light Terra Cotta.

White Markings:
1. The lower portion of white cheek patch is in light shadow. Add a little light Cerulean Blue.
2. The beak casts a shadow on the chin. Draw the shadow lightly with Cool Gray 70%.

Head's Black Markings:
Deepen the black patches with Black (soft lead type).

Head's Rust and Gray Markings:
1. Glaze over the gray portions of the head with Cerulean Blue.
2. Add shadows with Mouse Gray (medium lead type).
3. Deepen and shade the rust areas with Umber (medium lead type), but leave a highlight at the top of the head.

Chest and Wing:
1. Glaze over the gray at the left of the chest and also over the gray feathers on the wing with Cerulean Blue. On the wing feathers, be careful to glaze very lightly over the highlight areas.
2. Add more Terra Cotta to the right side of the chest to deepen the color.

Shadows:
To "round" the bird, add shadows of Umber (medium lead type) along the left side of the body, using both glazes of even color and strokes and patches to preserve the texture. Also strengthen the shadow under the wing with Umber.

Wing:
1. For the upper portion of the wing, use more Terra Cotta, then Umber (medium lead type) to deepen the color and form the feathers.
2. For the middle portion, shade with Umber.
3. For the lower portion, use Black (soft lead type) to darken the color.
4. Add a shadow of Umber along the top.

Black Markings:
Deepen the markings on the wing, chest, and tail with Black (soft lead type).

Tail:
Develop the form of the tail with shadows of Umber (medium lead type).

Legs:
Shade the legs with Dark Brown.

Branch:
Add Black (soft lead type) to the branch. ❏

Mixing it up with Mixed Media

Colored Pencil pairs beautifully with other media. Here are three different combinations that you may enjoy seeing. I hope they will provide you with inspiration to not only give these techniques a try, but also to experiment with combinations of your own. You can use these same techniques to combine them with any of the colored pencil drawings presented in this book.

Watercolor

I am not a watercolorist, but I love their beautiful, vibrant colors, and I like to use them as a base for colored pencil. In this mixed media technique, the watercolor lays in the base colors, and the colored pencil adds the detail.

Advantages:
1. The watercolor paint covers the paper quickly, especially with a large brush.
2. With hot press (smooth finish) watercolor paper, the color saturates the paper with no tiny white spots of paper showing through, as happens with colored pencil.
3. The transparent colors are absolutely brilliant, and they lend a vibrant quality to the drawing.

SUPPLIES
Paint: You do not need to make a large investment to add watercolor to your colored pencil drawings. You can begin with a few colors of paint that you often use in backgrounds.
Brushes: You need invest in just a few large brushes. I find large round brushes and a wash brush particularly useful.
Paper: Be sure to use watercolor paper. It is specially formulated to stand up to water-based media. I use 140lb (medium weight) hot press (smooth surface) paper and tape the corners to a rigid board as I work. The paper may buckle a little bit, but when I am done with my drawing I flatten it by laying it face down on a smooth table covered with freezer paper, lightly spraying the back with water, covering the paper with a towel, then covering the towel evenly with heavy books. After sitting overnight, the paper will be flat!
Masking fluid: Masking fluid is a special product for using with watercolor. It is similar to thin rubber cement. You apply it to the paper with a brush and after it is dry, paint over it. When the paint is dry, you can rub the masking fluid away. The mask has protected whatever was underneath it.

Using Masking Fluid:
• Masking fluid comes in white or a very pale yellow. I prefer the yellow fluid because it is easier to see where I have applied it. The color does not transfer to the paper.
• Do not leave the dried fluid on the paper longer than necessary. Try to remove it soon after the paint is thoroughly dry.
• Masking fluid is very hard on brushes, so do not use your best ones for this task. Thoroughly dampen the brush hairs and rub the brush on a cake of soap before dipping it in the masking fluid. This will make it harder for the masking fluid to cake on the brush.
• Masking fluid will dry quickly on your brush so wash brushes frequently.

• Slightly thinning the masking fluid with water will make it easier to work with.
• Do not shake the fluid because bubbles will transfer to the paper, burst as they dry, and leave tiny unprotected dots that the paint will go through.

Mandarin Duck
Here's How:
1. After masking out the area where the duck will be drawn, quickly paint the background with washes of brown tone watercolor.
2. While the paint is still wet, use the chisel edge of a damp brush to remove paint giving the illusion of grasses along the horizon line.
3. After the paint dries, remove the masking fluid.
4. Lay in broad areas of pale watercolor on the duck. Let dry.
5. Complete the colored pencil drawing.
6. Add more watercolor to intensify the shading in place. I used it under the chin and on the wing feathers. ❑

Parakeets
I have always loved the bright colors of these cheery little birds. To get brilliant color, use watercolor as a foundation for the parakeets. Also use watercolor and a series of masks for a somewhat abstract background.

Here's How:
1. To work on the background, first mask out the area where birds will be painted.
2. Wash the entire background with a very pale green (Sap Green). Let dry.
3. Mask out the lightest areas of the background and add another wash. Let dry. This second wash darkens the background everywhere except where you put the two applications of mask.
4. Next, mask out the second lightest areas of the background and add another wash.
5. Continuing in this way, build up several values of green in the background.
6. When the background is done and the paint is dry, remove all of the mask, including that over the birds. To remove the mask, gently rubb it off with your finger, then use a click eraser on any "straglers."
7. With all of the mask removed, apply a watercolor base over the birds. Do a little shading, but not much.
8. With the base colors in, finish the birds with colored pencil.
9. Finally, use colored pencil to add a little detail to the leaves and darken parts of the background. ❑

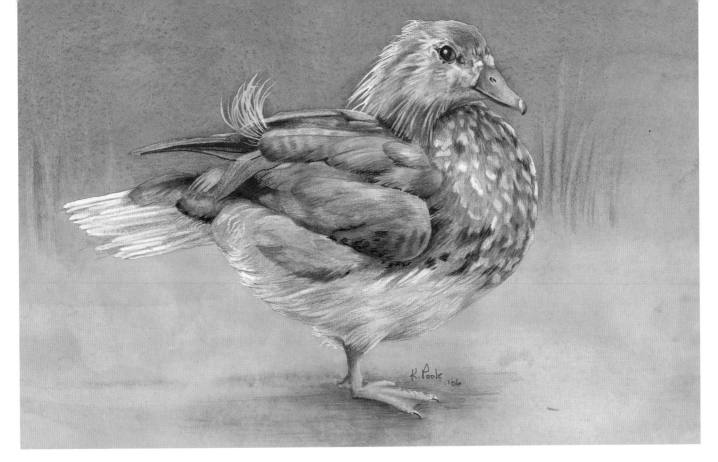

Iridescent Inks

There are so many beautiful iridescent, pearlescent, and metallic products available, that it is very tempting to combine them with colored pencil.

I used iridescent inks for the background in this drawing of a blue jay. In many respects, I treated the ink like watercolor, beginning by masking out the bird and branches then applying the ink. The difference is that the ink is thicker than watercolor, so it is harder to rub off the underlying mask. In fact, I find that this technique does not work well for small areas such as the tiny branches.

After applying the ink background and removing the mask, complete the bird with colored pencil. Also add colored pencil to darken the background directly behind the bird. ❏

Graphite

My favorite medium is graphite pencil, so it was natural for me to combine it with colored pencil. I like to use colored pencil to "tint" a graphite drawing, giving a look reminiscent of old-fashioned hand-tinted black and white photographs.

In both thesse examples, I first completed a graphite drawing that could stand on its own, then added a little color with colored pencil.

Sparrow

The colors in this drawing are minimal. After completing the graphite drawing, add a little Chestnut colored pencil to the head, shoulder, and wing, a bit of Terra Cotta to the feet, and Goldenrod to the grass. Also use colored pencil for the background and the shadow under the bird.

Baby Sparrows

Once again, first complete the graphite drawing, then add color. Work with hard lead type pencils and add Goldenrod, Terra Cotta and Indigo Blue to the birds, and Olive Green and Peacock Green to the grass.

Tip: Apply several light coats of fixative rather than one heavy coat. Too heavy a coat of fixative can sometimes change the colored pencil!

Metric Conversion Chart

Inches to Millimeters and Centimeters

Inches	MM	CM	Inches	MM	CM
1/8	3	.3	2	51	5.1
1/4	6	.6	3	76	7.6
3/8	10	1.0	4	102	10.2
1/2	13	1.3	5	127	12.7
5/8	16	1.6	6	152	15.2
3/4	19	1.9	7	178	17.8
7/8	22	2.2	8	203	20.3
1	25	2.5	9	229	22.9
1-1/4	32	3.2	10	254	25.4
1-1/2	38	3.8	11	279	27.9
1-3/4	44	4.4	12	305	30.5

Yards to Meters

Yards	Meters	Yards	Meters
1/8	.11	3	2.74
1/4	.23	4	3.66
3/8	.34	5	4.57
1/2	.46	6	5.49
5/8	.57	7	6.40
3/4	.69	8	7.32
7/8	.80	9	8.23
1	.91	10	9.14
2	1.83		

Index

Index

About Kaaren Poole

Kaaren Poole is a self-taught artist. Among her early works are her third grade arithmetic papers enhanced with horse portraits. While pursuing a career in the computer industry she took up china painting as a hobby, and from there, progressed to artists' acrylics and watercolor. Finding little sympathy for her favorite subject – animals – in the fine art world, she turned to decorative painting.

"Retirement" now allows her to work full-time on her art. Her first book, *Nature's Vignettes,* a collection of ten animal designs, was published by Plaid Enterprises, Inc. in 2005. Kaaren's other books published by Sterling Publishing are *How to Sketch Animals* (2007) and *Simple Landscape Painting* (2007).

Kaaren lives in rural Northern California with her three dogs, twelve cats, and four ducks. She has been a member of Sierra Wildlife Rescue's squirrel team for the last three years and has successfully raised and released orphaned fox squirrels and western gray squirrels on her property.

Kaaren may be contacted through her website, www.kaarenpoole.com.

A Final Word of Encouragement

I hope you have enjoyed reading this book as much as I have enjoyed creating it. And most of all, I hope you will pick up your pencils and draw birds! It is such a joy, and a small miracle, to begin with a blank piece of paper and end up with a creation that is all yours, based on a subject that you love and admire.

Do not be too hard on yourself, or drawing won't be a pleasant experience. But on the other hand, push yourself a little or you will never progress. Tackle a subject or medium that you haven't used before. Work with colors that aren't your favorites. Evaluate your work as you go with a discerning eye. Learn from the parts that you wish you had done differently. And never forget to compliment yourself for your successes – you did it!

If you are working from photographs, please remember that the goal is not to copy the photo, but to create your own piece of art. As you work, stay focused on the drawing you are building rather than on your source photos. And do not stress out if your drawing does not look exactly like the photograph – that is not what you're aiming for anyway. The photo is a lovely pathway in the woods, but the walk is all yours to enjoy!